MAP SHOWING
STATE PARKS AND PARKWAYS
ON LONG ISLAND
SCALE IN MILES

PREPARED BY THE
LONG ISLAND STATE PARK COMMISSION
BABYLON, SUFFOLK CO., N.Y.
1936

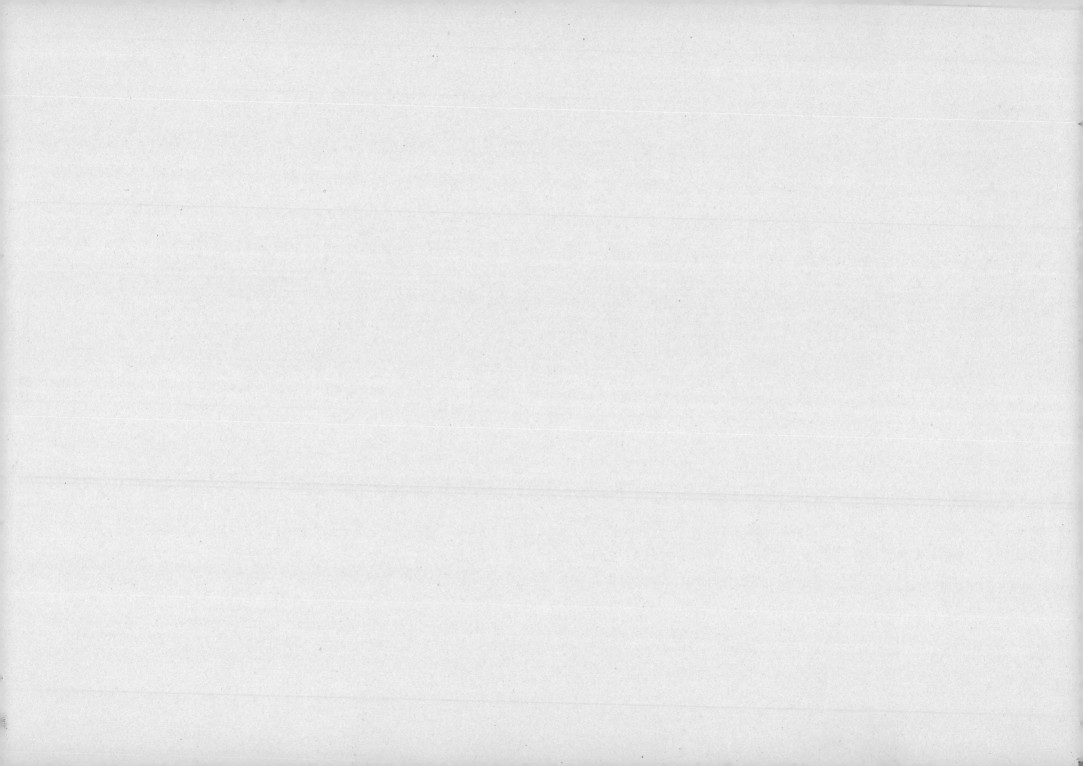

LONG ISLAND
LANDSCAPE PAINTING

Volume II: The Twentieth Century

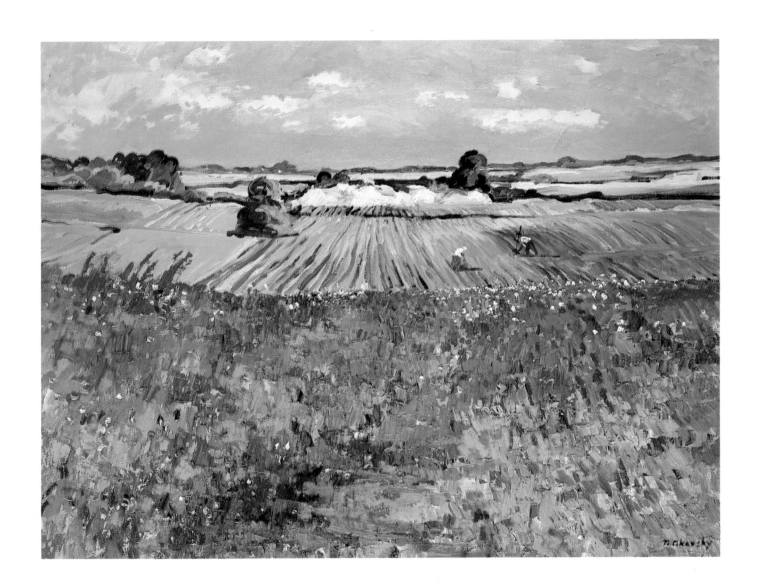

LONG ISLAND LANDSCAPE PAINTING

Volume II: The Twentieth Century

RONALD G. PISANO

BIOGRAPHICAL ESSAYS BY BEVERLY ROOD

DESIGNED BY JOHN ESTEN

A Bulfinch Press Book
Little, Brown and Company
Boston · Toronto · London

First Edition

The excerpt from "Bill's Burnoose" by Frank O'Hara is
reprinted from *The Collected Poems of Frank O'Hara*, edited
by Donald Allen, Copyright © 1971 by Maureen Granville-
Smith, Administratrix of the Estate of Frank O'Hara, by
permission of Alfred A. Knopf.

The photographs on pages 3, 7, 10, 30, 32, 36, 46, 52, 54,
58, 60, 62, 74, 84, 96, 102, and 156 appear courtesy of the
United States History, Local History & Genealogy Division
of the New York Public Library, Astor, Lenox and
Tilden Foundations.

Frontispiece: Nicolai Cikovsky, SUMMER SCENE
oil on canvas, 30³/₁₆ × 40⅛, The Parrish Art Museum,
Southampton, New York, gift of Professor Matthew and
Mrs. Roslyn W. Besdine.

Library of Congress Cataloging-in-Publication Data

Pisano, Ronald G.
 Long Island landscape painting: the twentieth century/
Ronald G. Pisano. — 1st ed.
 p. cm.
 "A Bulfinch Press book."
 Includes bibliographical references.
 ISBN 0-8212-1760-7
 1. Landscape painting, American — New York (State) —
Long Island. 2. Landscape painting — 20th century —
New York (State) — Long Island. 3. Long Island (N.Y.)
in art. I. Title.
ND1351.6.P58 1990
758'.174721'0904 — dc20 89-39724
 CIP

Bulfinch Press is an imprint and trademark of
Little, Brown and Company (Inc.)

Published simultaneously in Canada
by Little, Brown & Company (Canada) Limited

PRINTED IN JAPAN

CONTENTS

ACKNOWLEDGMENTS

Even before my previous book *Long Island Landscape Painting, 1820–1920* was written, a sequel to it was enthusiastically projected, and it was intended that this sequel should parallel the first book in terms of concept, form, and design. However, rather than having the second book take up exactly where the last one left off — at 1920 — and stop at 1990, a more general time frame was established, focusing on the development of Long Island landscape painting in the twentieth century. The twenty-year overlap between the two books underscores the fact that there is a continuum in this development. Representational art did not cease to exist with the advent of the twentieth century; it continued on in varying degrees along with abstract art, and at times even adopted some of the principles of modernism. The result is a rich and diverse array of views of Long Island's ever-changing landscape.

In selecting images for this book, I had to consider the following factors: first and foremost, the quality of the artwork; the dramatic range of styles that had to be represented; the geographic representation; and, ultimately, the number of color illustrations I was able to use. The task was not a simple one, and some artists who are presently painting Long Island landscapes may feel that they have been overlooked. It is my hope, though, that the interest generated by this book will benefit all of those artists who have chosen this subject for their paintings. The challenge is still there, as is the inspiration, and undoubtedly other art historians and critics will also continue to write about Long Island landscape paintings. In the meantime, I would like to thank all the owners of the works of art illustrated for allowing me to use these images for the book. I am particularly indebted to the artists, art dealers, museum personnel, and other individuals who have assisted me with this publication.

Among the many individuals associated with art galleries representing the artists included in this book, I would like to single out some who have been particularly helpful: Eliza Beghe, Marilyn Pearl Gallery; F. Frederick Bernaski, Kennedy Galleries; Melissa Brooks, the Pace Gallery; Betty Cunningham, Hirschl & Adler Modern; Terry Dintenfass and Lynda Bailey, Terry Dintenfass Galleries; Bella Fishko and Brooke Pickering, Forum Gallery; Jane Hart, Marlborough Gallery; Jeanne Havemeyer, B. C. Holland, Incorporated; Nathan Kernan, Robert Miller Gallery; Cecily Langdale and Melinda Kahn Tally, Davis & Langdale Company; Sandra Leff, Berta Walker, and Kristin O'Grady, Graham Modern and Graham Gallery; Carol Pevsner, Kraushaar Gallery; Anne Plumb and Elaine Equi, Anne Plumb Gallery; Lawrence Salander, Salander-O'Reilly Gallery; Natasha Sigmund, Paula Cooper Gallery; and Neil Winkel, Fischbach Gallery.

Special mention should be made of Ruth Vered and Janet Lehr for their help in sending me a wide array of slides of paintings by artists who have shown at the Vered Gallery in East Hampton.

Several individuals at museums have given special assistance in obtaining transparencies: Grant Holcomb, Memorial Art Gallery, University of Rochester; Charles Millard, Ackland Art Museum; Joseph Newland, Los Angeles County Museum of Art; Gary Reynolds, the Newark Museum; Clyde Singer, the Butler Institute of American Art; and Howard Wooden, the Wichita Art Museum.

Among those who have been especially helpful in answering historical questions and locating documentary photographs for this book, the following should be acknowledged for their kind assistance: Mitzi Caputo, Huntington Historical Society; Janet Culbertson; Louise Dougher, Centerport Historical Society; George A. Finckenor, Sr., Sag Harbor Village Historian; Peggy Gerry, Historic District Board, Roslyn; Sarah Greenough, Alfred Stieglitz Archives, National Gallery of Art; George Gurney, National Museum of American Art; Barbara Hillman, New York

Public Library, Local History Division; Deborah Johnson, Museums at Stony Brook; Mimi Kail, Northport Historical Society; Dorothy King, Long Island Collection, East Hampton Free Library; Claire M. Lamers, Brooklyn Historical Society; Carol Traynor, Society for the Preservation of Long Island Antiquities; Bonnie Yochelson, Museum of the City of New York.

Others who were most helpful with regard to information about specific artists were Sally Avery (Milton Avery); John Burrows (Harold S. Burrows); Vicky Cardaro (Jennifer Bartlett); Felicity Dellaquilla and Edna Richner (John Koch); Anne Cohen DePietro (Arthur Dove, Helen Torr, and John Marin); Robert Durell (Peter Bèla Mayer); Stanley Grant (Paul Georges), Jeffrey R. Hayes (Oscar Bluemner); Claire Jaeger, Niles Jaeger, and David Picken (George Picken); Sue Davidson Lowe (John Marin); Clark Marlor and Ida Rothbort (Samuel Rothbort); Alvin Novak and Robert Doty (John Button); Francis V. O'Connor (Jackson Pollock); Georgette Preston (George Constant); and Remak Ramsay (Thomas Dooley).

I would also like to thank the staff members of the following institutions where research for this publica-tion was conducted: the Archives of American Art, the Frick Art Reference Library, and the New York Public Library. Christina Strassfield of the Guild Hall Museum and Alicia Longwell of the Parrish Art Museum were also particularly helpful.

Since this book was inspired in part by an exhibition I organized for the Parrish Art Museum in 1982, I would like to express my thanks to the curatorial staff who assisted me with that show: Christine Bergman, Norma Loehner, Melinda Mumford, Beverly Rood, Mary Dexter Stephenson, and Penelope Wright, as well as Trudy Kramer, who succeeded me as the director of the museum.

The publication of this book would not have been possible without the enthusiastic support and guidance of Ray Roberts, senior editor at Little, Brown and Company, and the professional assistance of the following members of staff of this firm: Christina Eckerson, Dana Groseclose, Thacher Storm, and Dorothy Straight.

I am especially indebted to Helen Harrison, curator of the Guild Hall Museum in East Hampton, for her initial thoughts and suggestions regarding the selection of contemporary Long Island artists to be included in this book, as well as for her willingness to read my introductory text and offer valuable suggestions that have helped improve both its clarity and its content. Additional preliminary advice that was equally helpful was provided by David Cassedy. D. Frederick Baker was also of considerable help with regard to administrative details.

Finally, I would like to acknowledge my sincere gratitude to my colleagues in producing this publication — to John Esten for his assistance in locating appropriate images for the book as well as for designing it; and to Beverly Rood for her insightful biographical essays and for her perseverance in working on every stage of this book's production, from the time it was merely a proposal through all of the research, correspondence, coordination of visual materials, writing of the footnotes, and compilation of the bibliography. The diligence with which she accomplished these tasks cannot be too highly commended and should be singled out for special praise.

LINKING LONG ISLAND WITH ALL THE UNITED STATES

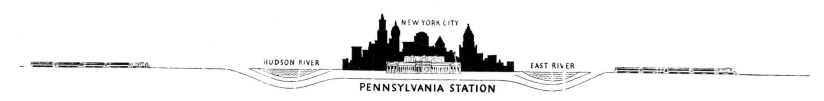

Pennsylvania Railroad brochure showing Long Island Railroad (detail), 1939
Courtesy of the Map Division, New York Public Library, Astor, Lenox and Tilden Foundations.

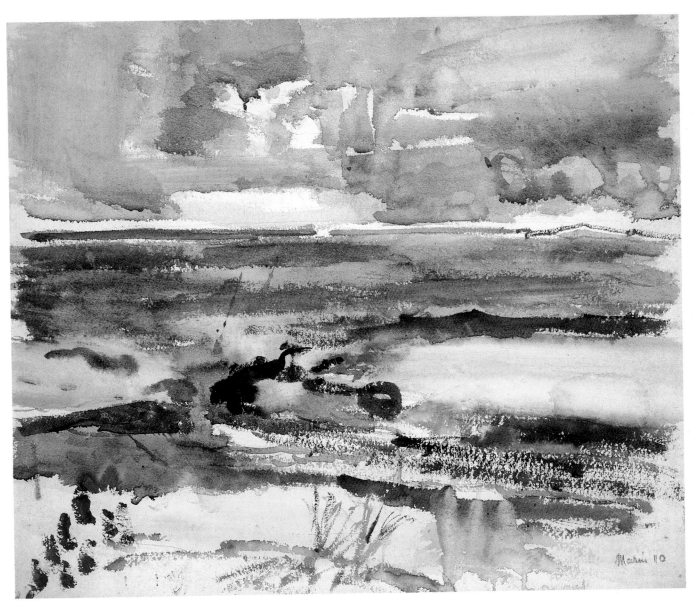

John Marin, PECONIC BAY, LONG ISLAND SOUND, 1910
watercolor on paper, 15½ × 18, Private collection, photograph courtesy of Kennedy Galleries, Incorporated, New York City.

INTRODUCTION

"It was a matter of chance that I should have rented a house in one of the strangest communities in North America. It was on that slender riotous island which extends itself due east of New York — and where there are, among other natural curiosities, two unusual formations of land. Twenty miles from the city a pair of enormous eggs, identical in contour and separated only by a courtesy bay, jut out into the most domesticated body of salt water in the Western Hemisphere, the great wet barnyard of Long Island Sound."

— F. Scott Fitzgerald, *The Great Gatsby*

The island mentioned by Fitzgerald is, of course, Long Island, comprising four counties — Brooklyn, Queens, Nassau, and Suffolk — and extending eastward from Manhattan Island for approximately 120 miles. Celebrated by writers and painters of the nineteenth century, Long Island continued to lure their successors in the twentieth. By 1922, when Fitzgerald rented a relatively modest stucco house at 6 Gateway Drive in Great Neck Estates, where he would spend the next year and a half writing *The Great Gatsby*, Long Island's poet laureate, Walt Whitman, had been dead for thirty years.[1] The environment that inspired Fitzgerald's popular novel was considerably different from that which had been celebrated in Whitman's nature poetry. Just what had transpired during the intervening years, and what effect would it have on the impressions of twentieth-century artists and writers?

The "curious formations of land" dubbed West Egg and East Egg in Fitzgerald's novel are in reality Great Neck and Sands Point on Nassau County's northern shore, in an area then popularly known as Long Island's Gold Coast, an enclave of approximately 500 baronial estates staked out and subdivided by America's leaders of commerce and industry. On these estates, some of which encompassed hundreds of acres, millionaires built country houses inspired by European castles and palaces, such as Castlegould, built for the financier Howard Gould in Sands Point in 1909. Winfield, a fifty-six-room Italian Renaissance palace, was constructed for F. W. Woolworth in Glen Cove in 1916, at an estimated cost of nine million dollars.[2] The formation of these estates protected the natural beauty of the area — if only for the pleasure of their wealthy inhabitants — as urban development encroached on other regions of Long Island, most particularly Brooklyn and Queens. Queens County, which originally had included all of what we now know as Nassau County, was divided in 1898. The western portion became the borough of Queens and,

along with Brooklyn, was then annexed to New York City; the eastern part became Nassau County. The landscape of Brooklyn and Queens changed as well: what were once pastures and farms became sprawling residential areas and industrial sites.

The rapid development of Brooklyn and Queens was further accelerated by the entry of the United States into World War I. In 1917 naval training stations were established in Brooklyn to prepare for this conflict, and operations in the Brooklyn Navy Yard were also greatly expanded. After the armistice was signed the following year, other industries flourished in Brooklyn and Queens. In 1919 Lasky and Zukor's Famous Players Film Company built motion-picture studios in Long Island City, Queens. In 1920 these became Paramount Studios, the center of the film industry on the East Coast.[3] Also in the 1920s, major highway construction took place on Long Island to accommodate the vast number of people who purchased cars during this prosperous period, and this

expansion of the road system accelerated the region's development.

Artists and writers portrayed the urbanization of Long Island's western territories and were sensitive to the survival of the relatively bucolic state of areas farther east. Among those who chose urban development and industrialization as a subject, some focused on the negative effects of rapid growth. F. Scott Fitzgerald provides a bleak description of the forsaken landscape of a section of Queens through which one had to pass to get from Long Island's Gold Coast to New York City:

About half way between West Egg and New York the motor road hastily joins the railroad and runs beside it for a quarter of a mile, so as to shrink away from a certain desolate area of land. This is the valley of ashes — a fantastic farm where ashes grow like wheat into ridges and hills and grotesque gardens; where ashes take the forms of houses and chimneys and rising smoke and finally, with transcendent effort, of ash-gray men, who move dimly and already crumbling through the powdery air. Occasionally a line of gray cars crawls along an invisible track, gives out a ghastly creak, and comes to rest, and immediately the ash-gray men swarm up with leaden spades and stir up an impenetrable cloud, which screens their obscure operations from your sight.[4]

A similarly haunting, ominous view of Queens was captured by Georgia O'Keeffe at about the same time in her painting *East River from the Shelton*, of 1927–1928. Instead of describing an automobile ride through Queens, as Fitzgerald had done, O'Keeffe painted this rather macabre view from her apartment on the thirtieth floor of the Shelton Hotel in Manhattan. The sinister effect of this scene — dark factories emitting impenetrable clouds of smoke that obscure the sunlight and enshroud the shoreline in toxic mist — is heightened by the blood-red waters of the East River, which serve as a border between Manhattan and its industrialized neighbor. Less dramatic but equally disturbing is George Ault's *Brooklyn Ice House*, of 1926. Rather than portraying a vast horizon of industrial waste, Ault limited his view to a single factory in Brooklyn, showing its smokestack and two leafless trees. In this barren locale, devoid of human life, man's presence is only implied, isolated within the walls of an icehouse.

While some artists focused on the dehumanizing environment of industrialized Brooklyn and Queens in the early twentieth century, others provided more positive images. What could be a more vital subject than Coney Island, America's greatest amusement park? The elation of its bright lights, shrill sounds, and intensified sensations is best conveyed in *Battle of Lights, Coney Island*, of 1913–1914, by the futurist painter Joseph Stella. Modernists such as O'Keeffe, Ault, and Stella were well equipped to convey the dynamic energy of industrialized Long Island in the twentieth century. Like Fitzgerald, they had a contemporary vocabulary that they used effectively to convey the essence of the modern age. Long Island provided Fitzgerald with a land of contrasts, both dazzling and bleak, nurturing and reflecting the characters of his novel. For modernist painters, industrialized western Long Island offered images of majesty and monstrosity, exhilaration and isolation. In contrast, eastern Long Island, for modernists and more traditional painters alike, represented a very different source of inspiration.

As industry boomed in Brooklyn and Queens in the first decades of the twentieth century, Nassau and Suffolk counties retained their roles as the farmland that supplied produce for the tables of New Yorkers. The establishment of the New York School of Agriculture in Farmingdale in 1916 underscored the importance of agriculture to the area. Long Island also had an important fishing industry, based mainly in Nassau and Suffolk counties, and Blue Point oysters, along with Long Island duckling and Long Island potatoes, all gained notoriety for the region.[5]

During World War I, Long Island contributed to the nation's defense. Camp Mills was established in Hempstead as a training center and debarkation camp, and 6,000 acres in Yaphank were cleared to construct Camp Upton, an induction center for up to 40,000 soldiers.[6] During this period aviation became an increasingly important industry on Long Island: in 1918 the first guided missile tests were secretly performed at a field in Amityville, and in 1923 the first transcontinental flight took off from Mitchel Field. The region's most celebrated event in aviation history occurred in 1927, when Charles Lindbergh completed the first nonstop solo flight across the Atlantic in the *Spirit of St. Louis*, thirty-three and a half hours after taking off from Roosevelt Field.[7]

Recreational and cultural developments on eastern Long Island during this period included the establishment of universities, parks, and the area's second art museum, the Heckscher, which was founded in 1920 to house the collection of August Heckscher. In later years the Heckscher Museum, along with the Parrish Art Museum in Southampton (founded in 1898) and the Guild Hall Museum in East Hampton (founded in 1931), would expand its scope to embrace contemporary art, serving as a showcase for internationally acclaimed artists as well as emerging artists of the region.

During the first three decades of the twentieth century, landscapes painted in Nassau and Suffolk counties varied dramatically in style. William Merritt Chase continued to paint plein air landscapes in the impressionistic manner he had mastered late in the previous century while spending the summer months at Shinnecock Hills. Another American Impressionist painter, William Lathrop, visited Long Island regularly aboard his twenty-six-foot sailboat, *The Widge,* making stops at North Shore towns and villages such as Oyster Bay and Port Jefferson. His colleague Childe Hassam, who first visited East Hampton in 1898 and made it his summer home in 1919, adjusted his impressionist style somewhat, reflecting his interest in more modernist aesthetics. The paintings of these artists continued a tradition of painterly realism. Meanwhile, modernist painters were already portraying Long Island's open dunes, undulating inlets, and quaint hamlets in an idiom very different from that of the American Impressionists. Their styles were derived from more recent developments in Paris, including Postimpressionism, Cubism, and other advanced movements. Furthermore, not only their idioms but also their subjects were notably unlike those produced by their more traditional colleagues. When Preston Dickinson visited Port Jefferson around 1920, he recorded a bold architectonic view of this village in the precisionist style of painting he had developed from Cubist principles. This majestic modernist statement contrasts dramatically with the quaint, intimate views of the old seaport done by painters of the previous century.

During this period similarly abstracted views of the area were created by other innovative painters who visited Long Island, including several associated with the avant-garde photographer and art dealer Alfred Stieglitz. Their works were exhibited in his New York galleries — first at 291 (The Little Galleries of the Photo-Secession, 1905–1917), then at the Intimate Gallery (1925–1929), and finally at Stieglitz's last gallery, An American Place (1929–1946). Among the Stieglitz associates who painted on Long Island at this time were John Marin, Georgia O'Keeffe, Arthur Dove, and Helen Torr. Marin was the first to paint scenes in this area — as well as the last. His earliest

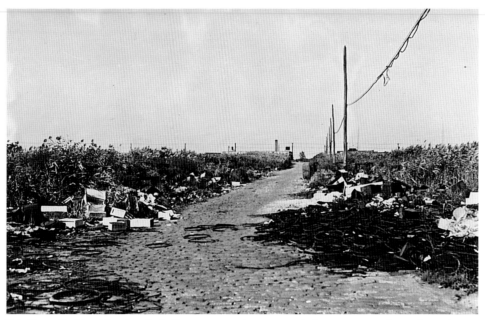

P. L. Sperr, Flushing Meadow Park, Queens — northern section before it was transformed into the World's Fair grounds, 1935
Courtesy of the New York Public Library Special Collections.

known treatment of a local scene is *Peconic Bay, Long Island Sound,* a watercolor dated 1910. In an abstract, reductive manner, Marin managed to capture the essence of the region: the open space, flat, unrelieved horizon, dramatic atmospheric conditions, and gentle, rhythmic motion of waves on the shoreline. Although worlds apart stylistically, Marin's views of the area relate remarkably to those of William Merritt Chase in terms of sentiment, lyrical mood, and artistic refinement. Nearly two decades later, Marin returned to eastern Long Island and painted *Long Island Potatoes, Spring of 1927,* choosing one of the region's chief agricultural activities as the subject for this watercolor.

Apart from Georgia O'Keeffe's views of industrialized Queens, done from her Manhattan apartment in the 1920s, only one other Long Island subject by her has come to light: *Sunset, Long Island,* of 1928, painted while she was visiting a friend on the Island's South Shore. In an abstract manner, O'Keeffe's painting uses simple forms to represent sun, sea, and land, while the undulating contours of the shoreline create a serene mood. Although the artist's choice of a band of black for her central feature may seem somewhat forbidding, it in fact merely suggests the darkness that will envelop the land when the sun sets.

Of all the artists in the Stieglitz group who painted on Long Island, Arthur Dove and Helen Torr most successfully, and most consistently, captured the ever-changing moods of nature. They began painting along the Island's North Shore in 1923, while sailing in their forty-two-foot yawl *Mona.* Most of their work during the 1920s and early 1930s was inspired by views of land and water that they had seen in and around Huntington, where they spent most of their time after 1924. Specific harbors, parks, and landmarks can be identified in their semiabstract renditions of local scenes. In their paintings, these two artists captured not only the "look" of the area but

the spirit as well — the effects of seasonal changes and fluctuations in the weather. Some of their works are cheerful and gleaming with bright, shimmering sunlight and warmth; others are cold and ominous, reflecting the harsh weather of the winter months along the shores of Long Island Sound. All are sensitive studies of nature, personal statements about the environment in which the artists chose to live and paint. In contrast to affluent artists of Long Island's halcyon years, such as Louis Comfort Tiffany (who built an opulent estate in Oyster Bay, farther west on the North Shore), Dove and Torr maintained a Spartan existence, barely scraping together enough money to frame their paintings.

In 1918 Tiffany made formal arrangements to establish "an art institute to be known as Louis Comfort Tiffany Foundation" to encourage the continued development of artists who had already benefited from some formal training. The following year the foundation was inaugurated at Laurelton Hall, Tiffany's luxurious 580-acre estate overlooking Cold Spring Harbor. From the start it was made clear that this was not a school — there were no required courses, no instructors, and no tuition fees. The intent was to provide selected artists "free access to Nature" and "free play to the development of individual artistic personality." Stanley Lothrop, the appointed director, indicated that Tiffany's purpose was to allow each artist to "devote himself to the study of nature . . . unhampered by financial considerations." Painting outdoors was encouraged, but these artists were also undoubtedly inspired by the fine and decorative artwork that adorned the setting in which they lived. Any American artist between the ages of eighteen and fifty was eligible for admission to the "colony" for a term of two months. Selection was made through a review of each applicant's work and letters of recommendation from well-known artists. In 1920 it was announced

that there would be a boarding fee of ten dollars a week, but the following year fellowships were offered to cover the expenses of artists in residence. Also in 1921 the admission age was changed, limiting eligibility to artists between the ages of twenty and thirty-five, focusing more directly on artists who had previous training but were still in need of assistance. Among the young artists who received Tiffany scholarships during the next two decades were Bradley Walker Tomlin (1922), Luigi Lucioni (1922), Paul Cadmus (1925), Ilya Bolotowsky (1929), Giorgio Cavallon (1929), and Ralston Crawford (1931). Through Tiffany's generosity, many young artists were introduced to Long Island's verdant hills and the undulating shoreline characteristic of Oyster Bay and the surrounding area. The foundation continued to operate after Tiffany's death, in 1933, until World War II, when the property was offered to the United States government for wartime use. The contents of Laurelton Hall were auctioned off in 1946, and the building itself was destroyed by fire in the 1950s.[8]

Meanwhile, another artists' colony had formed: the Idlehour Artists Colony, situated on William K. Vanderbilt's former estate, Idlehour, located in Oakdale, on Long Island's South Shore. Little is known about this particular colony, which began in 1926 and continued to about 1930. Among the artists associated with it were George Elmer Brown, Joseph Boston, Glenn Newell, Rosalie Osk, and Carl Nordell.[9]

Aside from these two colonies, summer art schools cropped up sporadically on Long Island's shores long after William Merritt Chase's famous school of plein air painting, the Shinnecock Summer School of Art, ceased to exist in 1902. Chase's school had been an extension of the New York School of Art, and when he discontinued his summer classes, other instructors

at the school carried on: in 1903 Douglas John Connah offered a summer class at Hampton Pines on Peconic Bay, and in the same year Robert Henri held a summer class at Bayport; in 1904 Henri and F. Luis Mora taught at Good Ground (now Hampton Bays).[10] In 1909 the New York School of Art went bankrupt, and summer sessions were disbanded. That same year the New York School of Fine and Applied Arts was formed, with Frank Alvah Parsons as president, and in 1914 a permanent summer school was established at Belle Terre, just north of the village of Port Jefferson, on Long Island's North Shore. Information about this summer school is scant. In 1914 enrollment was reported to be 150 pupils; in an account for 1915 it was stated that "instruction in painting, interior decoration, manual training and crafts, normal art, and children's classes" were offered. Tuition for that year was forty dollars for a period of eight weeks, and enrollment was 135. By the following year enrollment had grown slightly, reaching 165 to 168. By 1917, there was no longer any report on the school in the *American Art Annual*. It is possible that classes were discontinued due to the United States' involvement in World War I.[11]

In 1933, during the low point of the Depression, the Amagansett Art School held its first summer session under the directorship of Hilton Leech. In 1934 it was reported that there were six instructors and that the school offered training in "landscape painting, painting and drawing, sculpture, pottery, illustration and children's classes." Tuition was thirty-five dollars per class, and the term lasted from June 15 to September 15; enrollment ranged between thirty and fifty pupils until 1941, when the school apparently closed.[12]

Aside from these formal art schools, individual instructors also offered summer classes in various locales. Marshall Fry, formerly a student at William Merritt Chase's Shinnecock School, held informal classes in Southampton during the summer months between 1907 and 1916.[13] Leon Foster Jones, living in Port Jefferson, offered summer classes during the early 1920s, with a modest enrollment of seven reported.[14] In Nassau County, several attempts were made to establish formal art institutions, including the Hempstead/Nassau Institute of Art, which was founded in 1935 and lasted until at least 1938.[15] The establishment in 1948 of an Art Department at Adelphi, located in Garden City, under the chairmanship of Lincoln Rothschild, proved more enduring.[16] This course of study is still offered at Adelphi University, and similar courses in fine art and art history are now taught at other Long Island colleges and universities. Some of these classes benefited artists represented in this book. Aside from the offerings of these institutions located in Nassau and Suffolk counties, other programs are available at various locations in Queens and Brooklyn, including the Brooklyn Museum, where classes were first given in the nineteenth century, and the Art Department of Brooklyn College, which was formalized in 1942.[17]

During the late 1930s and the 1940s, Long Island developed more rapidly than any other region, especially in its western sector. Queens had a population of 1,291,314 in an area of 121 square miles, its growth attributed to the improved roads, bridges, and subway lines created for the 1939 New York World's Fair. Its approximately fifty individual communities were steadily "crystallizing into one vast residential area." During this same period in Brooklyn, it was reported that more than two and a half million people were "crammed into an area of 81 square miles."[18] Long Island's beaches and parks had to host hordes of tourists in addition to local residents; by 1940 more than a million people could be counted on the beach at Coney Island alone on a single favorable day. Fortunately the Long Island Park Commission, convened in 1924 under the guidance of Robert Moses, began buying up land to accommodate the recreational demand Moses had foreseen. At the time of the commission's formation, there was only one state park on Long Island: two hundred acres on Fire Island. Eventually the commission oversaw the acquisition of tracts of land that were designated as Wildwood, Sunken Meadow, Belmont Lake, Captree, Robert Moses, Orient Beach, Hither Hills, Montauk Point, and Heckscher state parks, among others. A system of parkways, referred to as the Island's "shoestring parks" since they consisted of strips of parkland bordering the roads leading to the major parks, was developed as well. Restricted to noncommercial vehicles, these parkways were designed to eliminate cross-traffic and stoplights; further, unsightly billboards were forbidden within 500 feet of the right-of-way.

During the Depression, the Works Project Administration, or WPA, initiated projects that improved living conditions on Long Island while they provided employment for artists.[19] Under the Federal Housing Program, the Williamsburg Houses were built in Brooklyn, serving to clear existing slums and provide low-rent housing. Artists were hired to paint murals for this project as well as for Long Island's post offices and other public buildings. Through the Writer's Program of the WPA, valuable information about Long Island was gathered and in 1940 published in *New York: A Guide to the Empire State*. Aside from employing writers, this publication served to draw attention to Long Island's cultural heritage and natural beauty.

During the 1930s, artists, most of them based in New York City, visited and painted on Long Island for various reasons. With the onset of the Depression, many New York artists who had previously spent their

summers in places such as Vermont and Maine were forced to stay in the city, but they found relief from the heat on Long Island's nearby beaches, which were becoming increasingly accessible. By this time Reginald Marsh had become well known for his paintings of boisterous throngs crowding the beach at Coney Island — as he described them, "crowds of people in all directions, in all positions, without clothing — moving like the great compositions of Michelangelo and Rubens."[20] Guy Pène du Bois traveled to eastern Long Island to teach at the Amagansett School of Art in the summer of 1938; there he painted the more refined and sedate bathers of this resort community, as seen in *Fog, Amagansett.* In this work, and more notably in his *Watching the Fleet,* which was also painted in Amagansett that summer, one detects a certain uneasiness, perhaps even an uncanny or inscrutable awareness of things to come — a stillness, like the calm before the storm, a brief interlude before the complacent life of eastern Long Island's elite was brought to an end. War was on the horizon, a bleak image that most Americans coming out of the Depression did not want to see or acknowledge.

In contrast, the theme of the 1939 World's Fair, "Building the World of Tomorrow," glowed with optimism, a positive spirit that was underscored by the conversion of the site, formerly a garbage dump in Flushing Meadow and the inspiration for Fitzgerald's "valley of ashes" in *The Great Gatsby,* into a spectacular international fairground.[21] In keeping with the upbeat mood, "Long Island: The Sunrise Homeland" was produced by the Fair Committee. This booklet was intended in part to draw greater attention to Long Island's appealing landscape and diverse cultural activities, and was in a sense a promotional device directed toward attracting the tourist trade. Both the gaiety and the naïveté of such hopes are reflected in Charles Prendergast's charming composition *World's Fair,* of 1939. Two years later America's vision of the "World of Tomorrow" was shattered by the Japanese attack on Pearl Harbor.

The war and its aftermath had a profound effect on Long Island's development. The aircraft industry, which had employed approximately 5,000 Long Islanders in the late 1930s, expanded dramatically to meet war needs, providing jobs for almost 90,000 workers.[22] And at the war's close, suburban development resumed at an unprecedented rate. To accommodate the rapidly growing need for suburban housing on Long Island, the company of Levitt and Sons devised a streamlined process for constructing houses, enabling it to build faster and cheaper than its competitors. Employing 15,000 workmen, at top production Levitt was able to complete thirty-five homes a day, which could be offered for $2,000 less than those built by other companies. The community was designed to house 83,000 people. To emphasize the "rural" aspect of suburbia, Levitt planted thousands of trees and planned to name its community Island of Trees; it was ultimately named Levittown instead.[23] Other less ambitious housing developments sprang up throughout the region, pushing suburbia farther and farther eastward.

The artistic milieu of the nation, specifically that of New York City, was affected by World War II and by postwar developments as well. For a variety of reasons, many European artists emigrated to America, most settling in New York City, which was by this time the unchallenged cultural capital of the country. These expatriate painters, many of whom had been at the forefront of modernist developments abroad, helped to rekindle modernism in America. During the 1930s and early 1940s, America had been retreating artistically, attempting to establish its own creative identity, which manifested itself in social realist and regionalist painting. In his book *The New York School: The Painters and Sculptors of the Fifties,* Irving Sandler provides an assessment of the changing New York art scene:

> The thirties, when the older abstract expressionists began their careers, were very unlike the late forties and fifties, during which they matured. The thirties was the decade of the Great Depression at home and a series of calamitous events internationally that led to World War II. The social urgencies of the time pressured artists to adopt Social Realist and Regionalist styles, but even the relatively few artists who ventured into abstraction tended to claim a social relevance for their painting and sculpture. Art-for-art's-sake and art for pleasure's sake were spurned.[24]

Furthermore, Sandler maintains that the artists who gained prominence during the 1940s and 1950s, specifically those grouped together as the New York school, were reacting to the emergence of a new postwar middle class bent on achieving the "American dream of affluence and, in the process . . . embracing conservative, corporate, and suburban values with so little critical questioning that the nation seemed to be in the throes of a massive social conformity."[25] In response to the new wave of conservatism, some artists refused to take an active role in provoking social change, choosing instead alienation, which provided them with both privacy and the freedom to develop their own work. As Sandler notes, these artists, along with dissident poets, composers, and dancers, became united in their rejection of "cliché-ridden culture." Abstract expressionism, action painting, gestural painting, and gestural realism sprang from similar desires, "for the personal voice, for the immediate impulse and its energy, for recognition of (even surrender to) process, to the elements

of randomness, whimsey, play, self-sabotage." Sandler asserts that both avant-garde artists and avant-garde writers were especially concerned with the "process" of creation, a process that is identified as direct, natural, and honest — autobiographical — "at the risk of self-indulgence."[26]

One might rightly ask, what does all of this have to do with Long Island — or with Long Island landscape painting? The answer is, a great deal. Many of the artists associated with the New York school of painters and their literary colleagues spent summers on Long Island, and some even established permanent studios and homes there — almost all on the South Fork. Among the earliest to settle in the area were Jackson Pollock and Lee Krasner, who moved to Springs, just outside East Hampton village, in 1945. Others followed — Willem and Elaine de Kooning, Joan Mitchell, and Grace Hartigan, to name a few. To varying degrees, the landscape setting that Long Island provided had an effect on these artists' work. As the art historian and Jackson Pollock scholar Francis V. O'Connor points out, "In the year immediately following Pollock's moving to East Hampton in November 1945, he reacted very strongly to his new environment, and produced during 1946 two series of paintings which he called the *Accabonac Creek Series* after the body of water behind his house, . . . and [the] *Sounds in the Grass Series.*" Substantiating the role this new landsape environment played in Pollock's work, O'Connor maintains, "If you contrast these open, highly colored, and directly painted works with the dark, brooding images of his 1945 city paintings, I think you will see the effect of the Long Island landscape on his work."[27] East Hampton had a similar influence on some of de Kooning's paintings. De Kooning absorbed his environment, assimilating the landscape's effects on him; he then painted spontaneously, with no subject necessarily in mind. He gave some of these paintings referential titles, such as *Montauk Highway,* in response to what he might see in the work during its process or after its completion. For many of these abstract painters, there is a certain bonding between nature and artist that is expressed in their paintings.

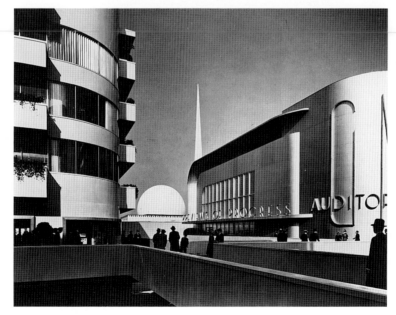

F. S. Lincon, View of Progress Auditorium, 1939 World's Fair, 1939
Courtesy of the New York Public Library Special Collections.

As Elaine de Kooning explained, "Today, for the artist with a signature, there is no simple 'what' — no reality, no subject, that does not include 'who' he is and 'how' he perceives it."[28] In the same vein, a group of these artists at the Artists Club in New York debated over "whether a form could be non-objective or 'unnatural.'" John Ferren contended that he had "watched Monet paint the lily pond. He never even looked at it when he painted, and besides, he was half blind." Al Newbill countered by saying, "Abstract painting put the painter into nature. He is no longer an isolated observing entity but is in nature and in the painting."[29] In her paintings Joan Mitchell drew upon sensations and emotions evoked by experiences she had had while spending time on Long Island, such as fishing excursions and hurricanes. In some paintings — *Rose Cottage*, of 1953, for example — Mitchell worked directly from nature, or within nature, under the awning of a summer cottage she rented in East Hampton.

Abstract expressionism was a dominant force in the New York art world of the 1940s and 1950s, and consequently extended its influence to eastern Long Island. Arthur Dove's late paintings, done in Centerport in the 1940s, became increasingly abstract and personalized reactions to nature, while John Marin's views of Huntington, painted in 1952, the year before his death, are more expressionistic. Representational art persisted in various forms as well. In sharp contrast to the abstract paintings of Dove and Marin, John Koch, living farther east on the North Shore, in Setauket, generally chose the more intimate setting of his own backyard for his outdoor genre paintings, which he executed in an almost photographic manner, using a technique that "conceals itself, . . . does not obtrude upon an attempt to replace the essential human communication."[30] Milton Avery, closely associated with the artists of the New York school, never totally abandoned the figure, and painted cheerful beach scenes

in a semiabstract manner at Coney Island and while making summer trips to Shinnecock Hills to visit his friend George Constant. Constant and another artist friend, Nicolai Cikovsky, painting nearby in North Sea, also created lyrical paintings based on the local landscape — colorful and painterly renditions of gardens, fields, and ponds.

The greatest concentration of artists working on Long Island was in fact to be found on the East End, particularly in the townships of East Hampton and Southampton. Other artists in the area used some of the techniques developed by their abstract-expressionist friends to paint spontaneous but recognizable images, creating a new mode for representational art in which immediacy was stressed and process "revealed." The style has been described as gestural realism, practiced by the artist Larry Rivers and championed by the poet Frank O'Hara. In her book *Frank O'Hara: Poet Among Painters*, Marjorie Perloff observes, "Rivers' view of art is immediately familiar to anyone who has read O'Hara. [Rivers] rejects the primacy of subject matter in painting, insisting that the 'how' supersedes the 'what.' Like O'Hara, he stresses the importance of 'the immediate situation'. . . of energy, of the role of 'accident' in art. . . ."[31] The time was the 1950s. The artists (to name a few) were Larry Rivers, Grace Hartigan, Nell Blaine, Jane Freilicher, and Paul Georges. Among the poets were Frank O'Hara, John Ashbery, James Schuyler, and Kenneth Koch; and the critics who were also painters included Elaine de Kooning, Robert Dash, and Fairfield Porter. The place, to all intents and purposes, was the Tibor de Nagy Gallery in New York, which provided the main showcase for the artists' work. The influences were complex and varied from artist to artist, but to one degree or another all were indebted to the abstract expressionists, Jackson Pollock and especially Willem de Kooning, who was most closely linked to

the group. Several of the artists associated with this circle also credit the precedent of the French Nabis painters Bonnard and Vuillard, whose work was featured in major exhibitions during the period. The close interaction of writers and artists created crosscurrents within the group. Among contemporary artists, Porter acknowledged his indebtedness to de Kooning as well as to Rivers, Freilicher, and John Button. He purchased his first painting by de Kooning in 1934; in 1949 he moved to Southampton and two years later, with the help of Elaine de Kooning, got a job as associate editor of *Art News* magazine. Porter was given his first one-man show at the Tibor de Nagy Gallery in 1951, at the recommendation of Willem and Elaine de Kooning, Freilicher, and Rivers.[32]

Taking note of this growing movement, the art critic Thomas Hess observed that the new generation of artists with the "New York look" was moving in a different direction. As he explained, "with descending age comes an increasing interest in figurative elements." However, as he noted, "the painterly 'look' was important to early-wave realists, since . . . it conveyed the impression of directness and of honesty."[33] The subjects these artists chose were extremely personal ones: their homes, their families, each other. Their poet friends developed along similar lines — most notably Frank O'Hara, who, by the end of the decade (in 1959), had founded a new movement in poetry, which he called Personism. This poetry was intended to be a "one-to-one communication, or better still, communion."[34]

During the 1960s the reputation of figurative painters in general, including those associated with Long Island's East End, grew slowly. In 1965 Porter organized an exhibition for the Parrish Art Museum in Southampton that

featured the works of eighteen artists whom he admired: among the local artists were Robert Dash, Paul Georges, Albert York, and Jane Freilicher.[35] Much of the region's natural beauty was expressed in their paintings.

What was left to inspire painters of the Long Island landscape in the 1970s and 1980s, and what will be left for future generations? What are the attitudes of those who have chosen to portray the region in recent years? Some artists, particularly those working on the western end of the Island, in Queens and Brooklyn, have chosen to focus on the "urban landscape." As early as 1932, Ogden Pleissner painted *Backyards, Brooklyn,* lovingly depicting an intimate scene within his immediate environment. The artist explained that he painted what he liked, and that he had lived in "some very nice neighborhoods."[36] More than thirty years later, Herman Rose painted an equally sensitive urban landscape in Brooklyn, *Looking Towards Verrazano Bridge,* viewed from the twentieth floor of the St. George Hotel in Brooklyn Heights. Rose's panoramic landscape is, in the artist's own words, a "vista of gleaming rooftops, waterfront and the great harbor stretching all the way to the spidery wisp of the Verrazano Bridge shining in the sun."[37]

In more recent years, artists working in Brooklyn have provided us with strong, vital images of the area's parks. In the early 1970s Harvey Dinnerstein began a ten-year project in Prospect Park called The Seasons, culminating in his monumental painting *Winter,* in which the tunnels in the park are used symbolically, representing "passage in time and space."[38] For more than twenty-five years David Levine spent the summer months visiting Coney Island, witnessing both its exhilarating rides and its ultimate decay, recently describing it as "a gothic ruin."[39] His painting *End of Joy* is thus symbolic as well, using the infamous roller coaster, the Thunderbolt, to represent the waning spirit of one of America's most famous amusement parks.

Obviously, artists' views of Long Island involve each artist's perceptions, past and present, and are colored by moods, intellectual concerns, and sentiments — that is what makes the images so varied and interesting. This variety is evident in the paintings that treat urbanized areas and also in those of artists working in regions farther east, where there is still open land that can inspire more traditional landscape painting. The decision to paint a particular setting can stem from different motives: familiarity with an area, interest in specific subject matter, preservationist concerns, or, most importantly, limitations of what landscape is left to paint. Due to continued development even on the eastern portions of Long Island, the subjects chosen generally fall into several categories: domestic scenes painted in the artists' own backyards; depictions of Long Island's waterways — rivers, ponds, and beaches — which are still relatively pristine; views of farmland; local genre scenes; and imaginary, or internalized, landscapes.

Clearly, most contemporary artists explore several of the subject categories listed above, and are motivated by more than one impulse. Bruce Lieberman is a case in point. Although Lieberman has painted on the relatively rural East End, he lives in Babylon, a suburban area in western Suffolk County. And when choosing to paint in that locale, he explains, "I have been forced to adjust and find beauty in the landscape wherever I can, . . . in my yard, my hedge or my vegetable garden. This element of the landscape is the majority of what is left." He paints a stand of trees across the street from his house, all that remains of what once was a "beautiful piece of woods." As a neighbor grooms his typically suburban property, cutting back the thickets and raking the leaves, Lieberman speculates that eventually all there will be left to paint will be "hundreds of big plastic bags" filled with leaves. Somewhat resigned, but with good humor, he admits, "I'll probably paint them too."[40] In an equally telling statement, Audrey Flack describes her pursuit of the sun in order to achieve the best vantage point for her sunset paintings. On at least one occasion, she took advantage of the fact that it was a chilly day and summer residents had cleared out of town. This allowed her to gain entry to several driveways that otherwise would have been inaccessible to her, and enabled her to capture the sunset from just the right location.

Of course farmland, though privately owned, is easily accessible subject matter on Long Island. Its broad, open vistas can be painted from roadsides bordering cabbage fields, potato fields, strawberry fields — from whatever vantage point catches the eye of a painter. In Casimir Rutkowski's landscape *Potato Blossoms — Hyland Terrace,* the artist has chosen a field owned by Cliff Foster and Henry Danowski in the Bridgehampton/Sagaponack area on the South Fork, not far from the artist's home in Water Mill. Joan Snyder, who lives in the small South Shore town of Eastport, did a series of paintings of beanfields simply because her house and studio were surrounded by them, and the setting inspired her. With a pragmatic spirit, Snyder says, "The farmer subsequently had a stroke and the fields turned to wildflowers and weeds — more paintings!"[41] Ty Stroudsberg focused on a cultivated field of flowers for her painting *Zinnia Field,* depicting a field farmed by the Cichanowicz family in Jamesport, on the North Fork. Stroudsberg began painting open fields and farmland in and around Southampton in 1980. However, disturbed by the rapid development of that area, she began traveling over to the North Fork, which retains more of its rural character. In 1985 she moved to Southold, making the local countryside the subject of her paintings.

The waterways of Long Island have provided inspiration for other artists, especially those interested in the effects of light — for example Pat Ralph, whose painting *Mill Pond, Autumn Afternoon* might be described as a study in reflected light. Those familiar with the area may recognize the subject as the Grist Mill Preservation Project Pond, located on Main Street, near Harbor Road, in the village of Stony Brook. West of Stony Brook on the North Shore, both Pauline Gore Emmert and Stan Brodsky have painted views of Cold Spring Harbor, the moods of their works varying with the season and the time of day. Although their initial inspirations were similar — stemming from their familiarity with the area, through which they pass routinely as well as on special visits — their approaches and their painting styles are quite different. Emmert's paintings are actual renderings of what she saw at specified times — in the case of *Cold Spring Harbor Winter II,* in February 1978. Brodsky's painting *Blue Harbor,* on the other hand, is less literal; it was developed entirely in his studio, but is based on his longtime observations of Cold Spring Harbor and, in this instance, on the brilliant light he witnessed on a particular afternoon. In Sands Point, even farther west along the North Shore, Jennifer Bartlett used Long Island's sandy shoreline as the setting for a series of views of the water's edge, in which houses, boats, water, and beach are placed in bold arrangements. At the opposite end of Long Island — actually, on Shelter Island, which is located between the South and North forks — Janet Culbertson paints in a very different manner. Intrigued by her natural environment as it appears at night, she has created eerie, evocative scenes of nocturnal life along the shoreline. Culbertson is perhaps the most outspoken and involved of the Long Island artists who are concerned about environmental issues, and she uses conservation as a major theme in her work. She explains, "I feel anxiety as we crowd out space, pollute the environment, pave the earth, and find there is no place to go."[42]

Others have been prompted to record what little "unspoiled nature" remains before it is destroyed. Mary Stubelek's *Storm over the North Fork* was inspired by her work on the Last Farm Project, an on-

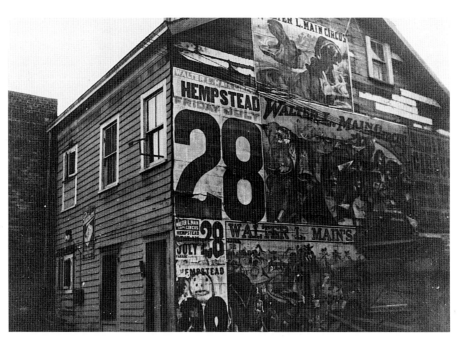

Remainder of Sammis' Hotel near the corner of Fulton and Main Streets, Hempstead, New York, 1922
Courtesy of the New York Public Library Special Collections.

going series that deals with the loss of farmland and a way of life on eastern Long Island. Her work is based on a specific location, a spot in Flanders where there is an open space between two houses and a long view to the North Fork. As Stubelek puts it, "As farms diminish in quantity on eastern Long Island, so goes the landscape." In preparing to capture this scene before it changed, she visited the location many times, making drawings and internalizing what she saw before painting her "expressive interpretation of the actual site."[43] Leo Revi was motivated to paint *Strawberry Stand* by similarly poignant concerns. More representational than Stubelek's work, Revi's canvas is an effort to document the strawberry fields of the South Fork before they give way to luxury hous-

ing developments or condominiums. As Revi says, the strawberries grow on prime real estate. In *Strawberry Stand* he is bent on recording a way of life, an actual activity that will one day disappear: "The colorful umbrellas, red and white, and big eye-catching signs, like a four-foot-high plywood cutout of a strawberry painted in red and green . . . big signs . . . that are to me real folk art."[44] Jane Freilicher realizes that her landscapes "may remain as documents of a vanished era" (even though this is not her intention), because of "the horrendous rate of real-estate development" on Long Island's East End.[45] Her concern is a valid one, as proved by Howard Kanovitz's *Hamptons Drive-In,* which memorializes an activity made obsolete by television and home video. Finally, some Long

Island landscape painters — Sheridan Lord, for one — have responded to the increasing development of the area by turning to other subjects, such as still life. And what about the imaginary paintings of Jane Wilson, which are based on the internalized experience of flat land, light, and other atmospheric effects of the South Fork, and the paintings of Berenice D'Vorzon, which are subjective rather than actual renditions of local landscapes? Will the inspiration for them remain once those conditions change? How many painters will even be able to afford to live on Long Island? Will landscape painters abandon it altogether? That is doubtful.

Over the past two centuries artists have found inspiration in Long Island's landscape, in the rolling hills

Doug Kuntz, *The End of an Era Comes to the Pleasure Palace — Bridgehampton, N.Y.,* 1989
Courtesy of the Photographer.

of its North Shore and the flat open fields of its eastern extremities. Its very proximity to New York City, where many of the artists are represented by galleries and where some maintain studios, assures the continuation of Long Island's artistic heritage as long as New York remains an art center. Also, Long Island's own art galleries and museums, including both those in Suffolk County, already mentioned, and those in Nassau County, Brooklyn, and Queens, continue to support local artists. Landscape painting has always been an important part of Long Island's history; for two hundred years many of our nation's greatest artists and writers, some native-born, others relocated or just passing through as visitors, have celebrated Long Island's natural beauty. Twentieth-century views of Long Island document how the region looks during this era, just as nineteenth-century paintings recorded for posterity the way Long Island's countryside appeared in the past. As time passes, the landscape will continue to change, as will the styles of art and the means of visual interpretation. Aside from their documentary, historical, and sociological significance as records of the changes in Long Island's landscape and in the activities of those who live in the region, these paintings are first and foremost works of art, and the best of them transcend time and place.

Undoubtedly Long Island landscape paintings done in the twenty-first century will be as different from those illustrated here as those of the twentieth century are from the paintings of the previous era.

Indeed, the style and focus of Long Island landscape paintings vary considerably even within each period. But in spite of these variations, there is a continuum, a thread in the fabric of Long Island's rich artistic heritage that links the future to the past.

It is not surprising that Arthur Dove's abstract renditions of nature, based on what he saw around him while living on Long Island's North Shore in the twentieth century, should be linked by art critics to the nature poetry of Walt Whitman, written in the nineteenth century, for they shared a common source of inspiration. The surface of the land had changed, and this is reflected in Dove's paintings, but the fundamental spirit remained the same. Gestural realist painters such as Fairfield Porter, who traveled to Centerport to visit Dove and who admired John Marin, were drawn together by this spirit as well. Porter first met Dove and Marin, as well as Alfred Stieglitz and other members of the Stieglitz circle, in 1928, while he was in New York studying at the Art Students League. Much later in life, when Porter was asked which artists he thought had been in the mainstream of American art in the 1920s, he singled out Marin as the first to come to mind, and then, "the people Stieglitz showed." He also credited Dove with having had "original ideas, as original as any ideas in France." And Porter claimed that he had a "kind of filial feeling toward" Marin, noting, "I don't know how much I like his pictures, but I can't ever get over the memory of

how much he meant to me at one time."[46] As Porter's case demonstrates, the bonds between one generation of Long Island landscape painters and its predecessors are not always direct stylistic influences; they are more complex. However, it is not surprising that Porter should have praised artists of the Stieglitz group and perhaps on some level identified with them. Both the Stieglitz group and the gestural painters and poets were repelled by a cliché-ridden culture and united in their own small subculture, based primarily on the premise of art-for-art's-sake and concerned with creating an impression that was direct and honest.[47] Interestingly enough, it is just this quality — "a fine assertion and credo of honest living and honest painting" — that, in the mind of one art critic, linked Dove to Whitman.[48] It is doubtful that anyone can identify a homogeneous "Long Island school" of painting and poetry in the nineteenth and twentieth centuries. Yet one senses a unity, a common bond based on the spirit of the landscape itself. With each new generation of artists and writers working on Long Island and responding to its geographical surroundings and the region's artistic heritage, there will be an innovative outlook and a new vocabulary of form arising in some way from its time there. Each member will have a personal reaction and an individual viewpoint, but those who will make history will have had an eye to the past as well. An extract from a Frank O'Hara poem written after a social visit to the East End demonstrates this point:

I feel just like Whitman said you should
 and the train burrs and treadles on
 diddleydiddleyGREENHORNETdiddleydiddley

I wish we weren't sitting on these Long Island asterisks, though

 did you have a clam?
 I had a cob of corn[49]

NOTES

1. Bernie Bookbinder, *Long Island: People and Places, Past and Present* (New York: Harry N. Abrams, 1983), 178.
2. Ibid., 179–188.
3. In 1925, however, it was announced that only 40 percent of their productions would be filmed in Queens, with 60 percent to be made in California. Henry Isham Hazelton, *The Boroughs of Brooklyn and Queens, Counties of Nassau and Suffolk*, V. 2 (New York: Lewis Historical Publishing Co., 1925), 1030.
4. F. Scott Fitzgerald, *The Great Gatsby* (1925; reprint, New York: Bantam, 1951), 31.
5. See Lewis Radcliffe, "Long Island's Shellfisheries," 1–16; Halsey B. Knapp, "Long Island's Agriculture," 18–34; LeRoy Wilcox, "Duck Industry," 440–458; all in Paul Bailey, ed., *Long Island: A History of Two Great Counties, Nassau and Suffolk*, V. 2 (New York: Lewis Historical Publishing Company, 1949).
6. Bookbinder, *Long Island*, 172–175.
7. Preston R. Basset, "Aviation on Long Island," in Bailey, *Long Island*, 419, 423, 425.
8. Based on *American Art Annual* 16 (1919), 204; 17 (1920), 251; 18 (1921), 212; see also Holly Pinto Savinetti, *Louis Comfort Tiffany: The Laurelton Hall Years* (Exh. cat.; Roslyn, New York: Nassau County Museum of Fine Art, 1986).
9. Information on Idlehour was provided in a letter from Deborah Johnson, Curator, Art Collection & Archives, The Museums at Stony Brook, January 23, 1989. Information on the house can be found in Richard Guy Wilson and Steven Bedford, *The Long Island Country House, 1870–1930* (Exh. cat.; Southampton, N.Y.: The Parrish Art Museum, 1988).
10. Ronald G. Pisano, *The Students of William Merritt Chase* (Exh. cat.; Huntington, N.Y.: Heckscher Museum, 1973), 7. Oddly enough, the last two summer sessions mentioned went under the names of the Shinnecock School of Drawing and Painting and the Shinnecock Summer School of Art, even though they were not held at Shinnecock.
11. See *American Art Annual* 11 (1914), 367; 12 (1915), 241; 13 (1916), 297.

12. See *American Art Annual* 31 (1934), 411; 32 (1935), 440; 33 (1936), 459; 34 (1937–1938), 538; 35 (1938–1941), 529.
13. *American Art Annual* 13 (1916), 302.
14. *American Art Annual* 19 (1922), 253; 20 (1923–1924), 242.
15. *American Art Annual* 33 (1936), 460; 34 (1937–1938), 539–540.
16. *American Art Annual* 37 (1948).
17. See Mona Hadler and Jerome Viola, *Brooklyn College Art Department: Past and Present, 1942–1977* (Exh. cat.; Brooklyn, N.Y.: Brooklyn College Art Department, 1977).
18. *New York: A Guide to the Empire State*, compiled by Workers of the Writer's Program of the Works Project Administration in the State of New York, American Guide Series (New York: Oxford University Press, 1940), 265.
19. See David Shapiro, *Art for the People — New Deal Murals on Long Island* (Exh. cat.; Hempstead, N.Y.: The Emily Lowe Gallery, Hofstra University, 1978); Francis V. O'Connor, ed., *Art for the Millions: Essays from the 1930s by Artists and Administrators of the WPA Federal Art Project* (Boston: New York Graphic Society, 1975); Marlene Park and Gerald E. Markowitz, *New Deal for Art: The Government Art Projects of the 1930s with Examples from New York City and State* (Exh. cat.; Hamilton, N.Y.: The Gallery Association of New York State, 1977).
20. Reginald Marsh, *Art Students League News* 2, no. 1 (January 1, 1949).
21. Helen A. Harrison et al., *Dawn of a New Day: The New York World's Fair, 1939/40* (Exh. cat.; Queens, N.Y.: The Queens Museum, 1980).
22. Bookbinder, *Long Island*, 218.
23. Ibid., 223–225.
24. Irving Sandler, *The New York School: The Painters and Sculptors of the Fifties* (New York: Harper & Row, 1978), 18.
25. Ibid., 19.
26. Ibid., 22.
27. Francis V. O'Connor, letter to Ronald G. Pisano, December 23, 1988.

28. Quoted in Sandler, *The New York School*, 98.
29. Ibid., 100, n. 22.
30. Mario Amaya, *John Koch* (Exh. cat.; New York: The New York Cultural Center, 1973).
31. Marjorie Perloff, *Frank O'Hara: Poet Among Painters* (New York: George Braziller, 1977), 93.
32. See John Ashbery and Kenworth Moffett, *Fairfield Porter: Realist in an Age of Abstraction* (Exh. cat.; Boston: Museum of Fine Arts, 1982).
33. Quoted in Sandler, *The New York School*, 93. See also ibid., n. 1.
34. Ibid., 23.
35. Fairfield Porter, "Eighteen Painters Invitational Exhibition" (Exh. checklist; Southampton, N.Y.: The Parrish Art Museum, 1965).
36. Quoted in Peter Bergh, *The Art of Ogden M. Pleissner* (Boston: David R. Godine, 1984), xi.
37. Letter from Herman Rose, March 16, 1989.
38. Letter from Harvey Dinnerstein, January 29, 1989.
39. Letter from David Levine, February 10, 1989.
40. Letter from Bruce Lieberman, undated.
41. Letter from Joan Snyder, undated.
42. Letter from Janet Culbertson, February 3, 1989.
43. Letter from Mary Stubelek, March 2, 1989.
44. Letter from Leo Revi, January 30, 1989.
45. Robert Doty, John Ashbery, Linda L. Cathcart, and John Yau, *Jane Freilicher: Paintings* (Exh. cat.; Manchester, N.H.: The Currier Gallery of Art, 1986), 53.
46. Quoted in Ashbery and Moffett, *Fairfield Porter*, "Interview with Paul Cummings," 52–53.
47. See Sasha M. Newman, *Arthur Dove and Duncan Phillips: Artist and Patron* (Exh. cat.; Washington, D.C.: The Phillips Collection, 1981), 32.
48. *Art News*, March 25, 1933, 5.
49. Frank O'Hara, "Bill's Burnoose," *The Collected Poems of Frank O'Hara*, ed. Donald Allen (New York: Alfred A. Knopf, 1971), 415–416.

GEORGIA O'KEEFFE
Sun Prairie, Wisconsin 1887–1986 Santa Fe, New Mexico

Georgia O'Keeffe's high school teacher persuaded her parents to allow her to study at the Art Institute of Chicago in 1905–1906. In 1907 O'Keeffe went to New York to study at the Art Students League, but after a year her family could not afford to pay for her classes any longer, so she began to teach, in Texas, Virginia, and, later, South Carolina. She returned to New York in 1914 to take courses at Columbia University Teachers College with Arthur Dow. At this time O'Keeffe became friends with Anita Pollitzer, who showed some of her drawings to Alfred Stieglitz, the beginning of their professional, and later personal, relationship. For a few years O'Keeffe stayed in the Fifty-ninth Street studio of Stieglitz's niece, and began to paint views of New York. In 1924 O'Keeffe and Stieglitz were married.

In 1925 the couple took two rooms on the thirtieth floor of the Shelton, a residential hotel at Lexington Avenue and Forty-ninth Street, the first skyscraper in the neighborhood. They moved into suite 3003, on the northeast corner, and she painted many views of the building as well as views from it, such as *East River from the Shelton*, showing industry along the East River with the smokestacks of Queens on the far side.[1]

While she was living in New York, O'Keeffe occasionally went to Coney Island with Alfred Stieglitz, and in 1928 she traveled to Long Island to visit her friend Mrs. Sybil Walker, who lived on the South Shore. This visit inspired *Sunset, Long Island,* in which the artist used a limited palette and simple contours to produce a bold statement.[2] O'Keeffe explained how she saw natural forms abstractly: "It is surprising to me to see how many people separate the objective from the abstract. Objective painting is not good painting unless it is good in the abstract sense. A hill or tree cannot make a good painting just because it is a hill or a tree. It is lines and colors put together so that they say something. For me that is the very basis of painting."[3]

In 1929 O'Keeffe went to see Mabel Dodge in New Mexico and, greatly affected by the landscape, returned as often as she could until she moved there permanently in 1949.

1. Laurie Lisle, *Portrait of an Artist: A Biography of Georgia O'Keeffe* (Albuquerque: University of New Mexico, 1986), 144–145.
2. Ronald G. Pisano, *Long Island Landscape Painting, 1914–1946: The Transitional Years* (Exh. cat.; Southampton, N.Y.: The Parrish Art Museum, 1982). At some point O'Keeffe also visited Arthur Dove and his wife, Helen Torr, on their boat the *Mona*, which they bought in 1923 and used to sail around the North Shore of Long Island, mostly anchoring in the Huntington area. *Sunset, Long Island* was included in the exhibition "American Art Today" at the 1939 World's Fair, held in Flushing Meadow.
3. Georgia O'Keeffe, *Georgia O'Keeffe* (New York: Viking, 1976).

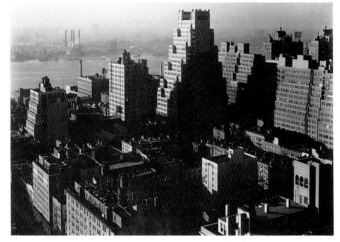

Alfred Stieglitz, *From My Window at the Shelton Looking Southeast,* 1931
Gelatin silver photograph, 7⅜ × 9⅜
National Gallery of Art, Washington, Alfred Stieglitz Collection.

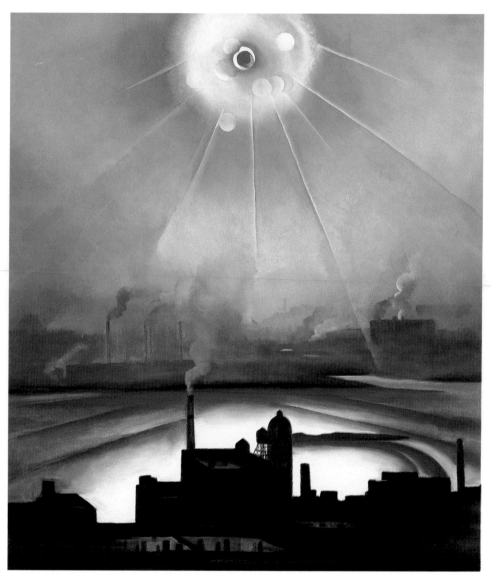

Georgia O'Keeffe, EAST RIVER FROM THE SHELTON, 1927–1928
oil on canvas, 25 × 22, New Jersey State Museum, Trenton,
purchased by the Association for the Arts of the New Jersey State Museum
with a gift from Mary Lea Johnson (FA1972.229).

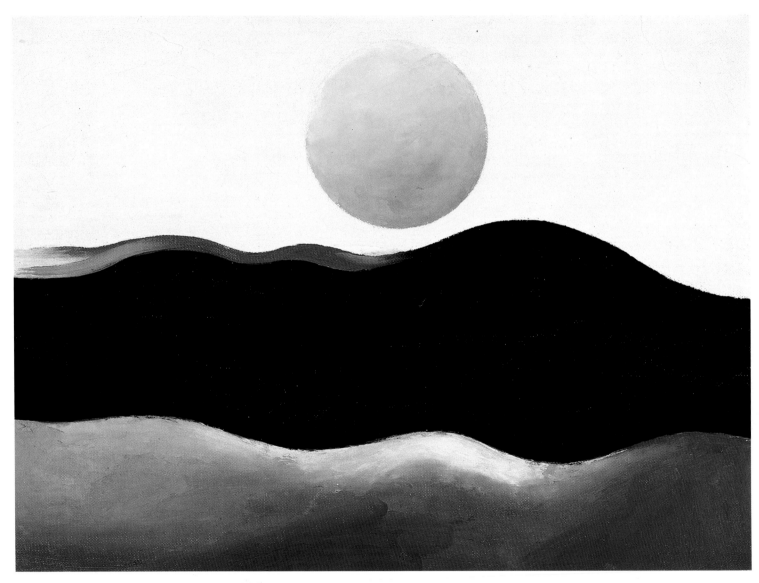

Georgia O'Keeffe, SUNSET, LONG ISLAND, 1928
oil on canvas, 6 × 8, Collection of Lynne G. Rosenthal.

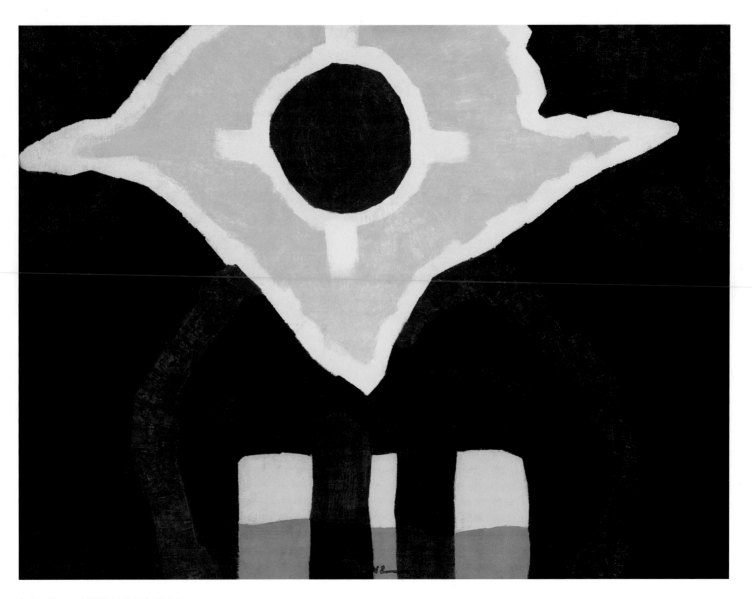

Arthur Dove, HIGH NOON, 1944
oil on composition board, 27 × 36, Wichita Art Museum, Wichita, Roland P. Murdock Collection.

ARTHUR DOVE
Canandaigua, New York 1880–1946
Huntington, New York

Arthur Dove's feeling for nature was shaped at an early age by a neighbor, Newton Weatherly, who was a farmer, naturalist, and amateur musician and painter. Dove attended Hobart College in Geneva, New York, for two years before transferring to nearby Cornell, where he studied art with an illustrator, Charles Wellington Furlong. After his graduation in 1903, he moved to New York City and began work as an illustrator. He married Florence Dorsey of Geneva, and in 1907 they left for a year and a half in Europe. Some of this time they spent in Paris, where Dove met a number of painters, including Alfred Maurer, who became a lifelong friend. They spent considerable time in southern France and visited Italy. Dove resumed work as an illustrator when he came

back to New York in 1909, but was determined to pursue fine art. He took his paintings to Alfred Stieglitz, who exhibited some of his work the following year at his 291 Gallery and gave him a one-man show in 1912. In 1913, after the birth of a son, the Doves moved to a farm in the artists' colony of Westport, Connecticut. There Dove developed his first abstract paintings and began working in pastel.

Dove separated from his wife in 1920 and soon after that he and Helen Torr, whom he had met in 1919, began living together on a houseboat in the Harlem River. They purchased a forty-two-foot yawl, the *Mona,* and spent the next seven years sailing Long Island Sound, visiting Port Washington and Lloyd Harbor and, after 1924, wintering in Halesite, part of Huntington. Life on the boat was physically difficult, and they had very little money. Dove's father refused to assist them, and if it had not been for the support

of Alfred Stieglitz and later the patronage of Duncan Phillips, their lives would have been very bleak indeed. During the period from 1924 to 1930, Dove made about twenty-five assemblages, including *Huntington Harbor,* which incorporates shells, corduroy fabric, and a bit of the Long Island Railroad schedule. For Dove these works were amusing and interesting texturally, probably easier to make on the boat than oil paintings, and certainly cheaper, owing to the use of found materials.

In 1929 Dove and Torr became caretakers at the Ketewomoke Yacht Club in Halesite, luxurious quarters compared to the cramped conditions aboard the *Mona.* That year Dove painted *Sunrise in Northport Harbor.* An early riser, Dove made several studies of this subject while he and Helen Torr were out on their boat that summer. His sister-in-law, Mary Ream, later wrote, "Reds always said he was a morning person,

C. Van Pelt, *View toward Centerport from Soper's Dock, Northport,* 1912
Northport Historical Society.

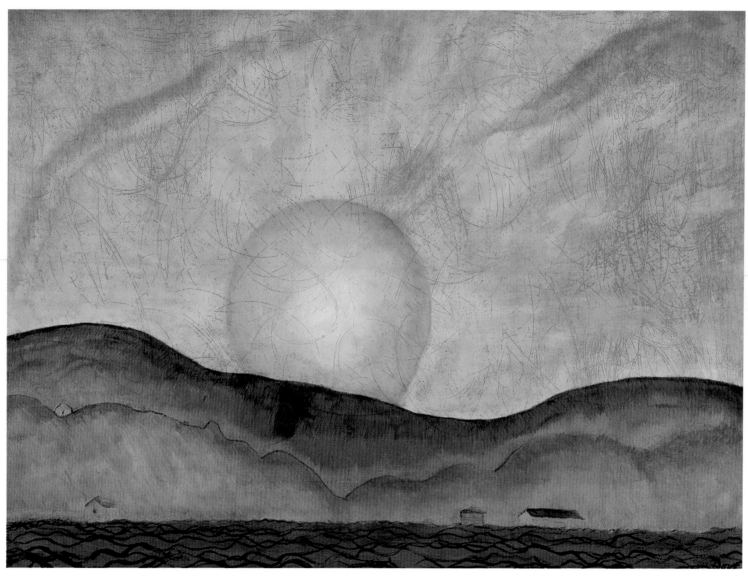

Arthur Dove, SUNRISE IN NORTHPORT HARBOR, 1929
oil on metal, 20 × 28, Wichita Art Museum, Wichita, Roland P. Murdock Collection.

he was most alive in the rising sun, the early morning light."[1]

During the summer of 1932, the year they were married, Dove and Torr each made studies of the two lighthouses at Lloyd Harbor. Dove chose to paint the older structure, which was built in 1857 and no longer in use, and Torr chose to depict the new building.[2] With its pale palette and bits of green, Dove's watercolor expresses a gentler mood than Torr's imposing view of the newer lighthouse. Dove used some of the watercolor sketches that he made directly out of doors to create finished paintings, which he would work on in his studio, sometimes using a pantograph or magic lantern to enlarge the sketch.[3]

The need to settle his parents' estate, a difficult task for Dove, made it necessary for the Doves to move to Geneva in 1933. When they returned to Long Island in 1938, they moved to an abandoned one-room post office on the mill pond in Centerport, which they purchased for $980. Almost immediately Dove became ill, and he was in poor health for the rest of his life, though he was able to paint sporadically until his death in 1946. *High Noon* is a late work, one of the many paintings having to do with the sun or moon that he began around 1935.[4]

Greetings from Huntington, L.I., ca. 1915
The Huntington Historical Society.

In the mid-1920s Dove wrote a poem, part of which follows, that sums up his feelings about nature and abstraction:

A Way to Look at Things

We have not yet made shoes that fit like sand
Nor clothes that fit like water
Nor thoughts that fit like air
There is much to be done —
Works of nature are abstract. . . .[5]

1. Mary Ream, "It's All Too Late, Too Late," in Ann Cohen DePietro, et al., *Arthur Dove and Helen Torr: The Huntington Years* (Exh. cat.; Huntington, New York: The Heckscher Museum, 1989), 85.
2. Helen Torr Dove papers, Diaries, 1930–1939 (July 1932), Archives of American Art, Smithsonian Institution.
3. Sasha M. Newman, *Arthur Dove and Duncan Phillips: Artist and Patron* (Exh. cat.; Washington, D.C.: The Phillips Collection, 1981), 27.
4. See Frederick S. Wight, *Arthur G. Dove* (Berkeley and Los Angeles: University of California Press, 1958), and Barbara Haskell, *Arthur Dove* (San Francisco: San Francisco Museum of Art, 1974).
5. Quoted in Newman, *Arthur Dove and Duncan Phillips*, 28.

Arthur Dove, HUNTINGTON HARBOR, 1924
oil, oil on paper, photomechanical reproductions, fabric, metal screening, seashell, 13⅛ × 19¼, Hirshhorn Museum
and Sculpture Garden, Smithsonian Institution, Washington, D.C., Museum purchase, 1979.

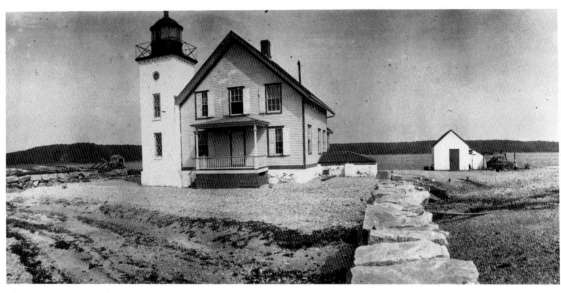

The "Old" Lloyd Neck Lighthouse, ca. 1906
The Huntington Historical Society.

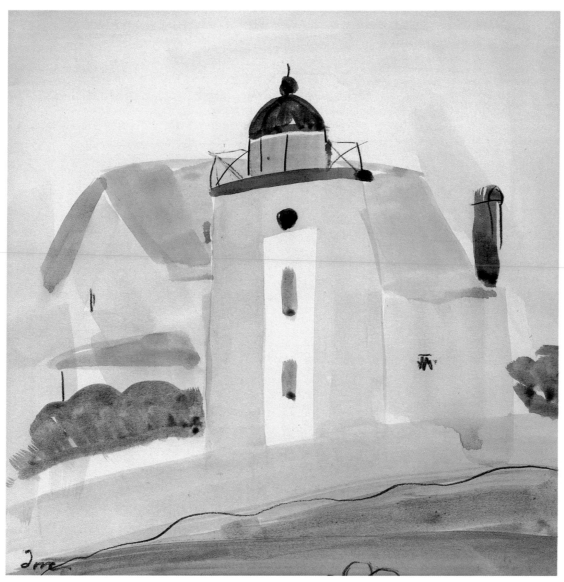

Arthur Dove, LIGHTHOUSE, LLOYD'S HARBOR, 1932
watercolor on paper, 5 × 7, Courtesy of Terry Dintenfass, Incorporated, New York City.

HELEN TORR
Roxbury, Pennsylvania 1886–1967 Bayshore,
New York

Helen Torr was known as Reds to her friends and her husband, the better-known painter Arthur Dove. She began studying art in about 1904 at the Drexel Institute in Philadelphia, and attended the Pennsylvania Academy of the Fine Arts on scholarship about two years later. Around 1913 she married the cartoonist Clive Weed, but their marriage was not a happy one. When in 1919 she met Arthur Dove, whose marriage was also unhappy, they fell in love, and by 1920 they were living together on a houseboat on the Harlem River. From 1923 to 1929 their home was the *Mona*, a yawl that was prone to breakdowns but in which they happily sailed around Long Island Sound, visiting towns along the North Shore of Long Island and, from 1924, anchoring during the winter in Halesite, part of the town of Huntington.

In 1929 Dove and Torr became caretakers of the Ketewomoke yacht club in Halesite. Many of Torr's paintings and charcoal drawings were based on things she gathered along the beach there, such as shells and rocks. She also used other natural objects, including leaves and feathers. The two artists were married in 1932, the same year that Torr painted her rather formidable view of the "new" lighthouse at Lloyd Neck, which she worked on in July. from sketches she made while out on the boat. This lighthouse was built on lower ground in 1912 to replace the original lighthouse, which had been put up in 1857.[1] She also painted a view of a typical fishing shack from a vantage point in the water, called *Along the Shore*, in which she took the simple form of the building and reduced it even further.[2]

In 1933 Dove and Torr moved to Geneva and spent five unhappy years taking care of Dove's family matters. Soon after they returned to Centerport in 1938, Dove suffered a heart attack, and Torr spent the years until his death in 1946 caring for him. After his death she never painted again, and her early output would have been lost if not for the efforts of Eva Gatling of the Heckscher Museum to exhibit and promote her work in the early 1970s. During Torr's lifetime her paintings were exhibited only twice, once in a 1927 group show chosen by Georgia O'Keeffe and then in 1933, together with Dove's work, at Alfred Stieglitz's gallery An American Place. Fortunately Torr's work has now received the attention it deserves.[3]

1. Information from Mitzi Caputo, Huntington Historical Society. Helen Torr Dove Papers, Diaries 1930–39, Roll 39, Archives of American Art, Smithsonian Institution, discusses this painting in entries for July 13–27, 1932.
2. Torr made no mention of *Along the Shore* in her diary entries for 1932 (Helen Torr Dove Papers, Diaries 1930–39, Roll 39, Archives of American Art).
3. Sandra Leff, *Helen Torr, 1886–1967: In Private Life, Mrs. Arthur Dove* (New York: Graham Gallery, 1980); see also Ann Cohen DePietro, et al., *Arthur Dove and Helen Torr: The Huntington Years* (Exh. cat.; Huntington, N.Y.: The Heckscher Museum, 1989).

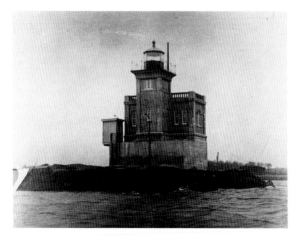

The "New" Lloyd Neck Lighthouse
The Huntington Historical Society.

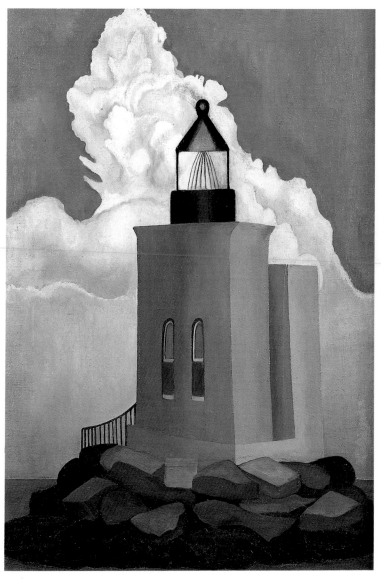

Helen Torr, LIGHT HOUSE, 1932
oil on canvas, 25¾ × 18, Collection of Anne and Vincent A. Carrozza.

Roselle's Dock and Stores, Huntington, L.I.
The Huntington Historical Society.

Helen Torr, ALONG THE SHORE, 1932
oil on canvas, 24 × 18, Graham Gallery, New York City.

RALSTON CRAWFORD
St. Catherines, Ontario 1906–1975 Houston,
Texas

In 1927 Ralston Crawford spent two terms at the Otis Art Institute in Los Angeles and then came east to the Pennsylvania Academy of the Fine Arts, where he studied for three and a half years. While in Philadelphia, Crawford was especially influenced by his teacher Hugh Breckenridge, whose summer class in East Gloucester, Massachusetts, he also took, and by lectures given by Dr. Albert Barnes, the well-known Philadelphia collector of European and American Impressionist and modernist painting.

In January 1931 Crawford was awarded a Louis Comfort Tiffany Fellowship and spent one month at Oyster Bay, Long Island. There he painted this early view of Cold Spring Harbor, showing what is likely the smokestack at the water's edge, which Tiffany, in his quest to make even the most utilitarian object decorative, had built to look like a minaret.[1] Tiffany began operating his foundation in 1919 at his palatial estate, Laurelton Hall, on the east side of Laurelton Beach Road overlooking Cold Spring Harbor. The artists and craftsmen who received fellowships were provided with their own bedrooms, created out of former stables; studio space and special workshops were also available.[2]

In 1935 Crawford moved to Pennsylvania, where he developed his mature style, which is characterized by industrial subject matter painted in flat, simplified shapes using smoothly painted areas of subdued color. In the 1940s Crawford's work became completely abstract, and he later developed an interest in photography.[3]

1. John B. Shiel, "Louis Comfort Tiffany," *Long Island Forum*, February 1983, 29, kindly provided by Carol Traynor, Society for the Preservation of Long Island Antiquities.
2. See Holly Pinto Savinetti, *Louis Comfort Tiffany: The Lau-*

relton Hall Years (Exh. cat.; Roslyn, N.Y.: Nassau County Museum of Fine Art, 1986), 13.
3. See Barbara Haskell, *Ralston Crawford* (New York: Whitney Museum of American Art, 1985).

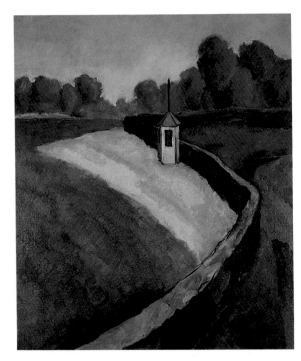

Ralston Crawford, COLD SPRING HARBOR, 1931 oil on canvas, 26 × 22, Robert Miller Gallery, New York City.

MAX WEBER
Bialystok, Russia 1881–1961 Great Neck,
New York

Max Weber came to the United States in 1891 and attended schools in Brooklyn until 1897. From 1898 to 1900 he studied at Pratt Institute, where he greatly admired his teacher Arthur Wesley Dow and studied the writings of Dow's mentor, Ernest F. Fenollosa. Weber taught from 1901 to 1905 and then, with the money he had saved, left for Europe. Over the next three years he lived in Paris, studying briefly at the Académie Julian, the Académie Colarossi, and the Académie de la Grande Chaumière. Weber made many important friendships and contacts in Paris, among them Henri Rousseau and Edward Steichen, and helped the latter to form the progressive New Society of American Artists. When Weber returned to New York in early 1909, he had seen the most avantgarde work being shown in Paris. At first his paintings reflected the influence of Matisse and Cézanne; then, over the next few years, he developed an abstract style with Cubist and Futurist elements. By 1919 he returned to painting figures, nudes, landscapes, and still lifes. He later painted a number of works with Jewish themes. He made prints and sculpture as well, and published two books: *Essays on Art* (1916) and a group of poems, *Primitives* (1926). He taught throughout his career.[1]

In 1921 Weber moved to Garden City, and in 1929 he purchased a home in Great Neck, where he lived for the rest of his life. *Straggly Pines* is a view from his studio on Hartley Road at the top of Baker Hill.[2]

1. Alfred Werner, *Max Weber* (New York: Harry N. Abrams, 1975); Lloyd Goodrich, *Max Weber Retrospective Exhibition* (Exh. cat.; New York: Whitney Museum of American Art, 1949).
2. Information supplied by Joy Weber, courtesy of Forum Gallery.

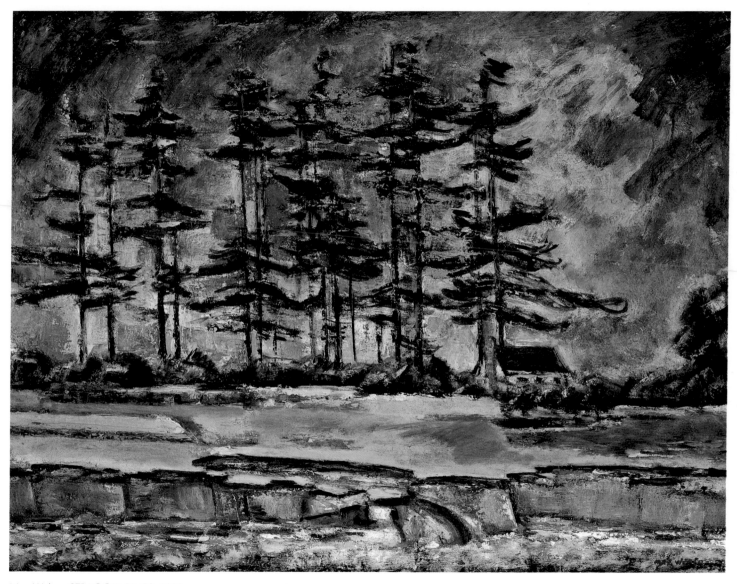

Max Weber, STRAGGLY PINES, 1933
oil on canvas, 24 × 32, The Metropolitan Museum of Art, New York City, George A. Hearn Fund, 1937 (37.45).

ARNOLD FRIEDMAN
New York City 1874–1946 Queens, New York

Arnold Friedman attended New York public schools and City College for two years and then embarked on a lifelong career as a postal clerk. In 1908 he took time off to visit Paris, where he met his wife, Renée Keller. After their return to New York he attended evening classes at the Art Students League with Robert Henri. At the age of thirty-two, Friedman was much older than most of his classmates, who included George Bellows and Edward Hopper. During the 1920s and 1930s Friedman painted mostly portraits, nudes, still lifes, and interiors in the evenings and on weekends. His works from this period are flat and tightly drawn and have a naïve charm. After his retirement from the post office, Friedman was able to devote himself full-time to painting. By then in his sixties, he painted many landscapes, such as *Flushing River,* around his home in Queens, as well as in upstate New York and New England. These landscapes have a grainy texture and use rich color with simplified composition.[1] A year after Friedman's death, Clement Greenburg said of these paintings, "It is his latest work that remains the high point of Friedman's art: pictures that came when he abandoned the brush and worked exclusively with the palette knife, aiming at broad effects of texture, flat color areas, abbreviated forms."[2]

1. Hilton Kramer, *Arnold Friedman* (Exh. cat.; New York: Salander O'Reilly Galleries, 1986).
2. *Arnold Friedman* (Exh. checklist with reprint of Clement Greenburg's 1947 essay; New York: Zabriskie Gallery, 1980).

Flushing River (Queens) near Willet's Point Boulevard
Courtesy of the New York Public Library Special Collections.

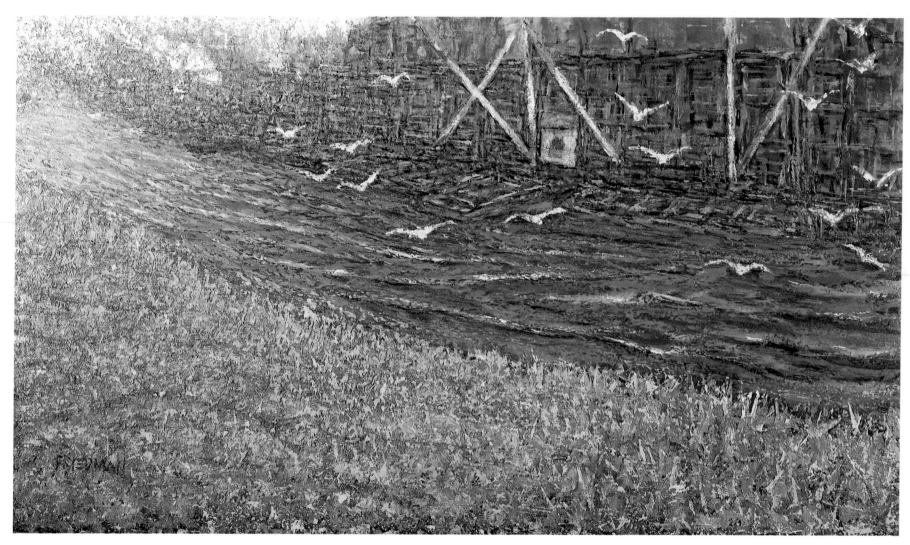

Arnold Friedman, FLUSHING RIVER, ca. 1944–1946
oil on canvas, 26 × 46, The Regis Collection, Minneapolis.

RALPH MAYER
New York City 1898–1979 New York City

Ralph Mayer graduated from Rensselaer Polytechnic Institute in 1917 with a degree in chemical engineering and went to work at Toch Brothers, Incorporated, in Long Island City, owned by his mother's brothers. Under the guidance of Dr. Maximilian Toch, an expert paint technologist, he began to accumulate knowledge about artists' materials and painting conservation and, on his own, to associate with artists. In 1926, at the age of thirty-one, he took his first painting lessons from the artist Bena Frank, who became his wife. He also studied for a short time at the Art Students League in that year and with the portrait artist George Lawrence Nelson. In 1929 the Mayers lived briefly in Brooklyn before moving back to Manhattan permanently. Although Mayer was now firmly committed to painting, he worked as a painting conservator to make a living. In 1940 he published his well-used book *The Artist's Handbook of Materials and Techniques*. He continued to do extensive research, publish, lecture, and act as a technical consultant to his many artist friends and on many different projects.

Mayer painted meticulously and slowly, completing less than forty works in all. Many of them serve as a log of his travels in the Northeast, California, the Caribbean, and Europe, sometimes supported through the various fellowships he was awarded from the late 1950s on. Mayer's paintings relate to precisionism in his thinly applied, smooth paint surface and in the urban and industrial subject matter he occasionally favored, as in *The Timber Basin*, painted near the Toch Brothers factory and showing Newtown Creek, a four-mile stretch of which separates Brooklyn and Queens. Newtown Creek at one time was said "to be the busiest avenue of water traffic of its length in the world," and millions of dollars' worth of materials were floated down its waters, including the lumber seen in Mayer's painting.[1] Of his attraction to industrial subjects, Mayer wrote, "The structures are silhouetted against the skies with a peculiar boldness and intensity, the forms sometimes exhibit a dramatic rhythm, or a flowing smoothness or an impression of terrific strength. . . . At the height of the working hours, these scenes are sometimes most sparsely populated, but an air of hidden animation somehow enlivens them and the few external signs of activity dispel all elements of loneliness."[2]

1. *Queens Borough: Being a Descriptive and Illustrated Book of the Borough of Queens* (Queens, N.Y.: Chamber of Commerce of the Borough of Queens, 1913).
2. Quoted in Hilton Brown, *On the Material Side: The Art and Archives of Ralph Mayer* (Exh. cat.; Wilmington, Del.: University of Delaware, 1984), 27.

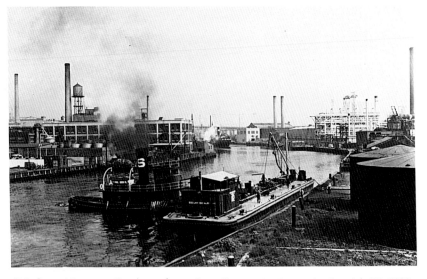

P. L. Sperr, Newtown Creek, northwest from Greenpoint Avenue bridge, July 25, 1939
Courtesy of the New York Public Library Special Collections.

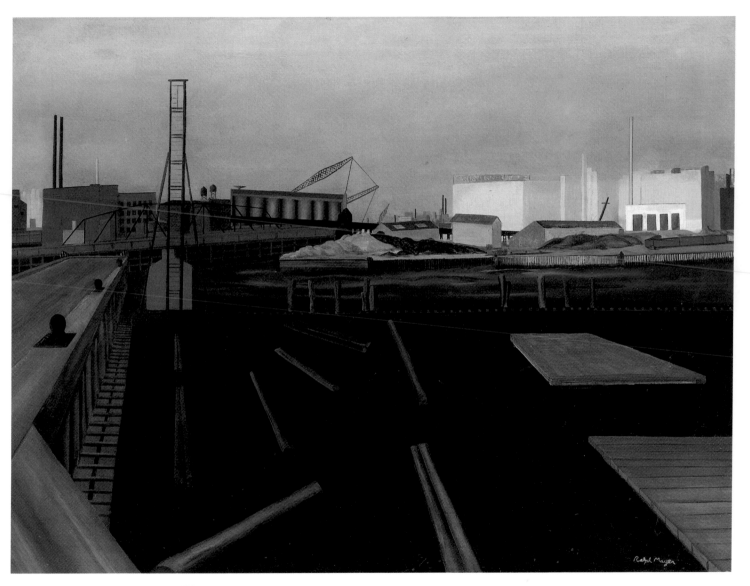

Ralph Mayer, THE TIMBER BASIN, 1938
oil on board, 26 × 34¾, Collection of Bena Frank Mayer.

PRESTON DICKINSON
New York City 1889–1930 Spain

Preston Dickinson was working as an office boy for a New York firm of architects when one of the partners, Henry Barbey, noticed his sketches and offered to sponsor his studies at the Art Students League. Dickinson worked at the League from 1906 to 1910, winning awards in William Merritt Chase's portrait classes and in Edward Dufner's class. Barbey continued to support the young artist by financing a trip to Europe; Dickinson studied at the École des Beaux Arts and the Académie Julian in Paris and traveled in Belgium, England, and Germany before returning home in 1914. He began showing his work at the Charles Daniel Gallery, attracting some attention for his cubist-influenced landscapes, many of them views of the steep terrain along the Harlem River in upper Manhattan.

Dickinson had very little money throughout his life, and in the late teens found it necessary to live with his sister Enid in Valley Stream on Long Island. She built him a studio, but he disliked living in the suburbs and found the flat South Shore uninteresting.[1] The steep hills around the North Shore harbor town of Port Jefferson did appeal to Dickinson, however, and there he executed this pastel, which shows what is now the First United Methodist Church on the corner of Main Street (Route 112) and Spring Street, built in 1893. The building on the hill above the church is Saint Charles Hospital, which was built in 1910 and operated by the sisters of the Order of Wisdom for the benefit of "blind, mentally and emotionally handicapped children."[2]

In 1924 Dickinson spent the summer in Omaha, and in 1925, after his sister moved to the West Coast, he went to Quebec and produced a number of paintings and pastels, once again inspired by a hilly landscape. In 1926 he made his way back to New York, eventually moving in with an aunt in Jamaica, Queens, where he lived until 1928. He visited Quebec once more and then, in June 1930, sailed to Europe with a painter friend. They settled in Spain, but by October they had run short of money, and soon afterward Dickinson died of pneumonia.

1. In 1924 Charles Daniels wrote in a letter of Dickinson's trip to Omaha: "He really needed this fresh inspiration away from the flat uninspiring Long Island where he has his home." Ruth Cloudman, *Preston Dickinson, 1889–1930* (Exh. cat.; Lincoln, Neb.: Sheldon Memorial Art Gallery, 1979), 31.
2. Deborah Johnson of the Museums at Stony Brook kindly gathered the information about the site shown. The church was originally built for the Methodist Society, then became the Methodist/Episcopal Church in 1835. In 1968 it became the First United Methodist Church.

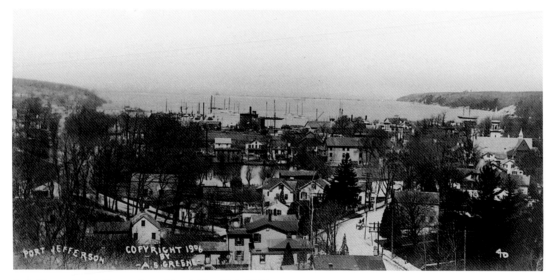

A. S. Green, *Port Jefferson, Long Island, New York,* 1906
Collection of The Museums at Stony Brook, New York.

Preston Dickinson, PORT JEFFERSON, LONG ISLAND, ca. 1920
pastel on paper, 22¾ × 17¼, Museum of Fine Arts, Boston,
bequest of John T. Spaulding.

GEORGE AULT
Cleveland, Ohio 1891–1948 Woodstock, New York

George Ault's father was an amateur painter who encouraged his son in his own artistic development. The family moved to London when Ault was eight, and there he studied at the Slade School of Fine Art and the St. John's Wood School of Art. He first exhibited his work in England, while his first American showing was with the Society of Independent Artists in 1920. After moving to New York, Ault lived in Greenwich Village and enjoyed some success with his work, exhibiting at the Whitney Studio Club and the Bourgeois Gallery. He had one-man shows between 1926 and 1928 at the Downtown Gallery and at Neumann's New Art Circle Gallery.

Ault admired Albert Pinkham Ryder and Giorgio de Chirico, and he chose as his own subject matter industrial buildings around New York, painted in a precisionist manner, sometimes as nocturnes. He painted several works in Brooklyn, among them *Brooklyn Ice House*, and also worked in Provincetown. The icehouse Ault depicted would soon become a thing of the past. The domestic refrigerator, which everyone called a Frigidaire no matter what the brand, was introduced in the early 1930s, for those who could afford one. Those who could not still made do with deliveries from the iceman every few days and more often in hot weather, and in the winter stored perishables in a "cold chest" outside.[1]

During the period from 1915 to 1929, three of Ault's brothers committed suicide, his mother died in a mental hospital, and his father died of cancer. Ault himself became an alcoholic, and his frequent depressions and ambivalence about city life led him to seek a new life in Woodstock, New York, where he painted moody landscapes and later, in the 1940s, dream-inspired works. A year after his death by drowning in 1948, possibly a suicide, the first major showing of his work since 1928 was held in Woodstock.[2]

1. Elliot Willensky, *When Brooklyn Was the World, 1920–1957* (New York: Harmony Books, 1986), 122–123.
2. Susan Lubowsky, *George Ault* (Exh. cat.; New York: Whitney Museum of American Art at Equitable Center, 1988).

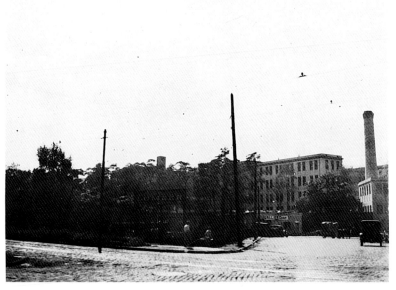

The Grill Ice Company, southwest corner of Hewes and Wallabout Place, Brooklyn, September 1928
Courtesy of the New York Public Library Special Collections.

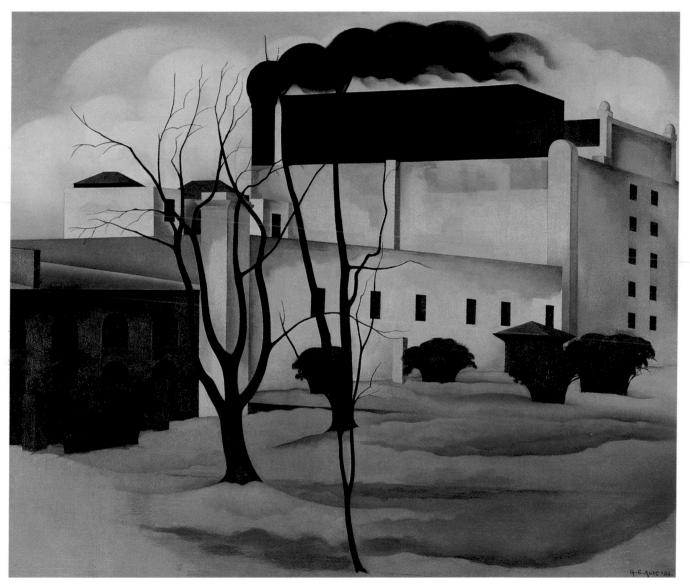

George Ault, BROOKLYN ICE HOUSE, 1926
oil on canvas, 24 × 30, Collection of the Newark Museum, Newark, purchase, 1928.

NILES SPENCER
Pawtucket, Rhode Island 1893–1952
Dingman's Ferry, Pennsylvania

Niles Spencer was a gregarious, elegant figure who was well liked by his many artist friends. He studied at the Rhode Island School of Design in 1913–1915, and during the summers of 1914 and 1915 at Ogunquit, Maine, with Charles Woodbury. He spent some time at the Art Students League working with Kenneth Hayes Miller in 1915 and at the Ferrer School with Robert Henri and George Bellows. After a short teaching stint at the Rhode Island School of Design in 1915, which did not work out because Spencer's ideas were too advanced, he came back to New York and married in 1917, living with very little money in Greenwich Village. From 1919 to 1921 he and his wife lived in Ogunquit, where Spencer felt that his work became more tied to nature. They then went to Europe for a year, where he saw a lot of Cubist work, especially the paintings of Georges Braque and Juan Gris. Back in New York, in 1923, he began exhibiting at the Whitney Studio Club, and then had his first one-man show at the Charles Daniel Gallery in 1925,

followed by another in 1928. During this brief period of success he summered in Provincetown (continuing to do so until 1940) and traveled to France and Bermuda in the late 1920s. In 1937 he executed a mural through the Treasury Department for a post office in Aliquippa, Pennsylvania, showing steel mills. He did not have another show until 1947, at the Downtown Gallery.

In 1947 Spencer remarried and moved to Dingman's Ferry. The following year he visited Alexander Brook in Sag Harbor and liked it so much that he purchased property next door and transported an old house to the site in 1949, spending much of his time thereafter renovating it. He died suddenly of heart trouble in 1952.[1]

While in Sag Harbor, Spencer painted *The Watch Factory*, which Fairfield Porter called "one of his more successful compositions."[2] Spencer painted very slowly, usually completing only one major work a year — primarily abstracted yet identifiable landscapes, often of industrial subjects, using a limited palette of tans, grays, rusts, and greens. The building Spencer depicted here was built in 1880 over the ruins of the

Steam Cotton Mills, which had burned down in 1879. Joseph Fahys, a watch-case manufacturer from New Jersey who had been a stockholder in the cotton mill, built a new factory to make watch cases, using local brick and local labor. The business eventually employed eight hundred people and was a mainstay of the village's economy. After Fahys's death in the 1930s, the factory ceased operation until another stockholder, Arde Bulova, took over and began manufacturing wristwatches. During World War II part of the factory was converted to make products for the war, such as bomb fuses and clock parts. In 1975, because labor was cheaper abroad, the factory was closed, and it remains unused today.[3]

1. Richard B. Freeman, *Niles Spencer* (Lexington, Ky.: University of Kentucky, 1965).
2. Fairfield Porter, *Art News* 51 (November 1952), 46. Of Spencer's work, Porter wrote, "As he did not impose on his paintings, neither do they impose on you. You have to come to them, and when you have, you discover a final firmness and unity."
3. Letter from George A. Finckenor, Historian of the Village of Sag Harbor, who kindly provided this information.

Fahy's Watch-Case Factory,
Sag Harbor, Long Island, ca. 1900
Sag Harbor Whaling and Historical Museum

Niles Spencer, THE WATCH FACTORY, 1950
oil on canvas, 28 × 42⅛, The Butler Institute of American Art, Youngstown, Ohio.

JOSEPH STELLA
Muro Lucano, Italy 1877–1946 Astoria,
Queens, New York

As a boy growing up in a small mountain village near Naples, Joseph Stella loved to draw, but he was discouraged from pursuing art by his father. He came to New York in 1896 and embarked on studies of medicine and pharmacology. He gave this up a year later and took classes at the Art Students League before entering William Merritt Chase's New York School of Art in 1898. His skill as a draftsman was noticed by Chase, and Stella earned a scholarship for another year's study in New York and also attended Chase's summer school at Shinnecock Hills in 1901. In about 1909 he returned to Italy, but in 1911 moved on to Paris, where he became immersed in avant-garde art circles.

A 1912 exhibition of Italian Futurist paintings in Paris made a great impression on Stella, and back in New York later that year, he began a series inspired by Coney Island's Luna Park, culminating in his masterwork *Battle of Lights, Coney Island*. Luna Park was opened in 1903, designed by architect Frederic Thompson and operated by himself and Skip Dundy to showcase their "Trip to the Moon" attraction. Thompson described his plan: "As it is a place of amusement, I have eliminated all classical conventional forms from its structure and taken a sort of free Renaissance and Oriental type for my model, using spires and minarets wherever I could in order to get [a] restive, joyous effect."[1] Stella explained how Thompson's creation affected him artistically: "I built the most intense dynamic arabesque that I could imagine in order to convey in a hectic mood the surging crowd and the revolving machines generating . . . violent, dangerous pleasures. I used the intact purity of the vermilion to accentuate the carnal frenzy of the new bacchanal and all the acidity of the lemon yellow for the dazzling lights storming all around."[2] About five years after Stella completed this work, Luna Park began to deteriorate, and a series of fires in the 1940s destroyed it completely by 1949.

Stella continued using Coney Island as a means to explore his own version of Futurism for a few more years, as can be seen in his painting *Coney Island*, owned by the Metropolitan Museum of Art, but in 1918 turned to another theme, the Brooklyn Bridge, using a more geometric, figurative style. He had moved to Brooklyn in 1916, but considered it "an industrial inferno . . . a place to run away from with both feet flying."[3]

Stella traveled regularly and lived abroad for four years in the early 1930s. Twice he attempted to reestablish a studio in Manhattan but retreated each time because of poor health to Astoria, where a relative lived. His work varied in style from meticulously rendered silverpoint drawings to abstract collages, highly stylized portraits, paintings of fruit and flowers, and large symbolic paintings.

1. David W. McCullough, *Brooklyn . . . And How It Got That Way* (New York: The Dial Press, 1983), 154.
2. John I. H. Baur, *Joseph Stella* (New York: Praeger Publishers, 1971), 32.
3. Irma B. Jaffe, *Joseph Stella* (Cambridge, Mass.: Harvard University Press, 1970), 50.

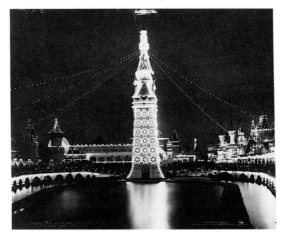

*Luna Park at Night, Coney Island, Brooklyn, N.Y.,
The Electric Tower at Night,* 1903
Central section of panoramic photograph,
Detroit Publishing Co.,
Courtesy of the Prints and Photographs Division,
Library of Congress, Washington, D.C.

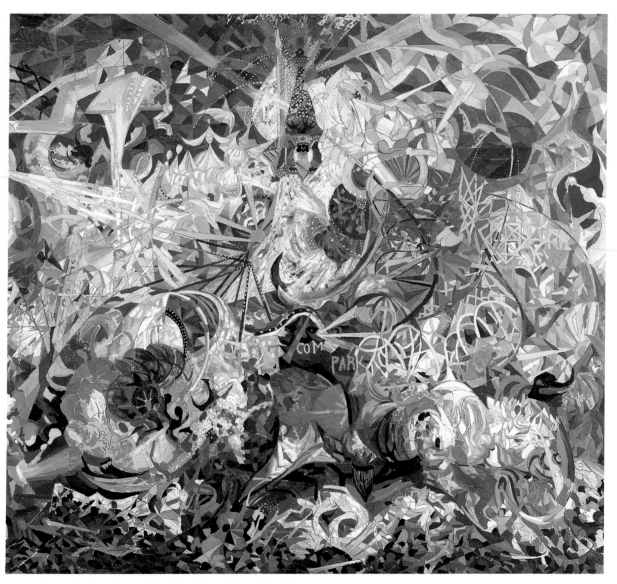

Joseph Stella, BATTLE OF LIGHTS, CONEY ISLAND, 1913–1914
oil on canvas, 75¾ × 84, Yale University Art Gallery, New Haven, gift of the Collection Société Anonyme.

REGINALD MARSH
Paris, France 1898–1954 Dorset, Vermont

Both of Reginald Marsh's parents were artists, and Marsh grew up drawing cartoons and had a lifelong habit of sketching constantly. He took classes at the Art Students League in New York when he was twenty-one, and after his graduation from Yale entered the League full-time, studying with John Sloan and Kenneth Hayes Miller for several years while doing illustrations for popular magazines and newspapers. In 1923 he began to paint seriously, preferring watercolor to oil. In 1929 he started to use egg tempera, though the watercolor medium remained important to him, and he later made use of the Maroger medium. Marsh's primary interest was in drawing; he was not a colorist. His subject matter is well known — usually working-class people portrayed in everyday activities set in and around New York City. He often grouped masses of robust figures in large compositions like those of Michelangelo and Rubens, two artists whom he greatly admired. Concerned that artists' knowledge of anatomy and drawing was declining, he stressed anatomical studies in his classes at the Art Students League and published a book called *Anatomy for Artists* in 1945.

Marsh is said to have elected to stay in New York and teach summer classes at the League rather than summer in Vermont with his wife, mainly so he could visit Coney Island. He was first sent there in the 1920s by his editor at *Vanity Fair*, and was immediately hooked.[1] Coney Island was connected to New York City by subway in 1920 and was therefore easily accessible for Marsh and thousands of other New Yorkers. Estimated attendance after the subway was constructed was about a million people on a hot Sunday, peaking on July 3, 1947, when two and a half million people were thought to be present.[2] Marsh delighted in this kind of excess, and said, "I like to go to Coney Island because of the sea, the open air, and the crowds — crowds of people in all directions, in all positions, without clothing, mov-

ing. . . ."[3] Men were not allowed to sunbathe or swim bare-chested at Coney Island until Mayor Fiorello La Guardia defended the practice in the 1930s.[4] A meticulous record keeper, Marsh estimated that one sixth of his production was done at Coney Island.

1. Marilyn Cohen, *Reginald Marsh's New York: Paintings, Drawings, Prints and Photographs* (New York: Whitney Museum of American Art in Association with Dover Publications, 1983).
2. David W. McCullough, *Brooklyn . . . And How It Got That Way* (New York: The Dial Press, 1983), 162.
3. *Art Students League News* 2, no. 1 (January 1, 1949).
4. Elliot Willensky, *When Brooklyn Was the World, 1920–1957* (New York: Harmony Books, 1986), 177.

GUY PÈNE DU BOIS
Brooklyn, New York 1884–1958 Boston, Massachusetts

Guy Pène du Bois was brought up in a Creole household and did not speak English until he was nine years old. His father was a critic with many connections and enrolled his teenage son in the New York School of Art after noticing his talent for drawing. There Pène du Bois studied with William Merritt Chase, James Carroll Beckwith, Frank Vincent Du Mond, Kenneth Hayes Miller, and Robert Henri, who exerted the biggest influence on him during the last three years of his studies. In 1905 Pène du Bois went off with his father to Paris, where he studied briefly at the Académie Colarossi and with Theophile Steinlen but spent most of his time sketching the street life and café society he observed.

When he came home Pène du Bois took a job as a reporter for the *New York American*, but was not well suited for it. He made better use of his talent when he became a full-time critic from 1909 to 1912,

and after that the editor of *Arts and Decoration*, a post he used to help promote the Armory Show of 1913. He worked there until 1916, when he began a two-year stint as art critic for the *New York Post*, later returning to the magazine for four more years. Pène du Bois also taught at the Art Students League in 1921 and again in the 1930s, and held his own classes in New York in 1923. In 1924 he moved with his family to France, where for the next six years he was able to paint without distraction. When he returned to New York he resumed teaching, and in 1932 began his own school in Stonington, Connecticut, which he conducted off and on until 1950.[1]

In 1938 Pène du Bois was invited to join the faculty of the Amagansett Art School, established in 1933 by Hilton Leech, where he made these two paintings. The artist explained *Fog, Amagansett*, formerly titled *The Beach*: "It was painted from notes and memory . . . toward the end of the summer. I had spent most of the summer doing sketches on *The Beach* and was full of information about it. The picture was done very easily and rapidly and is, I think, one of the most fluent ones I have done in recent years."[2] Although there was no base on the East End at the time that *Watching the Fleet* was painted, the eastern tip of Long Island was considered important to our defense as tensions mounted in Europe, and military craft offshore were a common sight. After the outbreak of World War II, Camp Hero was formed at Montauk Point by the Coast Artillery, and nearby Fort Bay Pond became the site of a Navy torpedo testing base. In 1942 four German saboteurs landed at Amagansett, buried supplies and explosives in the dunes, and boarded a train into New York City. Partly because they were spotted by a local person, the group was captured over the next two weeks.[3]

1. Betsy Fahlman, *Guy Pène du Bois: Artist about Town* (Exh. cat.; Washington, D.C.: Corcoran Gallery of Art, 1980).
2. George M. Tomko, *Catalogue of the Roland P. Murdock Collection* (Wichita, Kans.: Wichita Art Museum, 1972), 52.
3. Jeanette Edwards Rattray, *East Hampton History* (Garden City, N.Y.: Country Life Press, 1953), 165–167.

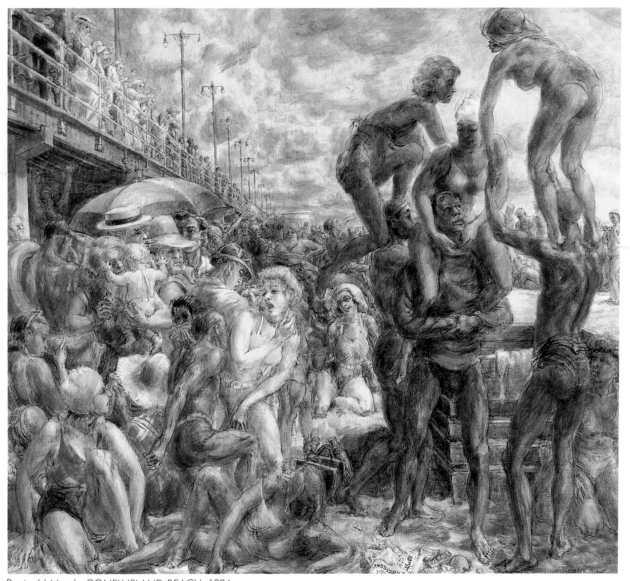

Reginald Marsh, CONEY ISLAND BEACH, 1934
tempera on panel, 36 × 40, Yale University Art Gallery, New Haven, gift of Mrs. Reginald Marsh.

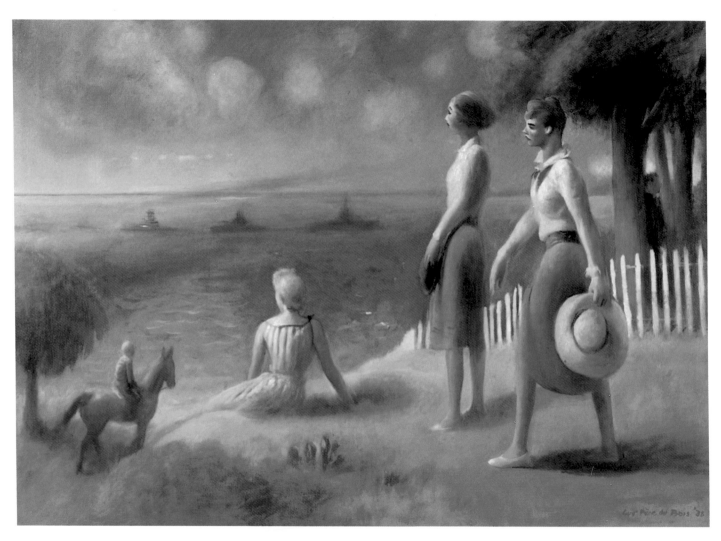

Guy Pène du Bois, WATCHING THE FLEET, 1938
oil on canvas, 24 × 34, Wichita Art Association, Wichita, gift of Friends of the Wichita Art Association, 1946.

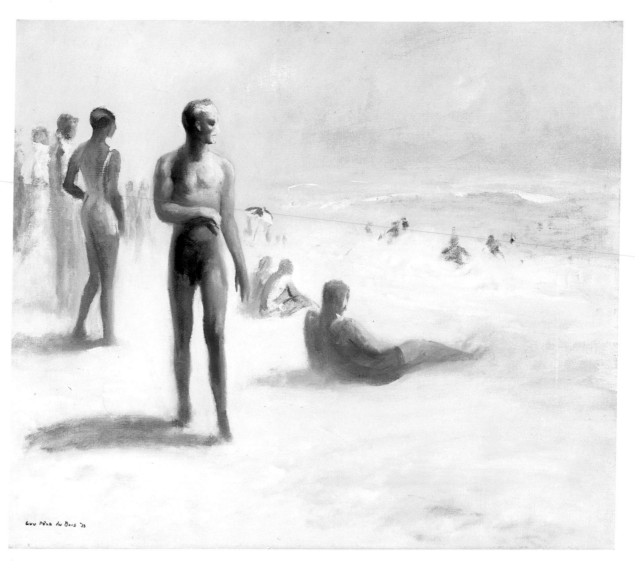

Guy Pène du Bois, FOG, AMAGANSETT, 1938
oil on canvas, 25 × 30, Wichita Art Museum, Wichita, Roland P. Murdock Collection.

CHARLES PRENDERGAST
Boston, Massachusetts 1863–1948 Westport, Connecticut

Charles Prendergast began to earn a living selling household wares and then went into custom woodworking. In 1895, with the encouragement of the artist Herman Dudley Murphy, he began making hand-carved frames for Murphy and other painters, including his better-known brother, Maurice Prendergast. In 1898 and again in 1911 and 1912 he visited Italy with Maurice, studying paintings in museums and churches and acquiring old frames. At about this time he began to make panel paintings with gesso, tempera, and gold and silver leaf, using his carving skills to create a low-relief surface. Prendergast created a completely individual style with a primitive look that drew from a wide variety of historical styles, including Persian and Hindu miniatures and early Italian panel paintings, with imaginary or religious themes for subject matter. He moved to New York in 1914 with his brother and began exhibiting his work the following year. Saddened by Maurice's death in 1924, Prendergast traveled to France, where he married. On their return he and his new wife settled in Westport, Connecticut, where he remained until his death except for trips to France in the late 1920s and to Florida in the mid-1940s.[1]

After 1932 Prendergast began to use contemporary life as his subject matter, favoring parks, zoos, and fairs, as his brother Maurice had, and as can be seen in this view of the World's Fair. Rather than depict the futuristic architecture or the wide open spaces that were a feature of the fair, Prendergast chose instead to focus on a small-scale scene with gaily waving flags and other charming details. The fair, held in Flushing Meadow, opened on April 30, 1939, and attracted thousands of visitors before it closed in the fall of 1941. Many artists were involved in designing more than one hundred murals for buildings housing technological wonders. Art lovers could also view a collection of more than five hundred Old Master paintings installed in a building financed by private subscription, as well as a two-part contemporary art exhibition called "American Art Today."[2]

1. See *The Art of Maurice and Charles Prendergast* (Exh. cat.; Williamstown, Mass.: Williams College, 1983) and Richard J. Wattenmaker, *The Art of Charles Prendergast* (Exh. cat.; New Brunswick, N.J.: Rutgers University Art Gallery and Museum of Fine Arts, Boston, 1968).
2. Helen A. Harrison, et al., *Dawn of a New Day: The New York World's Fair, 1939/40* (Exh. cat.; Queens, N.Y.: The Queens Museum, 1980), 63. Attendance never reached the expected levels, and the fair ended with a deficit of nineteen million dollars.

P. L. Sperr, Flushing Meadow Park, Queens:
Crowds waiting to get into the General Motors Building,
New York World's Fair, May 29, 1939
Courtesy of the New York Public Library Special Collections.

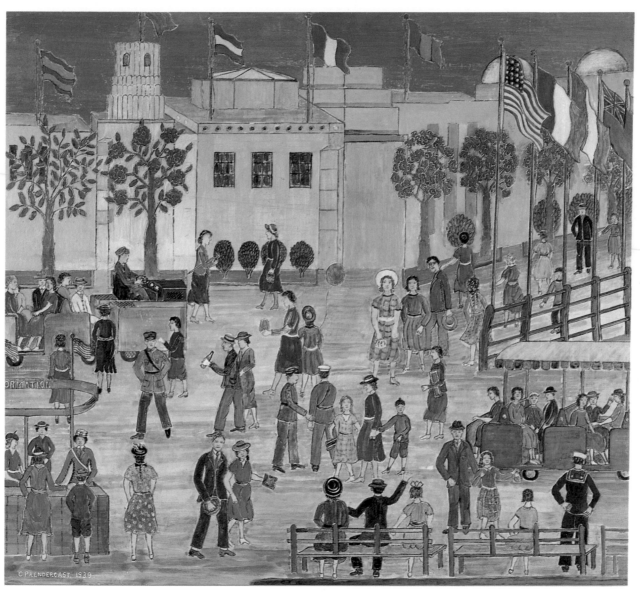

Charles Prendergast, WORLD'S FAIR, 1939
tempera and gold leaf on composition board, 24 × 27½, Collection of the Whitney Museum of American Art,
New York City, purchase (49.12).

OGDEN PLEISSNER
Brooklyn, New York 1905–1983 London, England

As a boy Ogden Pleissner drew constantly, and after his graduation from Brooklyn Friends Academy he enrolled at the Art Students League, where he worked from 1923 to 1929. From 1929 until 1941 he lived and had a studio at 186 Washington Park, where he painted *Backyards, Brooklyn,* which was promptly purchased by the Metropolitan Museum.[1] From 1930 to 1934 he taught at Pratt Institute, and from 1936 to 1976 at the National Academy of Design. During those same years Pleissner maintained a studio on the West Side of Manhattan, noting, "Although I had a nice studio in Brooklyn, it got so that I couldn't get anybody to carry pictures over from Brooklyn to the galleries."[2] He became an Army Air Force artist during World War II and was stationed in the Aleutian Islands, where he developed an interest in watercolors. When funds for his position were cut, he stayed on as an artist for *Life* magazine. After the war he continued to paint watercolors during travels out West and abroad, and around his home in Vermont, where he moved in 1947.

Pleissner is best known for his hunting and fishing scenes, inspired by a personal interest that brought him to Long Island again in the 1940s and 1950s to hunt pheasant in an area around the Carmans River in Brookhaven Town, now a nature preserve. "I just paint something because I like it," Pleissner explained. "I've always felt pretty free as to what I can do. I just paint something in the neighborhood I'm in, and I've been in some very nice neighborhoods."[3]

1. Ronald G. Pisano, *The Long Island Landscape, 1914–1946* (Exh. cat.; Southampton, N.Y.: Parrish Art Museum, 1982).
2. Quoted in Peter Bergh, *The Art of Ogden M. Pleissner* (Boston: David R. Godine, 1984), 4.
3. Ibid., xi.

OSCAR BLUEMNER
Prenzlau, Germany 1867–1938 South Braintree, Massachusetts

Oscar Bluemner attended technical high schools and, like his father and grandfather, became an architect. During this time he painted portraits and landscapes. He left Germany in 1892 and went to Chicago, where he worked as a draftsman on projects for the World's Columbian Exposition. Over the next few years he lived in several different cities before settling in 1900 in New York, where he designed suburban residences. He continued sketching and painting watercolors on visits to still-rural sections of Brooklyn, Queens, and western Long Island.

In 1910 Bluemner met Alfred Stieglitz, who became a friend and artistic supporter. Stieglitz's show of Cézanne's watercolors in 1911 made a great impression on Bluemner. Around this time, he began painting in oil, using bright color, as can be seen in this work. During a trip to Europe in 1912 Bluemner saw the most avant-garde art, and his own works were exhibited at a gallery in Berlin. The following year he exhibited five works at the Armory Show. In 1915 Stieglitz sponsored Bluemner's first solo show in New York, featuring paintings with intense color and architectonic shapes. Bluemner moved to New Jersey in 1916 and continued to paint while he wrote criticism and studied the artistic color theories of Chevreul, Goethe, and Bezold. In the 1920s he abandoned the geometric structure he had been using and, after his wife's death in 1926 and his subsequent move to Massachusetts, began a series of paintings with solar and lunar motifs. In 1935 he was struck by a car, and his eyesight began to deteriorate. His doctor ordered him to stop painting because of heart trouble. Bluemner took his own life in 1938.[1]

1. Judith Zilczer, *Oscar Bluemner* (Washington, D.C.: Smithsonian Institution Press, 1979).

SAMUEL ROTHBORT
Wolkovisk, Russia 1882–1971 Brooklyn, New York

Samuel Rothbort came to America in 1904 and settled in Brooklyn. He worked as a housepainter and then took a job as a watchman on a construction site, where he sometimes drew on the raw plaster. His supervisor encouraged him to pursue art, and so he began painting murals. After his marriage in 1909, Rothbort and his wife, Rose, decided to try farming, winding up with a chicken farm on two acres in Uniondale (or East Hempstead) in 1924. During this period Rothbort exhibited regularly with the Society of Independent Artists and at the Brooklyn Museum.

Across the street from the Rothborts' home at the intersection of Park and Uniondale avenues was the Rottkamp farm, the forty-acre spread of vegetables (or truck farm) depicted here.[1] Diagonally across the street was a cabbage farm run by the Meyers family. In about 1937, because of the Depression, the Rothborts were forced to sell the property for a very low sum since they could not pay their taxes. During this period of financial hardship, Rothbort made many watercolors and took up sculpting, using as his medium found materials such as fenceposts, fallen trees, and rocks from his property or driftwood he found at Coney Island. He later published a book, *Out of Wood and Stone* (1952), on this subject. After leaving their farm, the family then moved to Flatbush, where after 1940 Rothbort's fortunes changed. He began showing at the Charles Barzansky Gallery in New York and continued exhibiting and working until he was well into his eighties.[2]

1. The Southern State Parkway, begun in 1926 and completed in 1929, ran through part of Rottkamp's farm.
2. Information based on Francis Sugrue, "Portrait of An Artist," *New York Herald Tribune,* November 7, 1985, and additional material from Ida Rothbort, March 28, 1989.

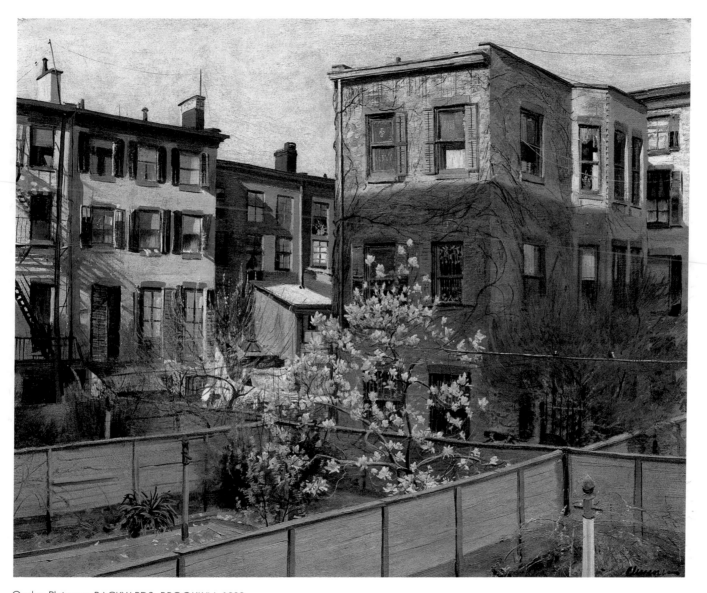

Ogden Pleissner, BACKYARDS, BROOKLYN, 1932
oil on canvas, 24 × 30⅛, The Metropolitan Museum of Art, New York City, Arthur Hoppock Hearn Fund, 1932 (32.80.2).

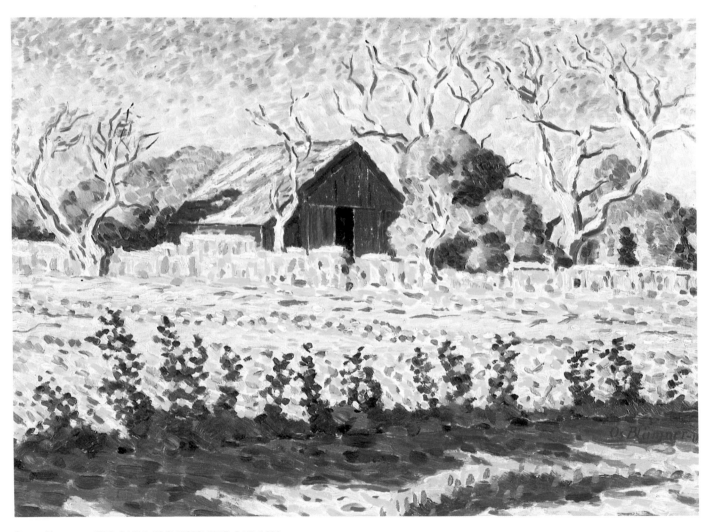

Oscar Bluemner, OLD BARN AT SHEEPSHEAD BAY, 1911
oil on canvas, 14 × 20, Joseph M. B. Guttmann Galleries, Beverly Hills, California.

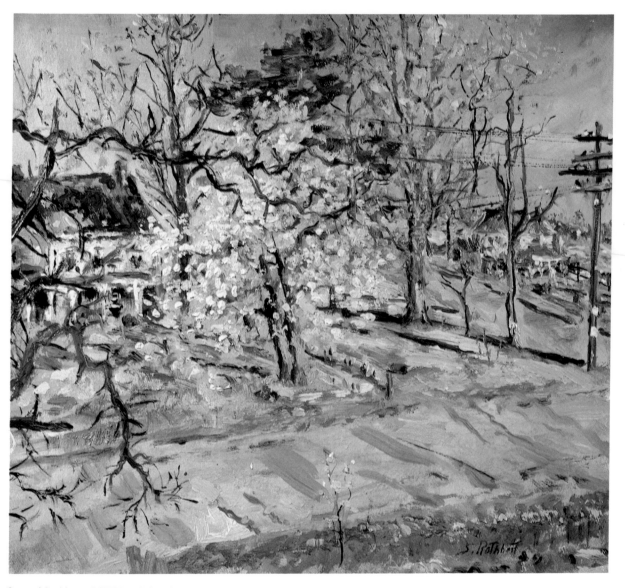

Samuel Rothbort, ROTTKAMP'S FARM, PEAR TREE IN BLOOM, UNIONDALE, LONG ISLAND, ca. 1931
oil on board, 21 × 24, The Marbella Gallery, Incorporated, New York City.

PETER BÈLA MAYER
b. Hungary, 1887

Bèla Mayer studied at the National Academy of Design from 1908 to 1915, working at night in life classes and from the Antique. He began exhibiting at the National Academy and at other major annuals shortly thereafter. He was friendly with Walter Farndon, Albert Groll, and Jonas Lie, with whom he took sketching trips outside New York, often to New Jersey. He developed a style marked by broadly applied, thickly painted color that he used to create structure and movement, often choosing a single palette of blues or golds to create an overall tone. He did not date his paintings. Mayer worked as a successful textile designer in New York. He added "Peter" to his name in the early 1940s because Bèla was often mistaken for a woman's name.[1]

By about 1922 Mayer had a studio in Port Washington, which he kept until he was in his nineties. Many of his landscapes were done in Port Washington and nearby Roslyn, but he also painted in New England and along the Hudson River. Mayer liked to paint snow scenes, such as *Roslyn in Winter*, showing the hilly, rocky terrain created by glacial movement, which is typical of the North Shore of Long Island and quite different from the flat sandy landscape of the South Shore. The exact location of this scene cannot be identified, and it is possible that the artist took liberties to suit his artistic purposes.[2]

1. Holly Pinto Savinetti, *Peter Bèla Mayer: An American Impressionist* (Exh. cat.; Roslyn, N.Y.: Nassau County Museum of Fine Arts, 1984).
2. Conversation with Mrs. Peggy Gerry of the Historic District Board, Roslyn. Mayer left Port Washington in 1986 and lived with his two daughters in Chicago and in the Houston area until he entered a nursing home in Houston. Conversation with Victor Weidner, Mayer's son-in-law, May 8, 1989. I am grateful to Robert Durell for putting me in touch with the family.

Eugene Armbruster, Main Street on Western Village Road, Roslyn, January 1923
Courtesy of the New York Public Library Special Collections.

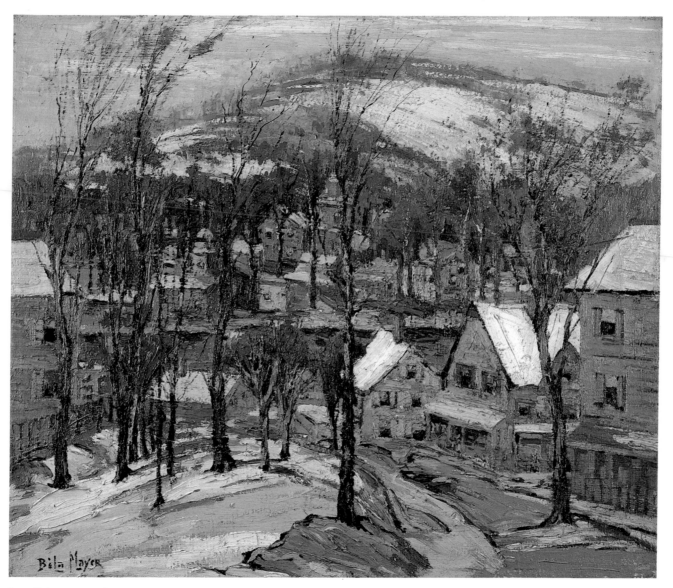

Peter Bèla Mayer, ROSLYN IN WINTER, ca. 1929
oil on canvas, 25 × 30, Collection of Robert and Sandi Durell.

STOKELY WEBSTER
b. Evanston, Illinois, 1912

As a boy of ten Stokely Webster went to Paris, where he studied painting with a family friend, Lawton Parker. He later took courses in architecture at Yale University and transferred first to Northwestern University and then to the University of Chicago before giving in to his early love of art. After living for several years in Chicago, he moved to New York City and worked as a textile designer from 1934 to 1935. In 1936 he studied for six months with Wayman Adams and painted copies of Old Master paintings at the Metropolitan Museum of Art. His early works were primarily portraits and figure studies in a dark palette and impressionistic landscapes, which later became his main interest. During World War II Webster worked at Grumman Aircraft Corporation while attending Columbia University's Engineering School at night, continuing to paint when he had free time.[1] This view of Little Neck Bay was painted at Willets Point in Queens, with a view of Great Neck to the right and, at the left, a distant view of Throg's Neck, in the Bronx, which would later be connected to Long Island by the Throg's Neck Bridge. When Webster painted this work, the area was still unspoiled, and he was "inspired by the beautiful vista, looking north from the approach to Fort Totten." The artist adds this anecdote: "An interesting sidelight on the painting of this picture is that while I was working on it, a convoy of jeeps came down the road into the Fort and stopped and Field Marshal Montgomery got out of a jeep, came over and looked at the painting and said 'Very good indeed.'"[2]

For many years Webster enjoyed a successful career as an engineer while painting on the side. In 1948 he took a temporary break from engineering and leased a studio in New York. Two years later he purchased a large barn on ten acres of the Gould estate in the Dix Hills section of Huntington, where he spent part of his time after converting it into a studio and home. After a disastrous fire in his New York studio in 1952, Webster and his wife moved to Huntington full-time and remained there for about thirty years. Webster explains, "This was a good central location for the starting point for my frequent landscape-hunting expeditions, which ranged all the way from the Hamptons and Shelter Island to the South Shore beaches and Brooklyn and New York docks and parks."[3]

1. See Harry Rand, *Stokely Webster: Paintings, 1923–1984* (Daytona Beach, Fla.: Museum of Arts and Sciences, 1985).
2. Letter from the artist, undated.
3. Ibid.

P. L. Sperr, Cross Island Parkway, showing the parkway under construction as part of the Belt Parkway system of vehicular highways, July 11, 1939
Courtesy of the New York Public Library Special Collections.

Stokely Webster, LITTLE NECK BAY, 1945
oil on canvas, 20 × 24, Collection of the Artist.

HAROLD L. BURROWS
Salt Lake City, Utah 1889–1965 Manhasset, New York

Harold L. Burrows, known as Hal, studied in Salt Lake City with Mahonri Young, a lifelong friend, and then came to New York at the age of seventeen. He continued his studies with Robert Henri and George Bellows in 1909–1910.[1] During World War I Burrows was a popular cartoonist for the Army newspaper *Stars and Stripes*. After the war, in 1919, he studied at the Académie Julian in Paris, and upon his return to New York became a free-lance cartoonist, publishing in *Life*, *Judge*, and other magazines during the 1920s and 1930s. In 1923 he became art director for MGM, working on the production of most of their major movies, including *Gone with the Wind*. He designed movie posters, combining graphics with illustration

and then photo-collage, creating MGM's distinctive poster style. He held this position until 1958 and also worked with MGM's advertising department, for which he designed the first animated electric signs, used in New York's Times Square and in Chicago. Burrows was a life member of the American Water-color Society and had several one-man shows of his watercolors in New York. His subjects were derived from Oriental, medieval, or American Indian themes. He also designed frames for these works.

Burrows began visiting Long Island in about 1910, and this view of Shelter Island was probably painted around 1920 on a sketching trip. Burrows's son John remembers that "he never tired of painting beach scenes on Long Island, and particularly liked the tran-quillity of Shelter Island."[2] Burrows sent his son to camp there in the 1930s. In 1928 Burrows moved to

Manhasset, and continued throughout his life to paint watercolors of local scenes, particularly of the North Shore beaches bordering Long Island Sound and of Coney Island on the South Shore.

1. Burrows's study record is unclear; some sources say that he studied with Young in New York, others say Utah; the *Tribune* lists him as studying at the Art Students League, but the League has no record to confirm that. Biography based on letters to Ronald Pisano, February 1, 1989, and to Beverly Rood, February 21, 1989, from the artist's son John Burrows, and on "Harold L. Burrows, Cartoonist and Artist," *New York Herald Tribune*, July 27, 1965; *Decorative Fantasies in Color by Harold Burrows* (Exh. checklist; New York: Grand Central Art Galleries, 1945); and "Catalogue of an Exhibition of Decorative Drawings and Water Colors by H. L. Burrows" (Exh. checklist; New York: Harlow, MacDonald & Co., 1927).
2. Letter from John Burrows, February 21, 1989.

Arthur S. Barnett, Jr., Ram Island Causeway, February 28, 1987
Originally printed in the March 5, 1987, issue of the *Shelter Island Reporter*.

Harold L. Burrows, SHELTER ISLAND, LONG ISLAND, ca. 1920
watercolor on paper, 12 × 18, Collection of John C. Burrows.

MILTON AVERY
Sand Bank (later renamed Altmar), New York
1885–1965 New York City

Milton Avery had worked as a mechanic, among other things, before enrolling in a lettering class at the Connecticut League of Art Students around 1910. He soon switched to the life-drawing class, and from then on devoted himself entirely to pursuing art. In 1918 he transferred to the School of the Art Society of Hartford, and until the mid-1920s painted portraits and landscapes with thick pigment, using a palette knife. From 1920 to 1924 he summered in Gloucester, Massachusetts, where in 1924 he met Sally Michel, a fellow artist. In 1925 he moved to New York City in order to be close to her, and they were married the following year. They were always short of money, and for entertainment made the rounds of galleries and museums each weekend, swam at Coney Island and Rockaway during the summers, and entertained their many artist friends at their apartment. Despite their tight budget, in the 1930s they spent most of their summers in Gloucester or southern Vermont.

Avery began exhibiting at the Valentine Gallery in 1935, an association that gave him the confidence to continue developing his distinctively personal style. Paul Rosenberg became his dealer in 1943, giving him steady financial support. During World War II gasoline was rationed, however, so the Averys could not travel as widely as they had during previous summers, though they did manage to get to Gloucester. Since Avery depended on new landscapes to inspire his paintings, many of his works during this period are figurative, such as his watercolor George Constant Fishing. Constant and Avery had become good friends in New York and exhibited their work together on at least one occasion, in 1944, when one critic described them as "Two artists whose work is so simpatico that none but a peaceful effect can be had from coupling them on the walls."[1] The Averys visited Constant at his country home in Connecticut and then later on Long Island, after Constant moved to the East End in 1945.[2] This work was probably painted in Hampton Bays or Shinnecock Hills, where Constant first settled.

In 1949 Avery suffered a heart attack, which limited his activities for the rest of his life. He made nearly two hundred monotypes in the early 1950s, and the oil paintings he did afterward retained the simplicity of handling he had adopted for the monotypes. In 1962 he suffered another heart attack and was in frail health until his death in 1965.[3]

1. "Avery and Constant," Art Digest 19, no. 4 (November 15, 1944), 14.
2. Conversation with Sally Avery, December 28, 1988.
3. See Barbara Haskell, Milton Avery (New York: Whitney Museum of American Art, 1982).

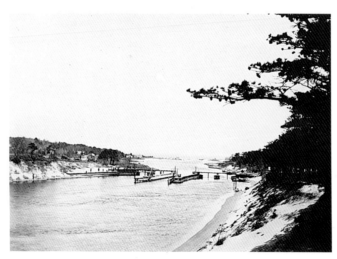

Eugene Armbruster, View of Canal at Canoe Place,
connecting Shinnecock Bay with Peconic Bay, April 1927
Courtesy of the New York Public Library Special Collections.

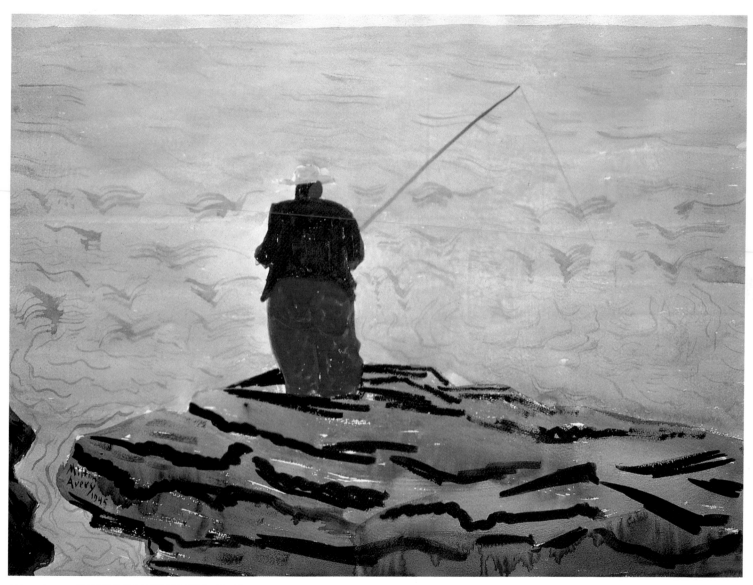

Milton Avery, GEORGE CONSTANT FISHING, 1945
watercolor on paper, 22 × 30, Collection of Mr. and Mrs. Charles Edward Eaton.

NICOLAI CIKOVSKY
Pinsk, Russia 1894–1984 Washington, D.C.

At the age of fifteen Nicolai Cikovsky traveled to Vilna to study art and went on to the Royal Art School in Penza from 1914 to 1918, and to the Moscow Higher Technical Art Institute from 1921 to 1923. In 1923 he came to the United States, but sadly was unable to bring any of his early artwork with him. In New York he formed lifelong friendships with the painters David Burliuk and Moses and Raphael Soyer, also Russian émigrés. Cikovsky's early work in this country was influenced primarily by Cubism, and he was soon associated with the Charles Daniel Gallery in New York. By the early 1930s his paintings had started to depict real life and he had begun to incorporate social themes into his work. He taught at the St. Paul School of Art, the College of Notre Dame, the Chicago Art Institute, and the Cincinnati Art Acad-.

emy as well as the Corcoran Gallery of Art. In the 1930s he completed murals for post offices in Towson and Silver Springs, Maryland, and for the Department of the Interior in Washington, D.C., where he lived for five years.

In 1942 Cikovsky began to summer in Southampton's North Sea area, and he and his wife moved permanently to their cottage on Wooley Pond in the late 1970s. Cikovsky's paintings blossomed with light and color when he came into contact with the farmland and beaches of the area. A favorite subject was farmers working the land, as in *Summer Scene*. "Whenever I painted, I looked for land that suited my personal likes," Cikovsky explained. "Sometimes I had to drive a long way before I stopped and started to paint. Then my admiration was so much a part of my life that I could not even express it." Other favorite subjects were bouquets of flowers taken from their

garden and intimate views of the many inlets and coves in the area, such as *On the Sound*. Cikovsky's friend Raphael Soyer said of him, "For me it was wonderful to watch Nick Cikovsky paint the white beaches, the ponds, the potato fields of Long Island. His reaction to nature is full of delight. He loves moving clouds, shimmering sunlight on rippling water, and the multi-colored flowers in his own garden which he has painted so often. If one could consider painting as poetry, then Nicolai Cikovsky may be called the poet of Long Island."[1]

1. Helen Harrison, *Nicolai Cikovsky* (Exh. cat.; Southampton, New York: The Parrish Art Museum, 1980); see also Grace Pagano, ed., *Contemporary American Painting: The Encyclopedia Britannica Collection* (New York: Duell, Sloan and Pearce, 1945), 21. For the last two years of his life Cikovsky lived with his son, Nicolai junior, in Washington, D.C.

Eugene Armbruster, View of Weesuk Boatworks,
East Quogue, Southampton, 1923
Courtesy of the New York Public Library Special Collections.

Nicolai Cikovsky, ON THE SOUND, ca. 1948
oil on panel, 7 × 15, Private collection.

WILLIAM LANGSON LATHROP
Warren, Illinois 1859–1938 Montauk, New York

William Lathrop was largely self-taught, his only formal study consisting of a brief period at the Art Students League with William Merritt Chase in 1887. Early in his career, Lathrop's illustrations appeared in popular periodicals, and he also made etchings and worked in watercolor. In 1888 he traveled to England, where he visited with the English artist Henry Snell and the American painter Henry Ward Ranger before traveling on to France and Holland. Lathrop taught art classes during the summers of 1897 and 1898 in the Poconos, and in 1899 he moved permanently to New Hope, Pennsylvania, where he continued to hold art classes. Lathrop and another New Hope resident, Edward Redfield, were the earliest members of what became a thriving artists' colony. Lathrop painted the tonal landscapes he became known for not directly from nature, but rather from memory. After about 1920 his palette lightened, and his paintings show the influence of the Impressionists.

In the late 1920s Lathrop built his own sailboat, the *Widge*, which measured twenty-six feet, with a beam of nine feet and draft of four feet, with no engine. During the 1930s he spent half of every year sailing off the New Jersey shore, off Martha's Vineyard, and on Long Island Sound, visiting towns along Long Island's North Shore and often anchoring off Montauk. He painted small oil sketches on board, which he later turned into paintings, as was the case with *Montauk,* of 1937. On September 21, 1938, Lathrop was anchored at Montauk during the great hurricane. A fishing boat cut his line, and as the *Widge* began to drift, Lathrop jumped overboard. He suffered a fatal heart attack as he attempted to swim ashore.[1]

1. Thomas Folk, *William Langson Lathrop: Tonalism to Impressionism* (Exh. cat.; Hempstead, N.Y.: The Emily Lowe Gallery, 1982).

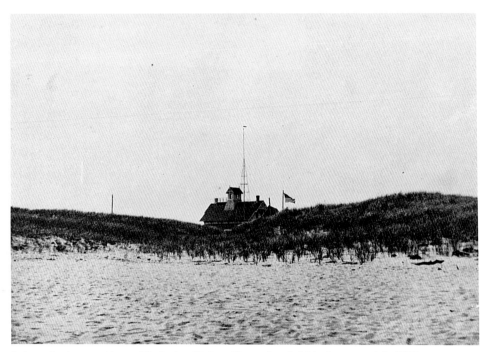

Eugene Armbruster, Mecox Life-Saving Station, Ocean Road, Bridgehampton, July 1923
Courtesy of the New York Public Library Special Collections.

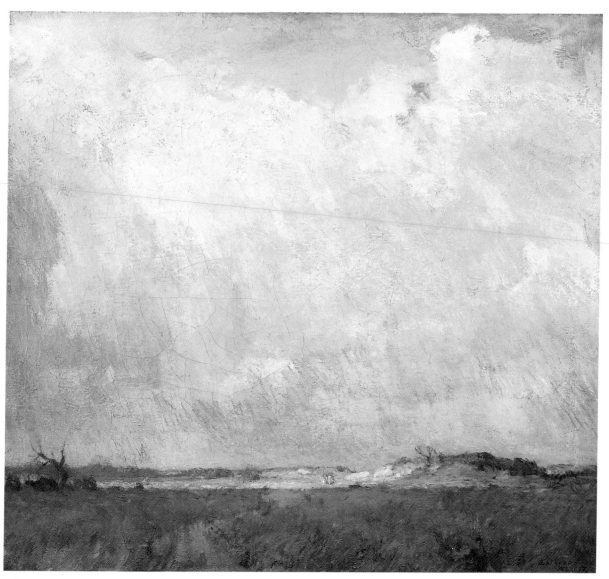

William Langson Lathrop, MONTAUK, 1937
oil on canvas, 36 × 40, Collection of Ray A. Roberts.

JOHN MARIN
Rutherford, New Jersey 1870–1953 Cape Split, Maine

John Marin was raised by two aunts after the death of his mother. He enjoyed spending time outdoors, hunting, fishing, and sketching, and would later make nature his primary subject. He worked in several architectural offices before opening his own office, building six frame houses in New Jersey before entering the Pennsylvania Academy of the Fine Arts in 1899. He remained there for two years and then moved to New York, where he studied briefly at the Art Students League.

In the fall of 1905 Marin convinced his father to send him on an extended trip to Europe, most of which he spent in Paris. In 1909 Marin met Alfred Stieglitz, who gave him an exhibition at his 291 Gallery the following year and became a great friend and champion of his work. Marin visited the United States for part of 1909–1910 and returned permanently that summer, when he made a trip to the East End and painted the watercolor *Peconic Bay, Long Island*

Sound. In contrast to this serene work, Marin began to use the city of New York as his subject, producing dynamic watercolors, drawings, and etchings to match the excitement he felt there. He spent the winter and spring of 1912–1913 in Flatbush, but after this moved to New Jersey and began passing his summers looking for new places to paint. He discovered Maine in 1914 and visited it off and on until 1933–1934, when he bought a house at Cape Split in Addison, where he spent summers for the rest of his life.

In 1927 Marin returned to the East End, where he painted another watercolor, *Long Island Potatoes, Spring of 1927*. Several years later he made a few oil studies of Jones Beach. Marin had experimented with oil painting in the teens, when he painted a series of sketches of Weehawken, and turned to it again in the late 1920s and the 1930s.[1] Despite limited critical approval and the reported opposition of Stieglitz, he continued to use the medium, and these works have received more appreciation in recent years. In his oils of the early 1950s he began using strong lines, which he likened to writing, created with thinned black paint

and applied with a syringe. *Huntington, Long Island #1* is one of at least five works Marin is known to have painted of the same scene while visiting Stieglitz's grandniece Sue Davidson Lowe at her home on Kane's Lane in Halesite in 1952.[2] Two trees on Lowe's lawn frame the view Marin painted, looking west across Huntington Harbor to the point of land reached by Wincoma–East Shore Road.

1. Much later in life Marin dated these sketches 1903–1904, but Sheldon Reich believes they date to about 1916. Sheldon Reich, *John Marin: A Stylistic Analysis and Catalogue Raisonné*, 2 vols. (Tucson: The University of Arizona Press, 1970), 97. See also Klaus Kertess, *Marin in Oil* (Exh. cat.; Southampton, N.Y.: The Parrish Art Museum, 1987).
2. Ann DePietro of the Heckscher Museum conducted an interview with Sue Davidson Lowe in November 1988 and kindly put me in touch with her. Marin and Lowe's father, Donald Douglas Davidson, were good friends, and thus Lowe knew the artist from an early age. Conversation with Ms. Lowe, June 11, 1989, and letter, June 29, 1989, provided the details of the local geography.

View of the Harbor from Halesite, Huntington, N.Y., ca. 1930
The Huntington Historical Society.

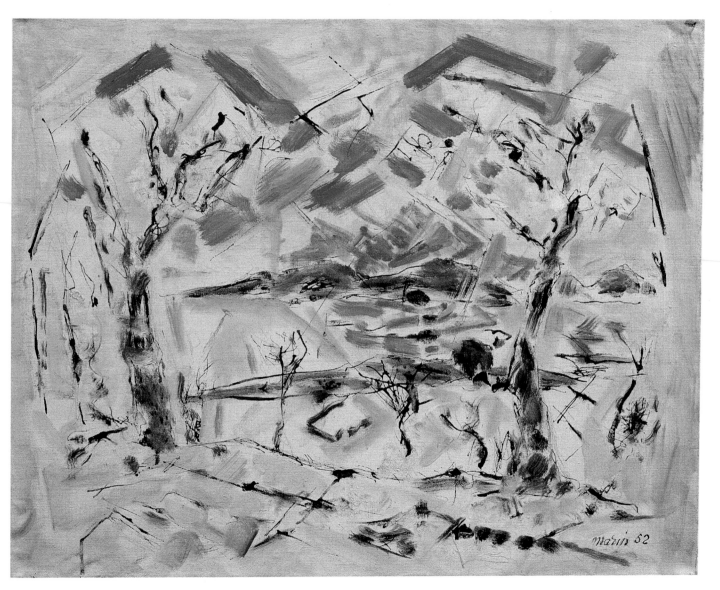

John Marin, HUNTINGTON, LONG ISLAND #1, 1952
oil on canvas, 22 × 28, Kennedy Galleries, Incorporated, New York City.

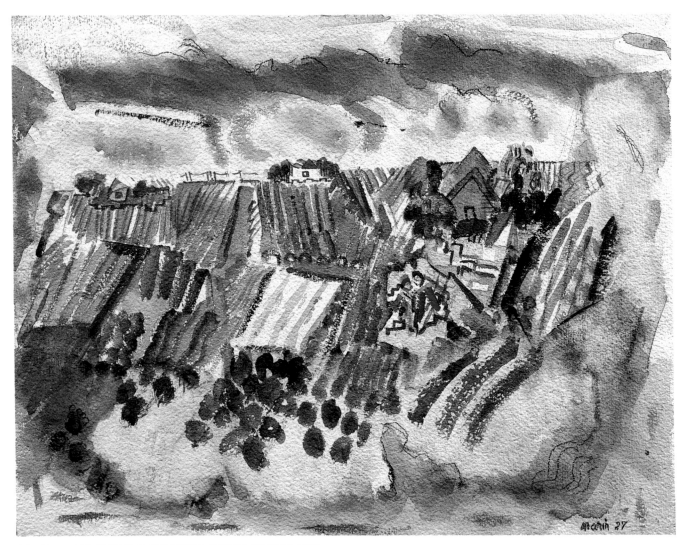

John Marin, LONG ISLAND POTATOES, SPRING OF 1927, 1927
watercolor on paper, 18⅛ × 23⅛, Kennedy Galleries, Incorporated, New York City.

GEORGE CONSTANT
Agion, Greece 1892–1978 Southampton, New York

George Constant was orphaned at the age of four and brought up by an uncle. He spent his summers at a monastery and formed an early attraction to Byzantine icons. Constant came to the United States when he was in his late teens and attended the School of Fine Arts at Washington University for about two years. In 1914 he won a scholarship to the Art Institute of Chicago, where he studied until 1918. There he came under the influence of George Bellows and Charles Hawthorne, and was introduced to the work of Cézanne. He and his friends started an art class at Chicago's Hull House, after which Constant was invited to become an instructor at the Dayton Institute from 1920 to 1922. He then moved to New York City, where he joined the Society of Independent Artists. In 1927 J. B. Neumann gave him his first one-man show. Constant was involved in the federal art programs of the 1930s, and in 1940 he was one of the founders of the Society of Modern Painters and Sculptors, and later served as president of that group.[1] Most of the works he exhibited during his lifetime were abstracted figures that show his admiration for Cézanne and pre-Columbian art. His work later evolved into complete abstraction.

Constant came to the South Fork in 1945 after the government appropriated his country home on Long Island Sound in Connecticut for use as an airstrip, which was never built. Many of his friends were already summering in the area, and he liked the hilly terrain around Shinnecock Hills because it resembled his former property in Connecticut. He first rented a house in Hampton Bays and later built a home in Shinnecock Hills, where he painted many watercolors inspired by the surrounding landscape, such as the work shown here. In an unfortunate coincidence, this house was taken over by New York State in the 1960s to extend the Sunrise Highway. Constant then moved to a house on Tuckahoe Lane in Southampton, where he summered until his death in 1978.[2]

1. Margaret Breuning, *George Constant,* with biographical sketch by Georgette Preston (New York: Arts Inc., 1961). Constant's birthplace is sometimes listed as Arahova.
2. Information supplied by Georgette Preston, in Ronald G. Pisano, *The Long Island Landscape, 1914–1946: The Transitional Years* (Exh. cat.; Southampton, N.Y.: The Parrish Art Museum, 1982).

ABRAHAM RATTNER
Poughkeepsie, New York 1895–1978 New York City

Abraham Rattner studied architecture in 1913 and 1914 at George Washington University, and also at the Corcoran School of Art from 1913 to 1915. He then went on the Pennsylvania Academy of the Fine Arts, but was drafted into the army to conduct camouflage-technique research in France. In 1919 he won the Cresson traveling scholarship from the Pennsylvania Academy, which enabled him to go back to Europe as a student. In 1920 he traveled through France, Spain, England, Holland, and Belgium before settling in Paris in 1921. He studied at various art academies there, including the École des Beaux Arts, and lived for a year in Giverny in 1922. He became part of the "Minotaure" group, which included the artists Picasso, Miró, and Giacometti, and contributed illustrations to their publication.

Rattner made his first trip back to the United States in 1928 but continued to live in Paris, where he had his first one-man show in 1935. He began exhibiting his work in this country shortly after that, and returned here to live in 1940 when the Nazis invaded France. He embarked on a trip across the United States with Henry Miller, who later wrote a book about the experience. Rattner made nearly four hundred sketches recording their journey before he and Miller parted in Louisiana.

During the late 1940s and the 1950s, Rattner taught at several art schools in New York and at a variety of colleges before establishing his own school with his stepson Allen Leepa in 1956 in Sag Harbor, which they operated until 1961.[1] Rattner had visited the area in the 1940s, and in 1952 he purchased an abandoned church in Sag Harbor, which he used as his studio and later for the school.[2] In 1972 he built a home and studio in East Hampton on Egypt Lane, designed by Marcel Breuer and Titian Papachristo, while keeping the church as a storage facility. A 1977 catalogue recorded that "Rattner responds to 'the beautiful vibrations of color' he considers special" to the East Hampton area, and mentioned that he and his wife, Esther, frequently visited the nearby beaches, where Rattner observed and sketched spontaneous works such as *Montauk Point IV.* Rattner said, "I'm always awed by the power and vastness of nature — the force of the waves, the ocean's changing moods."[3]

1. See Allen Leepa, *Abraham Rattner* (New York: Harry N. Abrams, 1979).
2. Ronald G. Pisano, *The Long Island Landscape, 1914–1946: The Transitional Years* (Exh. cat.; Southampton, N.Y.: The Parrish Art Museum, 1982).
3. Quoted in Enez Whipple, *Abraham Rattner: Selected Works, 1953–77* (Exh. cat.; East Hampton, N.Y.: Guild Hall Museum, 1977).

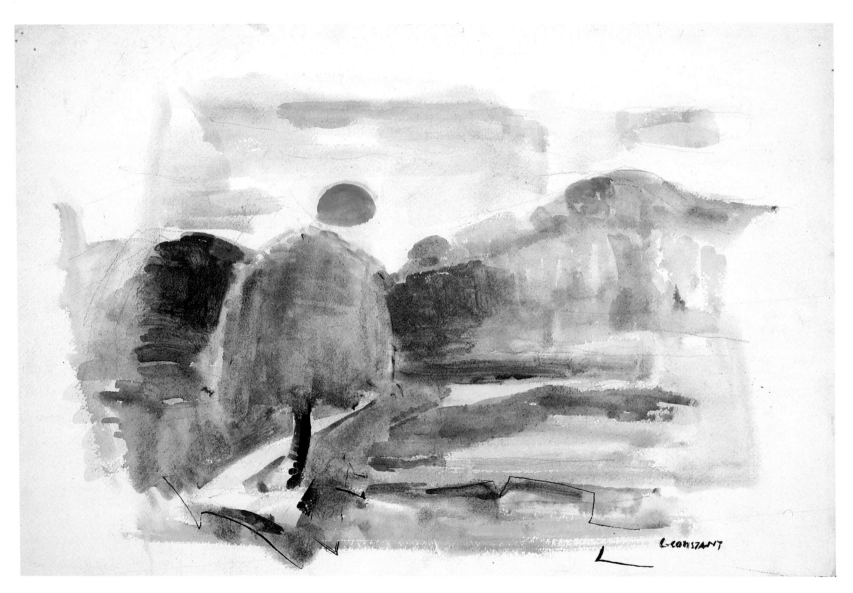

George Constant, LANDSCAPE, 1956
watercolor on paper, 14¾ × 22½, Collection of Mr. and Mrs. David Preston.

Abraham Rattner, MONTAUK POINT IV, 1945
watercolor on paper, 12¼ × 17¾, Kennedy Galleries, Incorporated, New York City.

LARRY RIVERS
b. Bronx, New York, 1923

Larry Rivers learned to play the piano and saxophone as a boy, and after high school worked as a professional musician. In 1945, while on tour with a band, he met the young artist Jane Freilicher. Back in New York the painter Nell Blaine gave Freilicher and Rivers informal instruction, after which Rivers enrolled at Hans Hofmann's school and began to paint in an abstract style in emulation of Blaine and Hofmann. After seeing the major Bonnard exhibition in New York in 1948, he turned to a representational style using bright color and thick pigment. That year Rivers began studying with William Baziotes in NYU's Art Education Program, from which he obtained a degree in 1951.

Rivers visited Jackson Pollock in East Hampton with Helen Frankenthaler in 1951, a trip he described as a "turning point," both because he then felt committed to painting and because it was when he first thought of leaving New York and moving to the country. In 1952 he rented a cottage in Water Mill along with Freilicher, Blaine, John Ashbery, and Kenneth Koch, and in 1953 moved to a house in Southampton. He taught at the Great Neck Adult Education art program and conducted a private class. Contrary to the prevailing mode among the avant-garde, Rivers began incorporating figures into his compositions, which he painted with a combination of fine draftsmanship and allowance of process, using thin washes of color and often leaving bare areas of canvas. In the mid-1950s major museums began acquiring his work, and in 1956 Rivers was able to buy a house on Little Plains Road in Southampton. *July* shows the yard of this house, with his mother-in-law, "Berdie," whom he continued to live with after his separation from her daughter in 1946.[1]

1. See Helen A. Harrison, *Larry Rivers* (New York: Harper & Row, 1984).

HERMAN ROSE
b. Brooklyn, New York, 1909

Herman Rose developed an early interest in nature when his family moved to New Rochelle, New York. After studying at the National Academy of Design, he spent a few weeks painting along the Housatonic River in Connecticut, living in a cabin in the woods, but found this too lonely and returned to New York, where he has lived and painted ever since, also teaching at many institutions in the area.

Rose first settled in the Canarsie–East New York section of Brooklyn. Even after moving to Manhattan in the early 1950s he returned to paint in Brooklyn because people left him alone there.[1] Although he has painted in other locations, he is most often associated with New York scenes, which pay special attention to the light of the city.

Returning from a trip to Europe in 1962, Rose and his wife spent a few days at the Hotel St. George, one of Brooklyn's tallest buildings, which attracted people from all over the world because of its spectacular view.[2] "We chose a room facing the harbor on the twentieth floor, and were charmed and excited by the lovely views on all sides," Rose writes. "After we settled ourselves in Manhattan in the spring of 1963, I returned to the St. George and painted a series of pictures from the same room. The first canvas was the vista of gleaming rooftops, waterfront and the great harbor stretching all the way to the spidery wisp of the Verrazano Bridge shining in the afternoon sun. This became *Looking Towards Verrazano Bridge*."[3]

1. Fairfield Porter, "Herman Rose Paints a Picture," *Art News* 54, no. 3 (May 1955), 38–41, 61–63; see also "In Full Stride," *Newsweek* 59, no. 8 (February 19, 1962), 94–95.
2. Elliot Willensky, *When Brooklyn Was the World, 1920–1957* (New York: Harmony Books, 1986), 201–203.
3. Letter from the artist, March 16, 1989.

PAUL RESIKA
b. New York City, 1928

Paul Resika began his art studies at the age of twelve with the painter Sol Wilson, a family friend, with whom he worked from 1940 to 1944. He was then introduced to Hans Hofmann through another family friend, and studied at his school from 1945 to 1947. He had his first one-man show at the age of nineteen at the George Dix Gallery in New York. Resika then traveled to Paris and Rome, settling finally in Venice from 1950 to 1953, where he met the American painter Edward Melcarth, who at that time was painting in a neo-Baroque style. Resika grew to admire the work of Tiepolo and Veronese, and during his sojourn in Europe his work changed from an abstract style with figurative references to a more representational one featuring portraits and figure groups. When he returned to New York he began studying nineteenth-century painters and eventually established a reputation for his landscapes, which he began exhibiting in 1964.

Resika began visiting his friend Paul Georges on the East End in the mid-1950s, and recalls that he and Georges used to paint outdoors (on at least one occasion accompanied by Fairfield Porter), a rare practice at the time. He explains the circumstances surrounding his *View of Amagansett*: "In 1959 I rented a house in Bridgehampton where I painted outdoors all summer. September, when the lease was up, Friedel Dzubas invited me to his place in Amagansett. I painted the 'view' from a hill overlooking the town. I remember the dryness and haze of the days. It was painted in the manner of Corot's Italian pictures which I loved."[2]

1. Lawrence Campbell and John Yau, *Paul Resika: A Twenty-Five-Year Survey* (New York: Artists' Choice Museum, 1985).
2. Letter from the artist, February 18, 1989, and conversation with the artist, April 4, 1989.

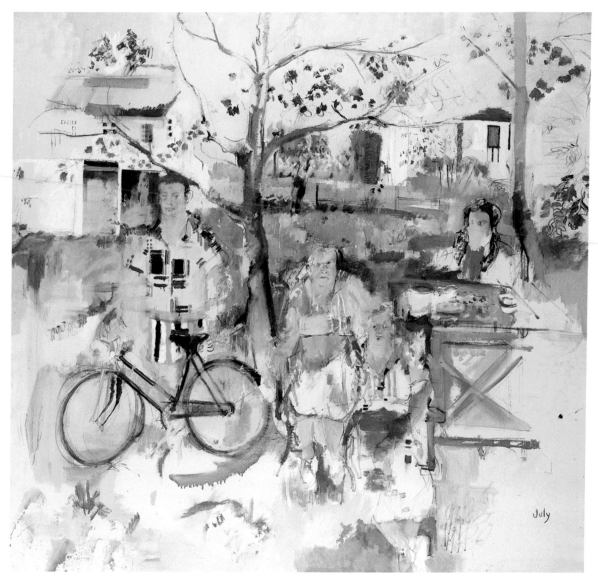

Larry Rivers, JULY, 1956
oil on canvas, 83¼ × 90¼, The Brooklyn Museum, Brooklyn, Anonymous gift (56.160).

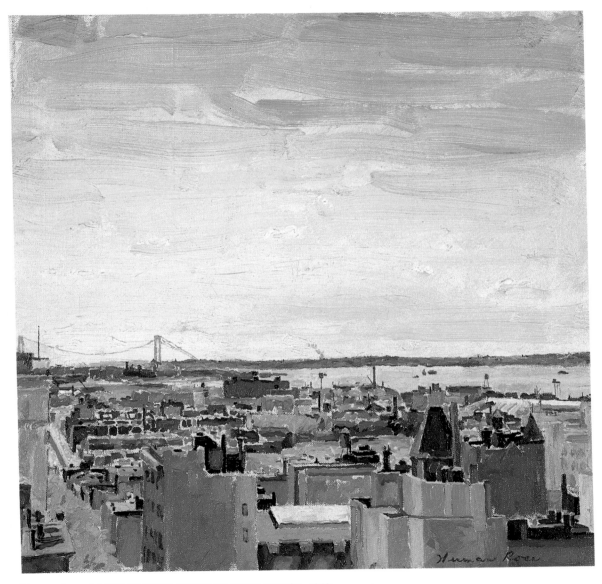

Herman Rose, LOOKING TOWARDS VERRAZANO BRIDGE, 1963
oil on canvas, 13 × 14, Hirshhorn Museum and Sculpture Garden, Smithsonian Institution, Washington, D.C.,
the Joseph H. Hirshhorn Bequest, 1981.

Paul Resika, VIEW OF AMAGANSETT, 1959
oil and tempera on canvas, 11 × 19, Collection of the Artist, courtesy of Graham Modern Gallery, New York City.

JOHN BUTTON
San Francisco, California 1929–1982
New York City

John Button attended the University of California at Berkeley from 1947 to 1950, as well as the California School of Fine Arts in San Francisco from 1949 to 1950. He then studied with Howard Warshwa and Altina Barret in 1951 and 1952 and, after his move to New York City in 1953, worked at Hans Hofmann's school. In 1964 he studied fresco technique with Willard Cummings. Button taught in a variety of places, including the Skowhegan School of Painting and Sculpture and the School of Visual Arts in New York. Although he first painted in an abstract-expressionist style, after his move to New York Button began working representationally and made this city as well as others his subjects, depicting rooftops, streets, and buildings in paintings, pastels, and gouaches that, because of their subject and quality of light, are often compared to the works of Edward Hopper.[1]

Button was an ardent conservationist and traveled widely, including a visit to the Florida Everglades. He began visiting Long Island when he moved to New York, and became part of the circle of poets and painters that moved between New York and the East End, among them Fairfield Porter, Larry Rivers, John Ashbery, and Frank O'Hara. He liked to talk about art, especially with Fairfield Porter, who was an important influence on Button's work at the time he painted *Beach House, Southampton*. Later, when Button suffered a series of health problems, including cancer, he went to stay with friends in Bridgehampton, continuing to paint the local landscape. Toward the end of Button's life, a group of Franciscan brothers in the Little Portion Friary near Mount Sinai provided a great deal of comfort to him. Despite his poor health, he painted a few landscapes there.[2]

1. Allen Ellenzweig, "John Button and Romantic Reality," *Arts Magazine* 50, no. 3 (November 1975); Gerrit Henry, "John Button at Fischbach," *Art in America*, December 1986, 136–137.
2. Conversation with Alvin Novak, March 18, 1989.

Eugene Armbruster, View of beach looking east
from the St. Andrew's Dune Church, Southampton, March 1926
Courtesy of the New York Public Library Special Collections.

John Button, BEACH HOUSE, SOUTHAMPTON, 1955
oil on canvas, 28 × 35, Collection of Mr. and Mrs. Howard S. Zagor, courtesy of Fischbach Gallery, New York City.

JOAN MITCHELL
b. Chicago, Illinois, 1926

With the encouragement of her mother, a poet, and father, an amateur artist, Joan Mitchell decided to be a painter when she was in the eighth grade. She attended Smith College from 1942 to 1944 and pursued further art studies at the Art Institute of Chicago from 1944 to 1947, where she won the Edward L. Ryerson Traveling Fellowship prize. She used this to live in France in 1948 and 1949, where she painted semiabstract views of her studio, figures, and bridges before turning to abstraction. Upon her return to this country she settled in New York and became friendly with Franz Kline and Willem de Kooning. In 1951 she was one of the few women included in the important Ninth Street exhibition.

In the summer of 1953 Mitchell rented Rose Cottage in East Hampton with Paul Brach and his wife, Miriam Shapiro. She painted two versions of the cottage, setting up her easel under the eaves, where she was protected from the rain.[1] From 1955 to 1959 Mitchell spent part of each year in Paris, moving there permanently in 1959, though she visited East Hampton again in 1960. In 1967 she bought a house in Vetheuil, north of Paris, and moved there full-time in 1968. This house gave her privacy and more contact with nature, an important element in her work.

In 1958 she explained her approach: "I am very much influenced by nature as you define it. However, I do not necessarily distinguish it from 'man-made' nature — a city is as strange as a tree. . . . I paint from remembered landscapes that I carry with me — I remember feelings of them, which of course become transformed. I could certainly never mirror nature. I would like more to paint what it leaves me with."[2]

1. Judith E. Bernstock, *Joan Mitchell* (Exh. cat.; Ithaca, N.Y.: Herbert F. Johnson Museum of Art, Cornell University, 1988), 29.
2. Ibid., 31.

GRACE HARTIGAN
b. Newark, New Jersey, 1922

Grace Hartigan had never drawn before her husband urged her to take classes in art while she was pregnant. She then studied with Newark's avant-garde teacher, Isaac Lane Muse, for four years. They fell in love, and Hartigan moved with him to New York. Upon seeing a Jackson Pollock painting in 1948, she and another artist hitchhiked to Springs to visit Pollock and Lee Krasner, and she continued to see them over the next few years. She was deeply influenced by both Pollock and Willem de Kooning during this period, and began to exhibit and sell her work regularly after 1950. In 1952 she started to paint after reproductions of Old Master paintings, and then to incorporate elements from the real world in her work. She painted in this manner until 1958–1959; then her work became totally abstract until the mid-1960s. Her more recent paintings employ recognizable imagery, brilliant color, and free-swinging brushwork.

Besides Pollock and de Kooning, Hartigan was also friendly with Larry Rivers and the poet Frank O'Hara, as well as with many others in the group of artists and writers that came out to the South Fork. *Montauk Highway* was painted in 1957, when Hartigan rented the guest cottage and barn at Alphonso Ossorio's estate, The Creeks, in Wainscott. It is, she writes, "about my feelings driving from Manhattan out to the Island, the gray of the highway, the glimpse of billboards and then the greens of the potato fields."[1] She bought a house in Bridgehampton in 1959, and remembered, "It was all so wonderful, the expanses of the potato fields, the skies, the sea. All so gorgeous, that I was worried. I was happy there."[2]

1. Letter from the artist, March 8, 1989.
2. Quoted in Cindy Nemser, *Art Talk: Twelve Conversations with Twelve Women Artists* (New York: Charles Scribner's Sons, 1975), 162.

JIM DINE
b. Cincinnati, Ohio, 1935

Jim Dine attended the Cincinnati Art Academy at night when he was in high school, and classes at the Boston Museum School in 1953. He graduated from Ohio University in Athens in 1957 and did graduate work there before moving to New York, where he got involved with performance art for about two years before going back to painting. He made his reputation on works that combined three-dimensional objects (often tools) with paintings. Dine acquired a love of everyday objects from his grandfather, who was a handyman and had a wide variety of tools, and from working in his father's hardware store. Throughout his career Dine has made series of painterly works with a repeated image or motif, such as a heart, an artist's palette, trees, or a bathrobe.[1]

Dine spent time in East Hampton from 1962 to 1968, at first in a rented house and then later in a home he purchased. He and his family came to the area because they wanted to be near the ocean.[2] Dine recently described their first summer in East Hampton and the circumstances that allowed him to paint works such as *Long Island Landscape*, which incorporates a tin pipe in one section of the huge canvas: "It was the first time our family had ever taken a holiday. We had two little kids then, and we rented the house of a painter. I had had a show the winter before at the Martha Jackson Gallery of ties and other objects, and we had a little money for a change. . . . it was the first time I could afford to buy the tools I wanted, to use as paint or next to paint."[3]

1. John Gordon, *Jim Dine* (Exh. cat.; New York: Whitney Museum of American Art, 1970).
2. Conversation with Nancy Dine, March 7, 1989.
3. Graham W. J. Beal, Martin Friedman, and Robert Creeley, *Jim Dine: Five Themes* (Minneapolis: Walker Art Center and Abbeville Press, 1984), 16.

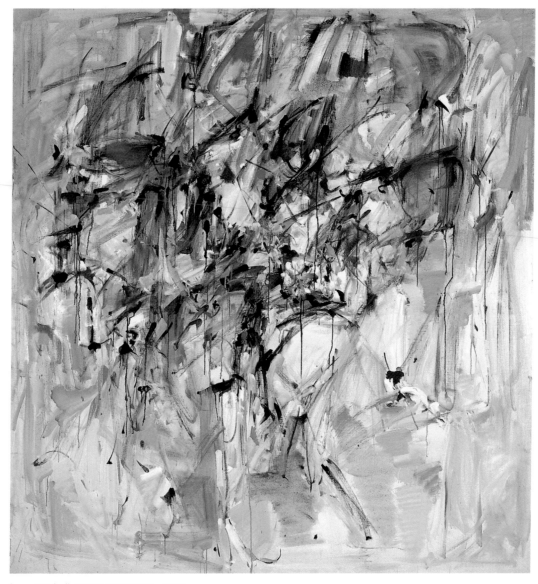

Joan Mitchell, ROSE COTTAGE, 1953
oil on canvas, 71¾ × 68¼; International Business Machines Corporation.

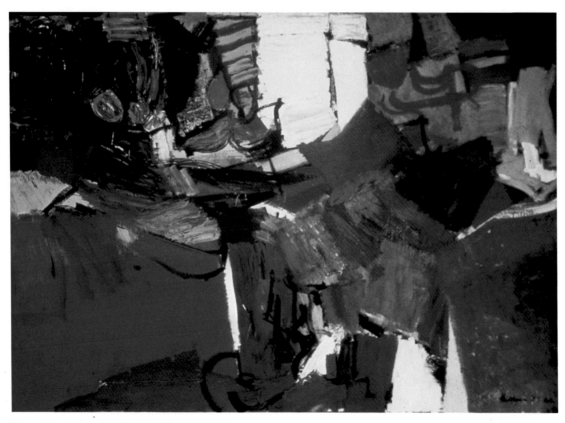

Grace Hartigan, MONTAUK HIGHWAY, 1957
oil on canvas, 91 × 128, Collection of Dr. and Mrs. J. F. Christensen.

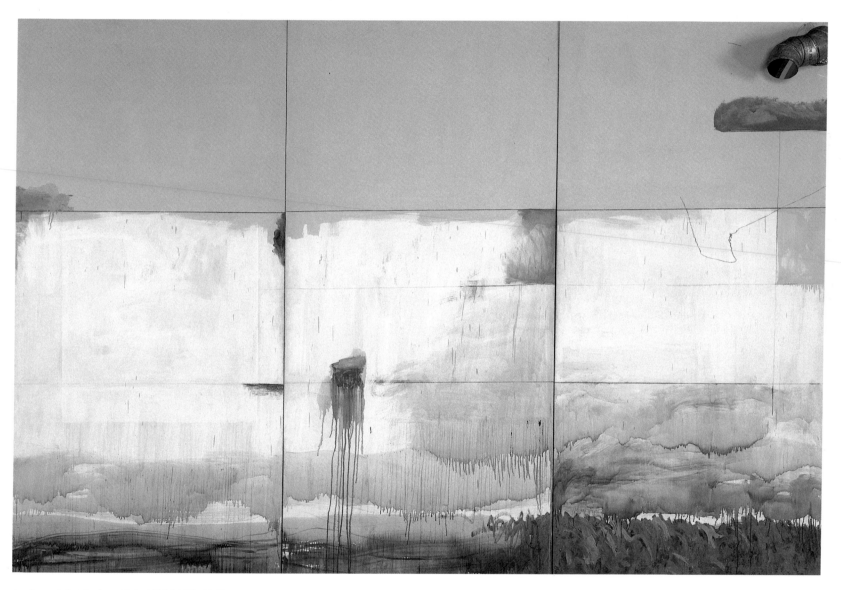

Jim Dine, LONG ISLAND LANDSCAPE, 1963
oil and collage of tin and wood, 96 × 162½, Collection of the Whitney Museum of American Art, New York City,
gift of Patsy and Myron Orlofsky in memory of Esther and Sam Orlofsky (71.238).

JACKSON POLLOCK
Cody, Wyoming 1912–1956 Southampton, New York

Jackson Pollock grew up poor, and his life as a painter did little to change his circumstances. As a teenager, after his family moved to Los Angeles, Pollock attended the Manual Arts High School in 1928–1929, where he had the opportunity to draw from life and to try sculpting on his own. In 1930 he followed his older brother Charles to the Art Students League in New York, where Thomas Hart Benton took him under his wing. Over the next four years the two became close friends, and they stayed in contact after Benton left the League in 1933. At that time Pollock started sculpting again, studying briefly with Robert Laurent before leaving the League for good. From 1935 to 1938 he participated in the easel division of the WPA, which gave him a small but much-needed income. In 1940 he met the important collector and painter John Graham, who was one of the first to recognize Pollock's originality and potential. The following year Graham invited Pollock to show in an exhibition he put together, where the artist met Lee Krasner. She introduced him to her wide circle, including the critic Clement Greenburg, who would become Pollock's champion in the years to come. Krasner moved in with Pollock in 1942.

In 1943 Pollock got a job at the Museum of Non-Objective Art (later the Solomon R. Guggenheim Museum), and soon after was asked to exhibit at Peggy Guggenheim's gallery, Art of This Century. Pollock's work first won critical acclaim in her May 1943 Spring Salon, a turning point for him that resulted in a one-year contract with a fixed income of $150 a month from Guggenheim.

In August of 1945 Pollock and Krasner visited their friends Reuben and Barbara Kadish in Amagansett. Krasner suggested that they move out to the country, thinking it might help Pollock's moodiness and drinking, which had been excessive since his student days. Pollock first scoffed at the idea but then agreed. They purchased an 1893 farmhouse on Fireplace Road in Springs, with no heating or plumbing but with a view of Accabonac Harbor, for $5,000.00. They obtained a mortgage for part of that sum and borrowed the rest from Guggenheim, who raised Pollock's stipend to $300 a month, with $50 subtracted to repay the loan and with *all* the paintings he produced in a year, save one, turned over to her. Pollock and Krasner were married, at his insistence, because he felt it would enable them to be better accepted in a small town. He turned the barn into his studio, moving it to the north side of the property so that their view of the water would be unobstructed. It was about eighteen by twenty-four feet, with no heat or electricity. Pollock said later, "Moving out here I found difficult — change of light and space — and so damned much to be done around the place."[1]

In 1946 he painted *Shimmering Substance*, which, with its overall "veil" of paint, is considered a transition to his poured paintings of the following year. In 1947 he began showing with the Betty Parsons Gallery and at his second show, in 1949, sold nine paintings, including one (his second) to the Museum of Modern Art. The year 1950 was a productive one for Pollock, but during the fall a two-year period of abstinence came to an end, and his alcoholism slowly took over again. In 1952 he joined the Sidney Janis Gallery, but the summer of 1953 was his last sustained period of painting, and he accomplished little from then until his death in a car accident in 1956.

In Springs Pollock loved to putter around the house, visit with neighbors, and garden. Lee Krasner had thought that moving to the country might help soothe Pollock's combative personality and ease his dark moods, and at times it did: "I remember sitting with Jackson on our country porch — sitting there for hours, looking into the landscape, and always at dusk, when the woods ahead turned into strange, mystifying shapes. And we would walk in those woods, and he would stop to examine this or that stone, branch or leaf. . . . His moodiness and depression would vanish, and he would be calm — and there would often be laughter."[2]

1. Quoted in Deborah Solomon, *Jackson Pollock: A Biography* (New York: Simon and Schuster, 1987), 164.
2. Ibid., 254.

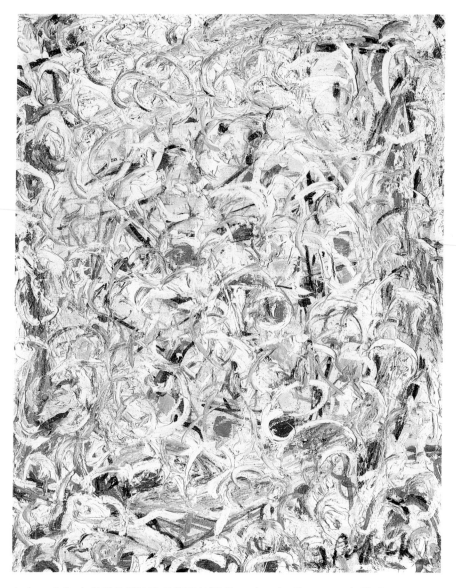

Jackson Pollock, SHIMMERING SUBSTANCE (Sounds in the Grass series), 1946
oil on canvas, 30⅛ × 24¼, Collection of the Museum of Modern Art, New York City,
Mr. and Mrs. Albert Lewin and Mrs. Sam A. Lewisohn funds.

LEE KRASNER
Brooklyn, New York 1908–1984 New York City

Lee Krasner knew early on that she wanted to be an artist and began studying art in high school. From 1926 to 1929 she studied at Cooper Union, and for the following three years at the National Academy of Design. Krasner knew many people in the New York art world; some she met while waitressing at a downtown café, others after she became involved with the Federal Art Project from 1934 to 1943, during which time she served as an assistant to the muralist Max Spivak and became active in the Artists' Union. From 1937 to 1940 she studied with Hans Hofmann, and in 1940 she began exhibiting with the American Abstract Artists. One of her friends was John Graham, who in 1941 invited her to participate in an exhibition, through which she met Jackson Pollock. Krasner introduced Pollock to her wide circle of friends, and the two began living together in his studio.

Krasner and Pollock were married and moved to Springs in 1945. She began to paint in an upstairs bedroom that had been used by Pollock until he converted their barn into his studio in 1946. Throughout her career Krasner went through unproductive periods and experienced strong dissatisfaction with her earlier work, which often resulted in its destruction. The late 1940s were a productive time, however: between 1946 and 1950 she created the "Little Image" series. Krasner again felt frustrated by her work in the early 1950s, which resulted in her ripping up earlier drawings and paintings; she then turned these fragments into an important group of collages. After Pollock's death in 1956 some recognizable imagery, primarily something that could be seen as "eyes," came into her work. Her work continued to be marked by cycles, sometimes exhibiting little color and other times vibrant color, but, as in *Eyes in the Weeds*, it was always infused with an energy inspired by nature.[1]

Krasner related an anecdote about the titling of this work and others she had done with her left hand after breaking her right wrist, noting that she often had difficulty titling paintings herself. "Little Frances, the six-year-old daughter of the woman that cleaned for me, titled them. She didn't know what the word 'studio' meant nor had she ever seen a tube of paint. She looked at one of the paintings and said, 'That is a limb and it is flowering.' ... Turning to another canvas with a kind of disdainful gesture of her hand, she said, 'That's nothing but a bunch of eyes in the weeds.' So I titled it *Eyes in the Weeds*. After all, I painted these pictures, but her reading of them gave me an insight that both fascinated and alarmed me."[2]

1. See Barbara Rose, *Krasner/Pollock: A Working Relationship* (Exh. cat.; East Hampton, N.Y.: Guild Hall Museum, 1981).
2. Cindy Nemser, *Art Talk: Twelve Conversations with Twelve Women Artists* (New York: Charles Scribner's Sons, 1975), 103–104.

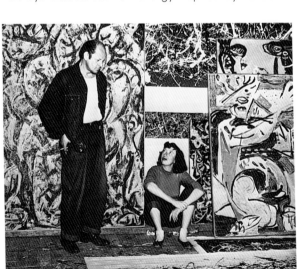

Jackson Pollock and Lee Krasner in the barn studio, ca. 1950
Photograph by Lawrence Larkin,
courtesy of the Guild Hall Museum.

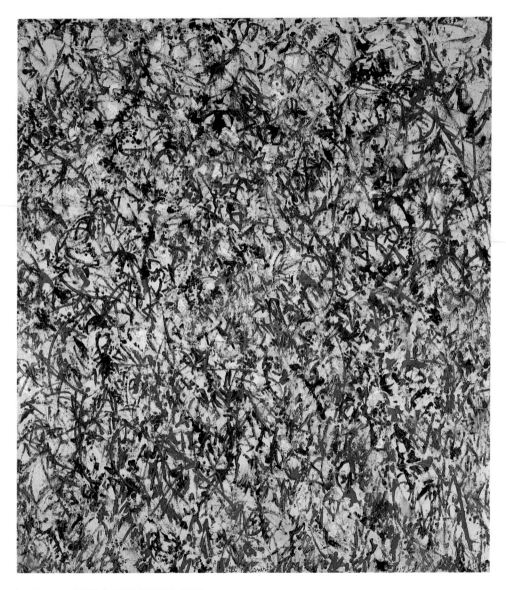

Lee Krasner, EYES IN THE WEEDS, 1963
oil on canvas, 64 × 58, Robert Miller Gallery, New York City.

WILLEM DE KOONING
b. Rotterdam, the Netherlands, 1904

As a teenager de Kooning began work as an apprentice in a firm of commercial artists and decorators while attending night classes at the Rotterdam Academy of Fine Arts and Techniques. He went to Belgium in 1924 to study at the Académie Royale des Beaux-Arts (from which he graduated in 1925) and at the Van Schelling Design School, while he earned a living as a sign painter and doing window displays and cartoons. He came to the U.S. in 1926 and worked as a housepainter in Hoboken, then pursued commercial art in New York City and painted murals for nightclubs and for two private residences. By the late 1920s he had met other artists, and in the early 1930s he began to earn a reputation for his color abstractions. In 1935 the WPA enabled him to paint full-time by granting him a mural commission for the Williams-

burg Federal Housing Project, but he was removed from the project when it was discovered that he was not a U.S. citizen. Later, through Burgoyne Diller, he designed a ninety-foot section of a three-part mural, entitled *Medicine*, for the 1939 World's Fair.

About this time de Kooning met Fairfield Porter, and Elaine Fried, whom he married in 1943. His work during this period involved several mediums: he designed sets for ballet, did fashion illustrations for *Harper's Bazaar*, and completed a set of four murals called *Legend and Fact* for the library of the S.S. *President Jackson*. In 1942, as the result of his first gallery exhibition, he met Jackson Pollock. De Kooning's first one-man show was held in 1948, and later that year he began giving talks and formed the Artists Club, which met Wednesday nights in a loft on East Eighth Street until the late 1950s. By the late 1950s and early 1960s de Kooning was beginning to exhibit interna-

tionally, and his work was winning prizes at major annuals. Sidney Janis and Martha Jackson were exhibiting and selling his work regularly. His reputation had been established by the Women series, a theme to which he has returned periodically throughout his career, and by the large landscape abstractions he began painting in the late 1950s. He experimented with printmaking as early as 1960, and later began making sculptures.[1] Now in his mideighties, he is still painting.

The de Koonings first went out to the East End to visit Jackson Pollock and Lee Krasner at their house in Springs in April 1948. After this, they went there regularly to visit other friends, such as Ileana and Leo Castelli, with whom they spent the summers of 1952 and 1953 on Jericho Lane in East Hampton. In 1954 the de Koonings, with Ludwig Sander, Franz Kline, and Nancy Ward, rented the "Red House" in Bridge-

Eugene Armbruster, View of Montauk Highway in Shinnecock Hills, just east of Canoe Place Inn, April 1927
Courtesy of the New York Public Library Special Collections.

Willem de Kooning, MONTAUK HIGHWAY, 1958
oil on canvas, 59 × 48, The Michael and Dorothy Blankfort Collection, on loan to the
Los Angeles County Museum of Art, Los Angeles.

hampton, where de Kooning painted in an upstairs room and in a small open shed next to the garage. Many paintings were destroyed in a hurricane that hit at the end of that summer. From the late summer of 1958 to January 1959, de Kooning, by now separated from Elaine, rented Conrad Marca-Relli's house on Fireplace Road in Springs. De Kooning always preferred Springs to East Hampton, saying, "I'm living on the other side of the resort," and "I like Springs because I like people who work."[2]

In 1959 he painted *Montauk Highway,* part of a series of highway paintings, of which he said, "It's a very free interpretation . . . but to sit in a car and move, it would be very much like that — going and passing things." In 1961 he bought his brother-in-law's house next to Harold Rosenberg's on Accabonac Road in Springs and immediately began designing a huge studio, which was built on land purchased from his friend Wilfred Zogbaum. In the meantime he used the garage as a studio, while at the same time completing large landscape-inspired works in his New York studio. In the summer of 1963 he began to live at Springs year-round, and by March of 1964 his studio was complete.

When asked by Harold Rosenberg if coming to Springs affected his work, de Kooning responded,

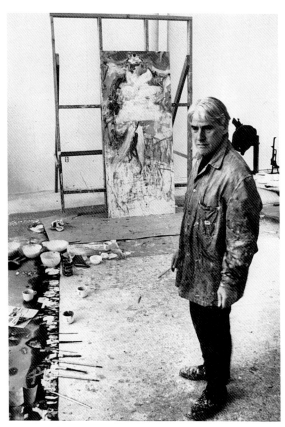

Willem de Kooning, 1967
Photograph by Dan Budnik,
Guild Hall Museum, gift of the Artist.

"Enormously! . . . I wanted to get in touch with nature. Not painting scenes from nature, but to get a feeling of that light that was very appealing to me. . . . I probably would have changed anyhow. When it did change, it had a lot to do with the country." De Kooning described the appeal that the colors of the sand, the gray-green vegetation of the beach, and the steely gray of the ocean had for him. In the late 1960s de Kooning did a series of Montauk paintings, incorporating the suggestions of figures and landscape, of which *Montauk I* is a part. He said, "There is something about being in touch with the sea that makes me feel good. That's where most of my paintings come from." And he added, "It would be very hard now to paint any other place but here."

1. Paul Cummings, Jorn Merkert, and Claire Stoullig, *Willem de Kooning: Drawings, Paintings, Sculpture* (New York: Whitney Museum of American Art in association with Prestel-Verlag, Munich, and W. W. Norton Co., 1983).
2. All quotes and information about de Kooning's visits to the East End are taken from Judith Wolfe, *Willem de Kooning: Works from 1951 to 1981* (Exh. cat.; East Hampton, New York: Guild Hall Museum, 1981), which uses many quotes from Harold Rosenberg, "Interview with Willem de Kooning," *Art News* 71, no. 5 (September 1972), 54–59.

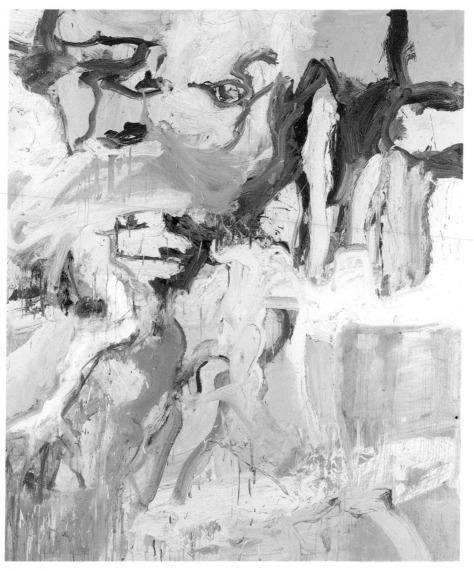

Willem de Kooning, MONTAUK I, 1969
oil on canvas, 88 × 77, Wadsworth Atheneum, Hartford,
the Ella Gallup Sumner and Mary Catlin Sumner Collection.

GEORGE PICKEN
New York City 1898–1971 Pittsfield, Massachusetts

As a soldier in World War I, George Picken made many drawings of war scenes. Upon his return to New York, he enrolled at the Art Students League, where he studied from 1919 to 1923, spending many months in the etching class, and it was for his prints that he first won recognition. In the 1920s he began exhibiting regularly in group shows in New York with the Louis Comfort Tiffany Foundation as well as the Whitney Studio Club. In 1931 he returned to the League to study lithography, and two years later he began teaching printmaking there, continuing until 1942. He also taught at Columbia University, Cooper Union, the Brooklyn Museum Art School, and the Kansas City Art Institute. During the 1930s and 1940s Picken earned a reputation for his city scenes, often of industrial subjects, and his landscapes of the countryside, many done in Maine, which he visited periodically. In 1935 he became affiliated with the Marie Harriman Gallery, and then exhibited at the Frank K. M. Rehn Gallery from 1942 to 1971. Picken was commissioned to paint several murals, in St. Ambrose Church, Brooklyn (1933), and post offices at Fort Edward, New York (1938), Hudson Falls, New York (1937), and Chardon, Ohio (1942).

Picken's dark palette gradually lightened as he began to paint landscapes of the countryside around Tyringham, Massachusetts, where he began summering in the 1940s. Picken also visited Fire Island regularly in the summers after his daughter, Claire, built a house in Ocean Bay Park in 1954. During the 1950s and early 1960s Picken experimented with abstraction, as can be seen in this interpretation of the surf at Fire Island, but later reintroduced natural forms into his work.[1]

Ocean Bay Park is one of fewer than twenty communities on the western half of the thirty-two-mile-long strip of sand that serves as a barrier beach between the ocean and Long Island's South Shore. Fire Island is unique in that cars are not permitted on the island, which is only half a mile across at its widest point. Robert Moses made many attempts to build a road there, all of which were resisted fiercely by residents.[2]

1. Material provided by the artist's family to Ronald G. Pisano.
2. Madeleine C. Johnson, *Fire Island, 1650s–1980s* (Mountainside, N.J.: Shoreland Press, 1983).

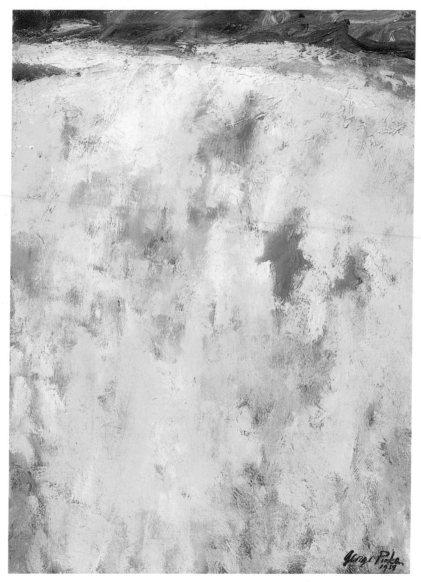

George Picken, BIG WAVE, 1959
oil on canvas, 40 × 30, Collection of Mr. and Mrs. David Picken.

BALCOMB GREENE
b. Niagara Falls, New York, 1904

Balcomb Greene studied a wide variety of subjects but never received any formal art training. He was brought up by his widower father, a Methodist minister, in small towns in Iowa and Colorado. From 1922 to 1926 he majored in philosophy at Syracuse University, where he met and married the sculptor and painter Gertrude Glass. They went to Vienna, where Greene attended lectures by Sigmund Freud, and in 1927 moved to New York, where he studied English literature at Columbia University. From 1928 to 1931 he taught freshman English at Dartmouth College, also writing fiction, none of which was ever published. In 1931 the Greenes went to Paris, where he painted without instruction at the Académie de la Grande Chaumière, developing a crisp, geometrical abstract style.

In 1933 the Greenes returned to New York, and a few years later Greene became the first chairman of the American Abstract Artists group. In 1934–1935 he became involved with two of the federal art programs begun during the Depression, for which he painted a mural at the Williamsburg Housing Project and designed a stained glass window for a school in the Bronx. In 1939 he painted an abstract mural for the Federal Hall of Medicine at the World's Fair. In about 1940 he began studying art history at NYU, where he received a master's degree in 1943. The human figure began to appear in his work, and by the late 1940s Greene had achieved a mature style. His figures, painted in a fragmented manner, gradually evolved into naturalistic proportions, with light and dark rather than color an important component, reflecting Greene's interest in photography.

In 1947 Greene bought land at Montauk, and he and Gertrude lived in an abandoned dugout used as an army lookout during World War II. Greene built a house himself, with cement-block walls, a flat roof, floors of weathered brick, and huge windows. In 1959–1960 he visited Paris, but otherwise he has spent most of his time at Montauk. By the late 1950s Greene was painting landscapes, almost totally missing in his oeuvre before that time. Many of his paintings, such as *Breakers in the Morning Sun,* are seascapes, reflecting his deep love of the water.[1]

1. See John I. H. Baur, *Balcomb Greene* (New York: The American Federation of Arts, 1961).

André Kertész, *Portrait of a Wave*
Guild Hall Museum, gift of the Artist.

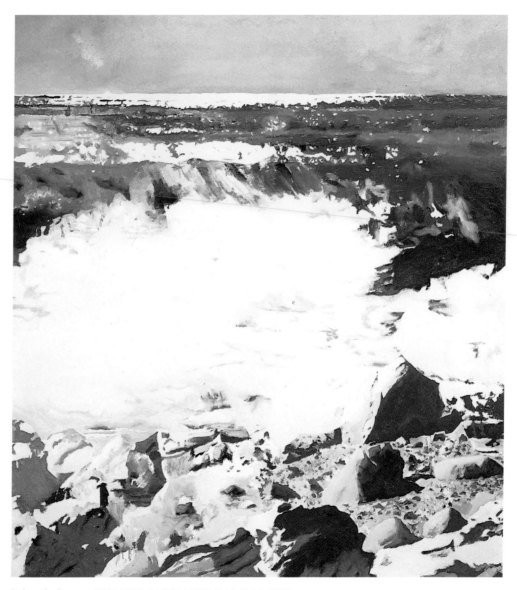

Balcomb Greene, BREAKERS IN THE MORNING SUN, 1975
oil on canvas, 62 × 56, ACA Galleries, New York City.

FAIRFIELD PORTER
Hubbard Woods, Illinois 1907–1975
Southampton, New York

Fairfield Porter, along with Jackson Pollock and Willem de Kooning, is largely responsible for attracting the numbers of artists that have visited and settled on the East End in the last few decades. Porter grew up in an intellectual family with means, and was exposed to a wide range of literature and art. The family traveled to Canada and Europe together, and from 1913 until the end of his life Porter spent almost every summer on Great Spruce Head Island in Maine, which his father purchased in 1912. He enrolled at Harvard in 1924, and in his junior year traveled to Europe on his own, visiting Moscow for several weeks, a stay that turned his sympathies toward socialism.

After his graduation in 1928, Porter attended the Art Students League in New York, where he studied for two years with Thomas Hart Benton and Boardman Robinson. He later complained that no one knew how to use *paint* during that period, and said that he had to acquire that knowledge on his own. In 1931–1932 Porter journeyed to Europe, his last trip there until 1967. Upon his return he married the poet Anne Channing, and they eventually had five children. In 1938 Porter saw an exhibition of Bonnard and Vuillard at the Art Institute of Chicago. He was struck by Vuillard's "natural" quality, and his work had an important influence on Porter's own, which he began to exhibit the following year. Having moved several times, in 1942 the Porters returned to New York, where they lived for seven years while he worked as a draftsman and took night classes at Parsons School of Design with Jacques Maroger. Porter adopted the mediums that Maroger had rediscovered, once employed by the Flemish and Venetian painters, and used them throughout his life, except for a brief period when he experimented with acrylics.

In 1949 the Porters moved once more, to Southampton. He later explained, "we moved here because I wanted to be in connection with New York, as a painter. It seemed a place that, if we couldn't afford to keep going to Maine, would be a place where in summer one could swim in the ocean."[1] Porter then began painting in earnest, using the local landscape and the interior of his home as well as family and friends as subjects. He later said that he deliberately stuck to representation just to be contrary to the prevailing abstraction championed by Clement Greenburg, but he did adopt aspects of the painterly technique of abstract expressionism. He knew Elaine and Willem de Kooning, and had purchased a painting by the latter in the early 1930s. In 1951 Porter got a job as associate editor at *Art News* through Elaine de Kooning, and he reviewed shows for the magazine until 1959. Many younger painters, along with the poets John Ashbery, James Schuyler, Kenneth Koch,

Fairfield Porter
Photographer unknown,
Guild Hall Museum Archives.

and Frank O'Hara, were frequent houseguests. "He and Anne became everyone's surrogate parents in their big house in Southampton," Robert Dash reminisced. "James Schuyler came for a weekend and stayed eleven years, and often poets would be at table simply because they needed three squares. It was a come-as-you-are household."[2]

Porter had his first one-man show at the Tibor de Nagy Gallery in 1951, after Jane Freilicher, Larry Rivers, and the de Koonings recommended his work to the director, John Myers. By the end of the 1950s Porter was contributing essays to other periodicals, and he began to lecture at various universities and art schools in the mid-1960s. His paintings were widely exhibited from about 1959 on, but it was not until after his death that his reputation as a painter surpassed his reputation as a critic.

A range of landscapes painted around Southampton is included here. The earliest work, *Calverton,* captures the rural quality of this area outside of Riverhead, while a similar subject painted much later, *The Beginning of the Fields,* shows the change in Porter's palette to lighter, pastel colors late in life. "I don't look for places to paint," the artist said. "A place means a lot to me not because I decided that it did. It just does; I can't help it. The most important thing is the quality of love. Love means paying very close attention to something and you can only pay close attention to something because you can't help doing so."[3]

1. Quoted in Rackstraw Downes, ed., *Fairfield Porter: Art in Its Own Terms: Selected Criticism 1935–1978* (New York: Taplinger Publishing Company, 1979). See also John Ashbery and Kenworth Moffett, *Fairfield Porter (1907–1975): Realist Painter in an Age of Abstraction* (Exh. cat.; Boston: Museum of Fine Arts, 1982).
2. Whitney Balliett, "The Art World: An Akimbo Quality," *The New Yorker,* March 14, 1983, 146.
3. Alan Gussow, *A Sense of Place: The Artist and the American Land* (San Francisco: Friends of the Earth, ca. 1973), 145.

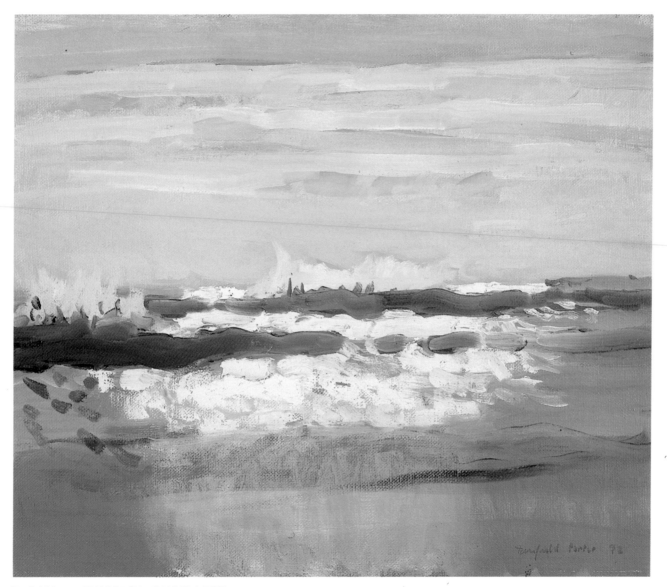

Fairfield Porter, THE BEACH AT NOON, 1972
oil on canvas, 20 × 24, The Parrish Art Museum, Southampton, New York, gift of the estate of Fairfield Porter.

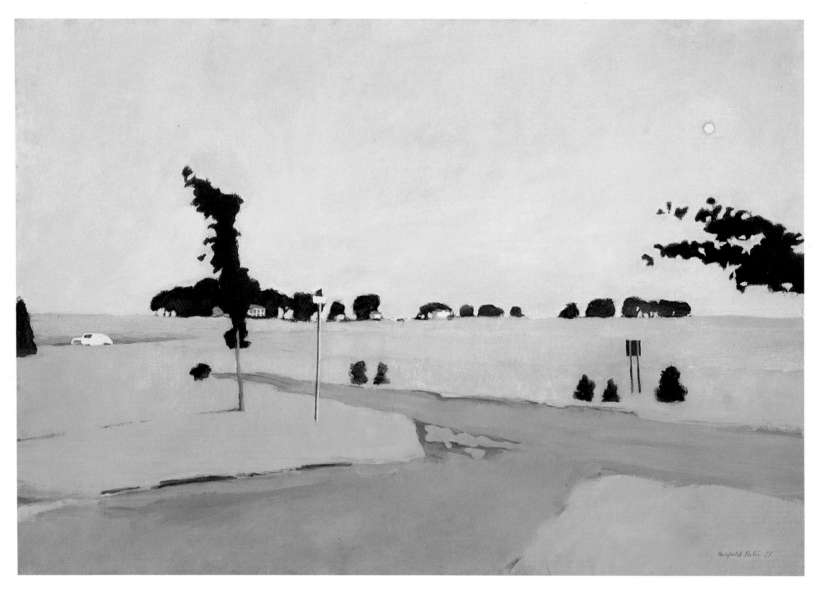

Fairfield Porter, THE BEGINNING OF THE FIELDS, 1973
oil on canvas, 52 × 76⅛, Memorial Art Gallery of the University of Rochester, Rochester, New York, Marion Stratton Gould Fund.

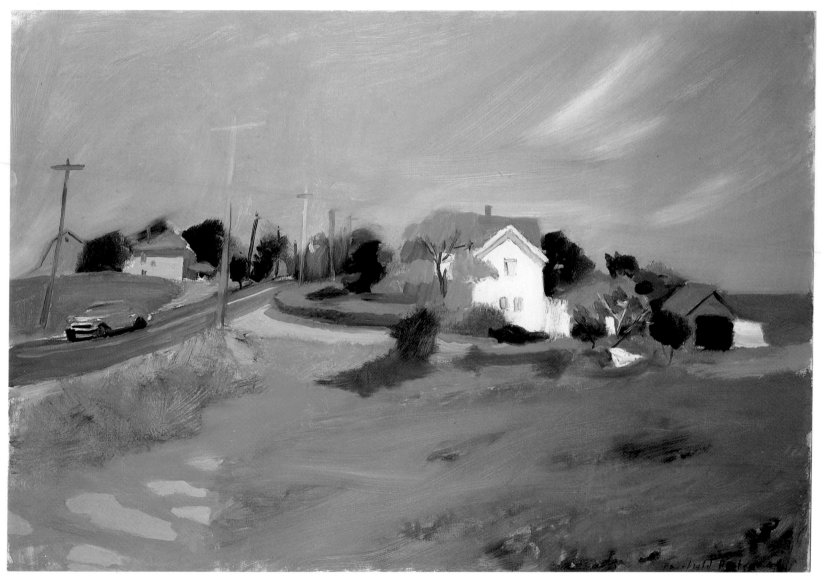

Fairfield Porter, CALVERTON, 1954
oil on canvas, 29⅝ × 44, The Parrish Art Museum, Southampton, New York, gift of the estate of Fairfield Porter.

JANE FREILICHER
b. Brooklyn, New York, 1924

After her graduation from Brooklyn College in 1947, Jane Freilicher spent about a year at Hans Hofmann's school in New York and his summer school in Provincetown, at the urging of her friend Nell Blaine. She earned a master's degree from Columbia University in 1948 and began to paint still lifes and interiors in her New York studio. During this time she saw major exhibitions of the work of Bonnard, Vuillard, Courbet, and Matisse, which made a lasting impression on her. Freilicher's works have been used on book covers and as illustrations for volumes by her friends John Ashbery, Kenneth Koch, and James Schuyler, among others, and she has designed sets for theatrical productions. In 1952 Fairfield Porter reviewed the first of her many one-woman shows at Tibor de Nagy Gallery, and they became friends.[1]

Freilicher and her husband, Joe Hazan, decided to get a place in Water Mill in the late 1950s as a result of their visits with the Porters in Southampton. Freilicher has continued to paint still lifes and views from her studio in New York, but some of her best-known paintings are of the landscape around her Water Mill home, sometimes seen through the large windows of her studio, juxtaposed with still lifes that include flowers from her garden. She says, "When I'm out on Long Island, I'd have to wear a blindfold to avoid the landscape. It's the very air one breathes." She has commented that her open landscapes, such as *View toward Southampton*, "may remain as documents of a vanished era," because of the rapid rate of development on the East End, which is now encroaching upon her view.[2]

1. It was Freilicher, along with Larry Rivers and Willem and Elaine de Kooning, who recommended Porter's paintings to John Myers, director of Tibor de Nagy. John Ashbery, Linda L. Cathcart, John Yau, and Robert Doty, ed., *Jane Freilicher Paintings* (Exh. cat.; Manchester, N.H.: Currier Gallery of Art, 1986), 49.
2. Ibid., 51, 53.

Eugene Armbruster, View of Kellis' Pond on the south side of Montauk Highway, east of Hand's Lane, Bridgehampton, 1924
Courtesy of the New York Public Library Special Collections.

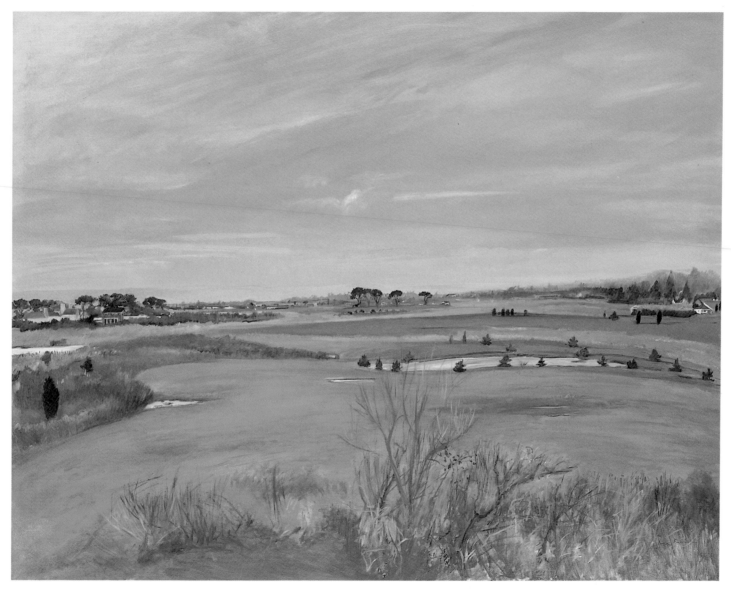

Jane Freilicher, VIEW TOWARD SOUTHAMPTON, 1987
oil on canvas, 60 × 79, Collection of Mr. and Mrs. Theodore C. Rogers, courtesy of Fischbach Gallery, New York City.

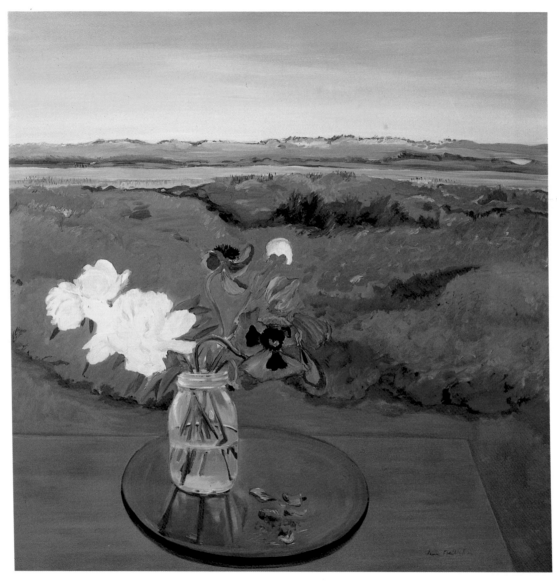

Jane Freilicher, POPPIES AND PEONIES, 1981
oil on canvas, 36 × 36, Collection of Mr. and Mrs. David H. Rush, courtesy of Fischbach Gallery, New York City.

JANE WILSON
b. Seymour, Iowa, 1924

Jane Wilson became attuned to wide-open spaces, the specific quality of light, and changes in weather during her childhood in the Midwest. She earned her M.F.A. from the University of Iowa in 1947 and taught there for two years before moving to New York with her husband. She painted abstractly during the late 1940s and early 1950s, but these works evolved into "memory-scapes" of the light and sky of Iowa. She worked as a model for seven years to earn money, painting at night and on weekends. In 1953 she was invited to be a founding member of the Hansa Gallery, an artists' cooperative named after Hans Hofmann. This gave her an opportunity to exhibit her paintings, and as a result the Museum of Modern Art and the Whitney Museum acquired her work and she joined the Tibor de Nagy Gallery. In the 1960s she embarked on a series of cityscapes inspired by the view from her Tompkins Square apartment; in the 1970s she painted still lifes, at first lush and full of objects and then more austere. In the early 1980s Wilson turned to landscapes, making serene paintings in a horizontal format, exploring lights and darks, and most recently treating weather as a subject.[1]

Wilson first visited the South Fork of Long Island in the early 1950s, spending a week at Barnes Hole in Springs. Despite the fact that other artists were going there, Wilson was not attracted to that area. A few years later she went to Water Mill and found the light there as "exceptional" as she had heard it was in Springs. In 1959 she and her husband bought a barn, and they have spent time there regularly ever since. Although Wilson's landscapes are imaginary, they are clearly inspired by the flat land and constantly changing sky of the South Fork. She says that the light of the area "has long since been internalized," and describes one aspect of it: "*Three O'Clock Sun* is about the steady warmth of Water Mill light that occurs midafternoon in summer. It is a time of stillness when people begin to feel and act like dogs dozing in the sun. It is an hour of deep trustful rest. It is a time of regeneration."[2]

1. Paul Gardner, "Jane Wilson's Weather Eye," *Art News*, December 1985, 56–60.
2. Letter from the artist, January 22, 1989.

JOHN MACWHINNIE
b. Rockville Center, New York, 1945

John MacWhinnie grew up in Nassau County before moving with his family in 1963 to Southampton, where his mother opened an antique shop. Between 1964 and 1972 he studied philosophy at Southampton College and attended the New School for Social Research and Hunter College in New York. In 1965 he lived in New York's Greenwich Village, where he began painting. In 1966 he studied with Larry Rivers, and then from 1966 to 1968 with Ilya Bolotowsky. Fairfield Porter, whom he first met in 1964, became a friend of MacWhinnie's from 1967 until his death in 1975. During this period MacWhinnie was also friendly with Willem de Kooning, and made portraits of both of these artists in their studios. This studio series also included a painting of Roy Lichtenstein and a self-portrait. Around 1969–1970 MacWhinnie began winning awards and gaining attention for his work, which led to a one-man show at the Borgenicht Gallery in 1974. The Guggenheim purchased his monumental work *The Studio* in 1975.[1]

MacWhinnie's early work was done in a loose painterly style, as can be seen in his *Southampton Landscape*. When asked about living in Southampton, MacWhinnie responded, "I've been very influenced by the light here, and I don't have to think about it."[2] More recently, although he still incorporates freely painted passages in his work, particularly in landscape, his figures are generally painted in a smooth, simplified, two-dimensional manner.

1. Carter Ratcliffe, *John MacWhinnie* (Exh. cat.; New York: Marlborough Gallery, 1979).
2. David Shapiro and Lindsay Stamm, "Beyond Photography: An Interview with John MacWhinnie," *Art International*, December 1976, 20.

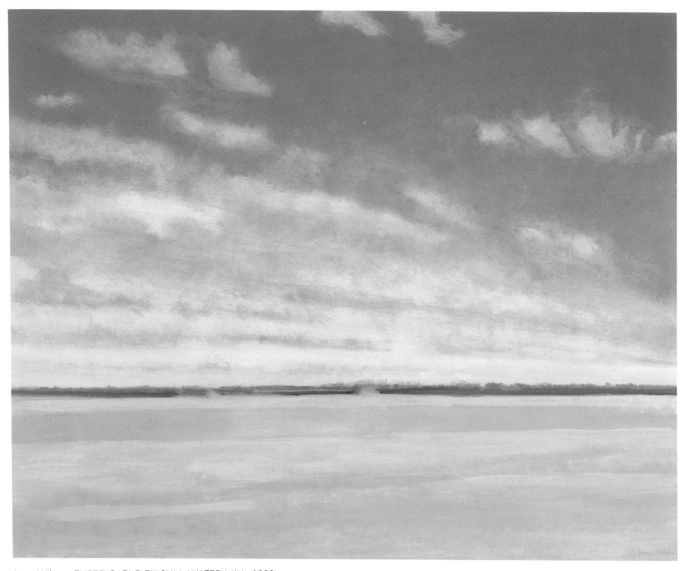

Jane Wilson, THREE O'CLOCK SUN, WATER MILL, 1988
oil on linen, 60 × 76, Courtesy of Fischbach Gallery, New York City.

John MacWhinnie, SOUTHAMPTON LANDSCAPE, 1974
oil on board, 30½ × 23½, Guild Hall Museum, East Hampton,
New York, gift of Grace and Warren Brandt.

ROBERT DASH
b. New York City, 1934

A longtime resident of Sagaponack, Robert Dash writes that "painting here seems to me to be as logical and as plain as a row of potatoes." Dash had no formal art training, but has spent much time looking at other artists' work in museums and in books, as well as visiting studios of his contemporaries. The works of Edouard Manet, Willem de Kooning, and Fairfield Porter, with whom he shared a studio in New York in the late 1950s, have a particular appeal for him. Dash worked as a reviewer for *Art News* and *Arts* between 1957 and 1959 and continues to write on a wide variety of topics, including poetry and gardening. He has taught at Southampton College and the

Dord Fitz School of Art in Amarillo, Texas.

Dash moved to Sagaponack in 1966 but before then had visited often, sometimes renting a house for the summer. He was one of many artists who rented the gatehouse at Alphonso Ossorio's estate, The Creeks. Dash describes the light on the East End as "the wettest one going," and says, "where I live . . . in four miles, one can go, south to north, from ocean and beach through dunes, wetlands, and tilled fields past scrub pine and oak woods filled with mountain laurel at the spine of the Island, which is 212 feet high here and sufficiently elevated to turn blue in the distance." Despite the representational aspect of Dash's work, he does not work from nature. *Spring II*, for example, was one of many "Spring" paintings that

were painted in the middle of winter. "Generally there would be one on paper, one on a wooden panel, and one on canvas. I never look at a view," Dash explains. "*The Day My Father Died* is entirely invented, but I am sure that endless staring at and working with this landscape here has provided me with an almost reflex series of reactions — a vocabulary and a grammar of flatness and of lowering and rising."[1]

1. Letters from the artist, December 12, 1988, and February 10, 1989. In a letter to Ronald Pisano, December 4, 1988, Dash says, "*The Day My Father Died* might be considered my last purely realistic work. Since that one, the work is more abstract, although its roots are clearly obvious — foliant form held very close to the eye."

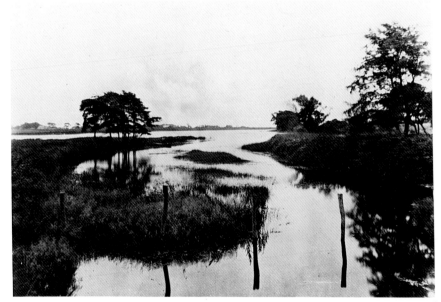

Eugene Armbruster, Sagg Pond looking south, Bridgehampton, September 1923
Courtesy of the New York Public Library Special Collections.

102

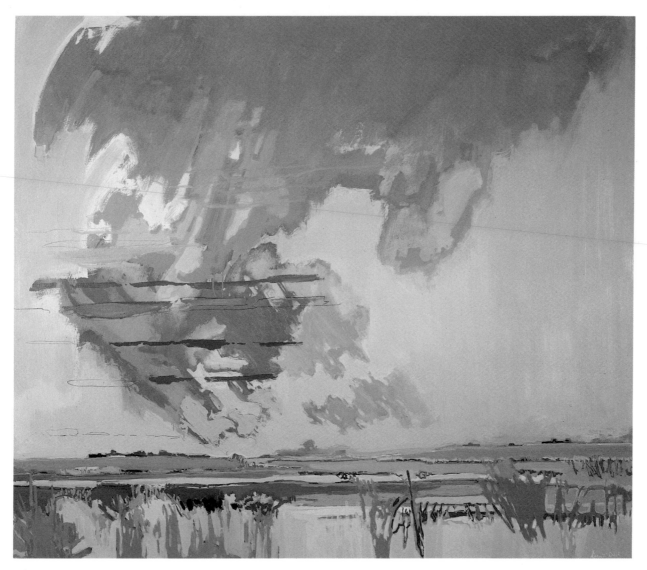

Robert Dash, THE DAY MY FATHER DIED, 1983
oil on linen, 60 × 70, Collection of the Artist.

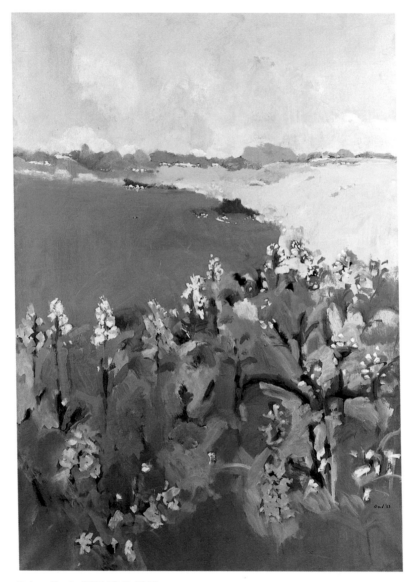

Robert Dash, SPRING II, 1963
oil on canvas, 70 × 50, Private collection.

N. HAYDN STUBBING
London, England 1921–1983 London, England

N. Haydn Stubbing, also known as Tony Stubbing, served in the military from 1939 to 1947, spending much of that time in Africa. After being discharged, he entered the Camberwell School of Arts and Crafts in London, where he studied with William Johnston and Sir William Coldstream. In the fall of 1947 he moved to Spain and painted copies of Old Masters at the Prado. While in Madrid he became one of the founding members of the school of Altimira, a group of avant-garde artists interested in prehistoric art. Probably because for fifteen years he followed the ancient technique of painting directly with the hands, Stubbing developed a severe allergy that prevented him from painting at all for four years, during which time he sculpted and made theatrical designs. He moved to Paris in 1954 and then to New York in the early 1960s. From New York he made his way out to Sagaponack, and from 1974 until his death divided his time between his studio there and London. In 1977 he was the first painter and sculptor elected as a fellow of the Lindisfarne Association, and he spent the summer of 1981 as artist-in-residence at its facility in Creston, Colorado.

During his years in Sagaponack Stubbing painted small, abstracted landscapes directly from nature, which he called "notes" and which he sometimes used as references for larger canvases. He explained, "From early fall to April, I watch and make notes of the Hampton seas, skies, birds, trees. My painting draws on these observations, though I try to go beyond mere fact to get through to a deeper vision; a vision that dismisses surface references . . . in other words, qualities that go beyond the eye and beyond the camera."[1]

1. *Winterscape* (Exh. cat.; East Hampton, N.Y.: Guild Hall Museum, 1982), 10, and material provided by Yvonne Hagen to Ronald G. Pisano.

PRISCILLA BOWDEN
b. New York City, 1942

Priscilla Bowden's mother was a painter, so she spent her childhood on Long Island taking art classes. Her formal training began when she attended the Art Students League from 1966 to 1970. In 1970 she won the League's Chaloner Prize, which enabled her to spend time in France painting. Her real love, however, is for the flat landscape on the South Fork, which she has been painting ever since she moved to East Hampton in 1976, but which she had known even before that from previous visits to the area. She says, "I knew it was time to come home [from France] when I found myself driving around the Alpes-Maritimes looking for landscapes like Sagaponack." Her painting *Head of Pond Road* is typical, with its low horizon line and pale palette. She explains the setting of the work: "*Head of Pond Road* is one of a series of roads known collectively to East Enders as 'the back way' — i.e., the way to travel between Wainscott and Shinnecock without touching the congested and over-developed Montauk Highway. The back way retains much of the rural beauty that has attracted so many painters to the area."[1]

1. Letter and material from the artist, undated.

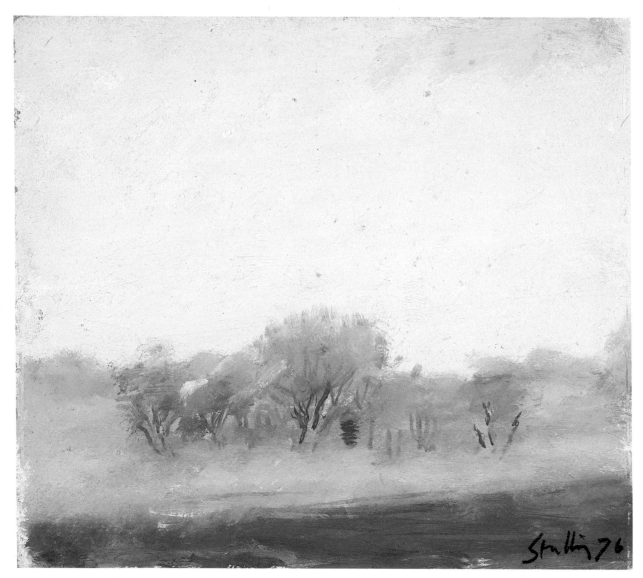

N. Haydn Stubbing, LONG ISLAND POTATO FIELD, 1976
oil on board, 5¾ × 6½, Private collection.

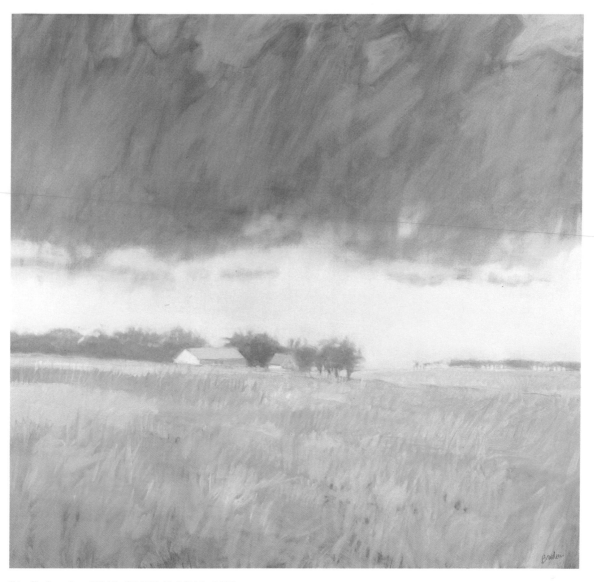

Priscilla Bowden, HEAD OF POND ROAD, 1988
oil on canvas, 48 × 52, Collection of the Artist.

PAUL GEORGES
b. Portland, Oregon, 1923

After attending the University of Oregon, Paul Georges came to New York City and studied with Hans Hofmann there and at his summer school in Provincetown. Georges then spent several years in Paris, where he studied with Fernand Léger from 1949 to 1952. Back in New York, Georges developed a figurative style with a painterly freedom that was indebted to the abstract expressionist painters. His straightforward still lifes, portraits, and landscapes, many of them painted in Sagaponack, where he maintained a home from 1962 to 1984, are intermixed with more ambitious works, such as a series dealing with political assassinations and the student turmoil of the late 1960s and early 1970s and, most recently, a series treating the violent tale of the goddess Diana and the hunter Actaeon.[1]

Georges first visited the East End in the mid-1950s. *Roses* is one of several paintings of the luxuriant rose-bushes that Georges transplanted to his property on Poxabogue Pond in Sagaponack. This work and many others celebrate the natural and unspoiled landscape around his home. Frustrated because they could not obtain permission to build a studio there, and after learning that their private paradise was about to be intruded upon by the construction of houses across the pond, the Georgeses sold their home and bought a farmhouse in France, where they now spend most of the year.[2]

TY STROUDSBERG
b. East Stroudsberg, Pennsylvania, 1940

Ty Stroudsberg, née Brockstedt, changed her name in the mid-1960s, taking the name of her hometown. She attended New Jersey State College at Paterson, where she studied briefly with Stevan Kissel, who introduced her to French Impressionism and encouraged her to continue painting. She obtained a B.A. from Southampton College in 1970, but as a painter Stroudsberg considers herself largely self-taught.

Stroudsberg visited Noyac in the fall of 1963 and was so taken with the area that she moved to South-ampton the following year. Although she was working abstractly at the time of her move, the colors and broad horizons of the South Fork began to affect her work. By 1980 she began using the open fields and farmlands as her subject, albeit with a heightened sense of color and retaining elements of slashing brushwork from her abstractions. Disturbed by the increasing development in the Hamptons, Strouds-berg began to travel over to the North Fork to paint and, in 1985, made Southold her home. Her painting *Zinnia Field* shows the Cichanowicz farm, on the south side of Sound Avenue near the Hallockville restoration in Jamesport, a small town west of Southhold. The family has been farming in the area for over fifty years, growing potatoes and other vegetables as well as the cutting flowers that Stroudsberg chose to paint.[1] The artist writes, "The painting was preceded by several sketches made with colored pencil. A week of fog and rain had obliterated the usually vibrant colors from the fields, but the grayness also served to enhance the reds in the field of zinnias."[2]

CASIMIR RUTKOWSKI
b. Erie, Pennsylvania, 1941

After graduating from Penn State University, Casi-mir Rutkowski studied at Pratt Institute, with Richard V. Goetz, and at the Cape School of Art, with Henry Hensche. He first visited eastern Long Island in 1964, while working at the Art Students League with William Draper. Early on, Rutkowski was attracted to Pisarro's work, and later to that of the Nabis and Symbolists. He was familiar with the ideas of Hans Hofmann and grew to admire the figurative painters who sprang up out of the abstract-expressionist current, among them Fairfield Porter, Jane Freilicher, and Paul Georges, whom he knew at Pratt. In the early 1970s Rutkowski was artist-in-residence at Westark Community College in Fort Smith, Arkansas, where he also served as director of the art center.

In 1975 Rutkowski began living in East Hampton, and now has a home in Water Mill. He exhibits his still lifes and landscapes frequently and has won awards from the Parrish Art Museum and the Guild Hall Museum, as well as the National Academy of Design, where he has taught since 1985. This particular work is part of a series of three that Rutkowski painted during the summer of 1987, directly on the spot. The artist says, "Hyland Terrace is a short road between Bridgehampton and Sagaponack that goes to a slight rise overlooking the northern tip of Sagg Pond, with the trees along Sagg Main Street in the distance. Cliff Foster and Henry Dankowski farm the fields in the view in the painting." He adds, "I've [painted] at that spot for the last six years, and continue to do so, always marveling at the possibilities."[1]

1. Robert G. Edelman, "Paul Georges," *New Art Examiner*, n.d.; Jed Perl, "Autumn Alphabet," *The New Criterion*, March 1989; Timothy Cohrs, "Paul Georges," *Arts Magazine*, February 1987. Clippings courtesy of Anne Plumb Gallery.
2. Conversation with the artist, May 7, 1989.

1. Conversation with Charles Cichanowicz, Jr., April 6, 1989. I am grateful to Shelly Doroski for identifying the owner of the farm.
2. Letter and materials from the artist, February 27, 1989.

1. Letter from the artist, January 23, 1989.

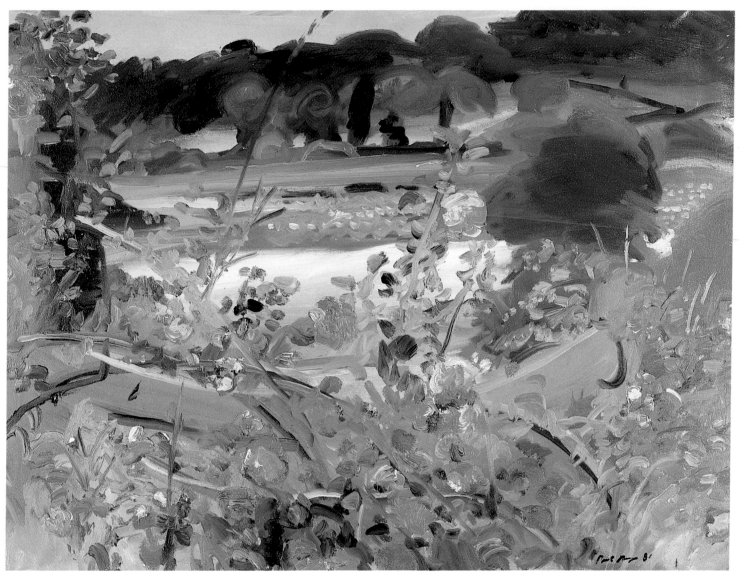

Paul Georges, ROSES, 1981
oil on canvas, 30 × 40, Courtesy of Anne Plumb Gallery, New York City.

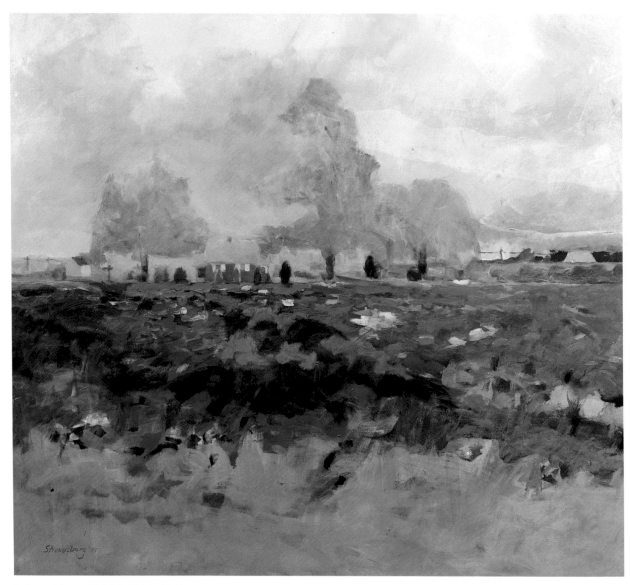

Ty Stroudsberg, ZINNIA FIELD, 1987
acrylic on canvas, 44 × 50, Collection of Al and Ellen Postrel.

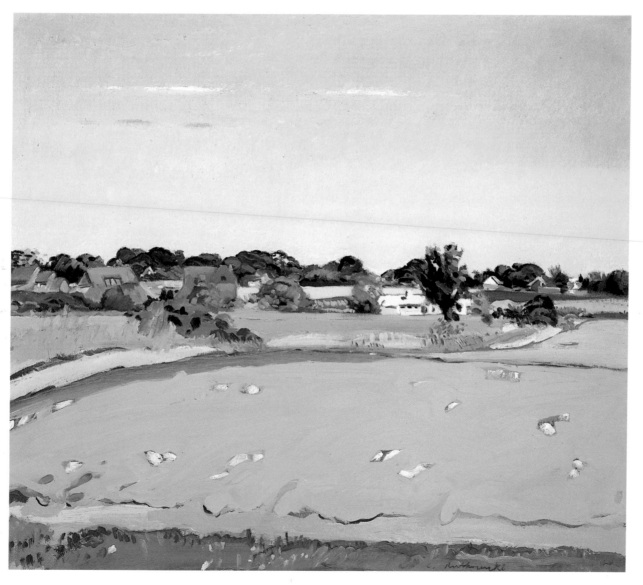

Casimir Rutkowski, POTATO BLOSSOMS — HYLAND TERRACE, 1987
oil on canvas, 24 × 28, Private collection, New York City.

DARRAGH PARK
b. New York City, 1939

Darragh Park spent most of his summers as a boy in Southampton, where his mother's family had gone for many years. After graduating from Yale University in 1961, Park went to Africa for three years, teaching French there. On his return, he obtained an M.A. from Columbia University, and has lived in New York ever since. He exhibits primarily on the South Fork and in New York, most recently with the Tibor de Nagy Gallery, and has made a number of book covers for John Ashbery, James Schuyler, and other writers.

Park is known for the everyday subjects he paints around his New York apartment in Chelsea and in Bridgehampton, where he has had a house since 1980. Before that he rented and visited friends in the Sagaponack–East Hampton area. Using familiar objects, the local landscape, and friends as his subject matter, with an emphasis on the paint itself, in the tradition of Vuillard and, more recently, Fairfield Porter, Park's paintings have been praised for their quiet tone.[1] The artist explains his choice of subjects: "It is that point where there is a sensation of clarity provoked by some display of light or arrangement of forms or colors which somehow appeals to me and is the basis for my paintings. . . . The imagery is found and incorporates the 'beautiful' with the banal, the daily with the extraordinary, the convivial with the dramatic in no intentionally meaningful way. . . . *Cameron Dusk* evolved from the walks I take most every evening when I'm in Long Island [to W. Scott Cameron Beach on Dune Road in Bridgehampton], at the point where Mecox Bay and the ocean almost meet."[2]

1. See John Ashbery, "Darragh Park at Tibor de Nagy," *Art in America*, May 1987, 186, and "Darragh Park," *Arts Magazine* 58 (Summer 1984), 35.
2. Letter from the artist, December 20, 1988.

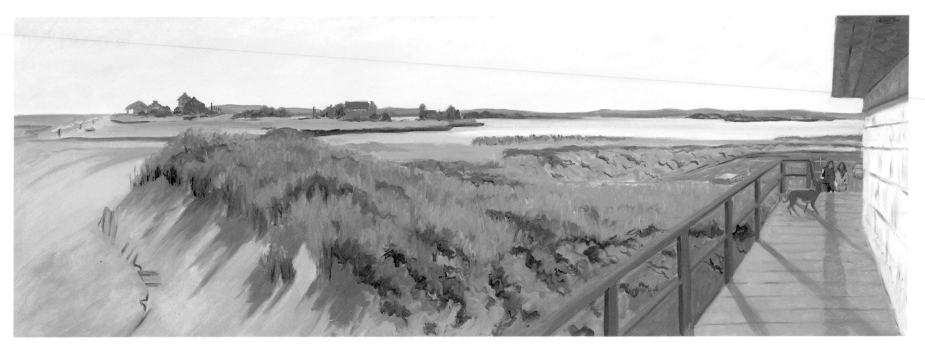

Darragh Park, CAMERON DUSK II, 1988
oil on canvas, 31 × 91, Courtesy of Tibor de Nagy Gallery, New York City.

LIZBETH MITTY
b. New York City, 1952

Lizbeth Mitty grew up in Kew Gardens and spent a lot of time visiting an older brother who lived farther out on Long Island, in Great Neck. She attended Stony Brook University for two years before transferring to the University of Wisconsin in Madison, where she earned a B.S. in 1973 and an M.F.A. in 1975. From 1982 to 1985 she taught night classes at Nassau Community College and during that period used many of the locations she passed while commuting on the Brooklyn-Queens Expressway and the Long Island Expressway as subjects for paintings. Although she lives in Manhattan, she continues to paint neighborhoods and industrial scenes of Brooklyn and Queens from memory.

Her painting *Attached and Semi-Attached* "was made after a visit to the street where I lived from my birth until I entered college," Mitty says. "I was acutely aware while painting it of a mingling of that recent memory with past memories. The time of the visit was a chilly late fall day. I have always liked the raunchy green foliage and drab brick in this type of landscape — colors which can become so rich when translated into paint. Secret gardens in back alleys actually exist in this one square block. The breaks between the un-attached houses lead to broken playgrounds and overgrown courtyards. The title comes from a description I once heard of the neighborhood housing."[1]

WARREN BRANDT
b. Greensboro, North Carolina, 1918

After graduating from high school, Warren Brandt came to New York, where he attended Pratt Institute at night. At the outset of World War II he joined the National Guard, where he made sketches for the Army newspaper. After the war Brandt returned to New York and studied at the Art Students League with Yasuo Kuniyoshi, then spent seven months in Mexico with the aid of the GI Bill before entering Washington University in St. Louis, where he studied with Philip Guston. In 1948 he received the University's Milliken Fellowship, which enabled him to spend ten months in Rome and Paris. From 1949 to 1962 he headed the art departments of colleges in North Carolina, Mississippi, and Illinois, earned his M.F.A. from the University of North Carolina in Greensboro, and spent periods of time in New York City, where he taught at Pratt and took art-history classes at NYU.[1] Brandt began painting the colorful, lavish still lifes and studio interiors he is best known for after 1964.

Brandt first came to Water Mill on Long Island in 1963 with his second wife, Grace Borgenicht, moving twice before settling in their present residence on Mecox Bay in 1983. He maintains a separate studio in a converted barn nearby. The artist writes, "The painting *Spring on Millstone Road* was inspired by a beautiful old house with flowering trees which I always love to see at springtime. One morning I drove there very early so as to get the best light and set up my easel about a hundred and fifty yards away and tried to get or put down the essence of early spring in the Hamptons."[2]

PATON MILLER
b. Seattle, Washington, 1953

In the mid-1960s Paton Miller moved with his family from Seattle to Hawaii, where he later spent one year, from 1973 to 1974, studying at the Honolulu Academy of Art. After this he traveled west around the world, making stops in the Orient, the Middle East, and the Mediterranean. From Morocco he went to New York, and from there to Southampton to visit a friend. Miller learned by chance of a scholarship to the Art Department at Southampton College, and decided to submit his work. He won, and began his studies in January 1975. After his graduation in 1978, he remained in Southampton.[1]

Miller began to paint in the studio of the late Fairfield Porter in 1979, at the invitation of Anne Porter, a neighbor, who wanted the space used by a working artist. The studio is on the second floor of an old barn, with the first floor devoted to storage. Many of Miller's early works were scenes from around this South Main Street neighborhood, such as *View from the Studio*, a view framed by the hayloft door, across the yard to the house on the south side of the property, painted at dusk.[2] Miller has also painted in the Caribbean, in Mexico, and in other more exotic locales, where he spends his winters pursuing a favorite sport, surfing. In about the mid-1980s his work began to take on a more serious tone, with a darker palette and more personal, imaginary subject matter.

1. Letter from the artist, February 21, 1989.

1. See Nicholas Fox Weber, "Warren Brandt," *American Artist* 53, no. 560 (March 1989), 48–53, 75–81.
2. Letter from the artist, January 25, 1989.

1. John T. Spike, *Paton Miller at Nohra Haime Gallery* (Exh. cat.; New York: Nohra Haime Gallery, 1986); see also *Paton Miller: New Painting* (Exh. cat.; New York: Nohra Haime Gallery, 1989), and Biddle Duke, "Where Comedy and Drama Converge," *The Southampton Press*, July 7, 1988.
2. Conversation with Joanne Miller, March 15, 1989.

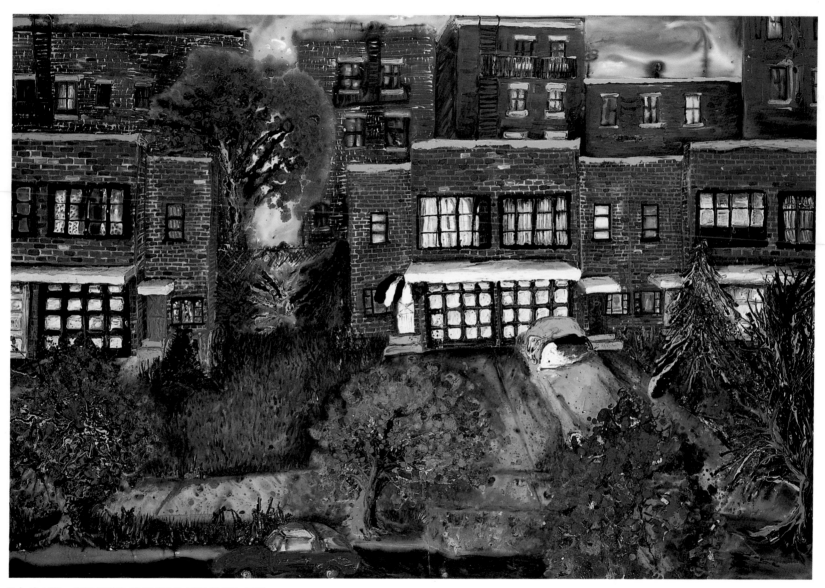

Lizbeth Mitty, ATTACHED AND SEMI-ATTACHED, 1983
acrylic on canvas, 72 × 108, Collection of the Artist.

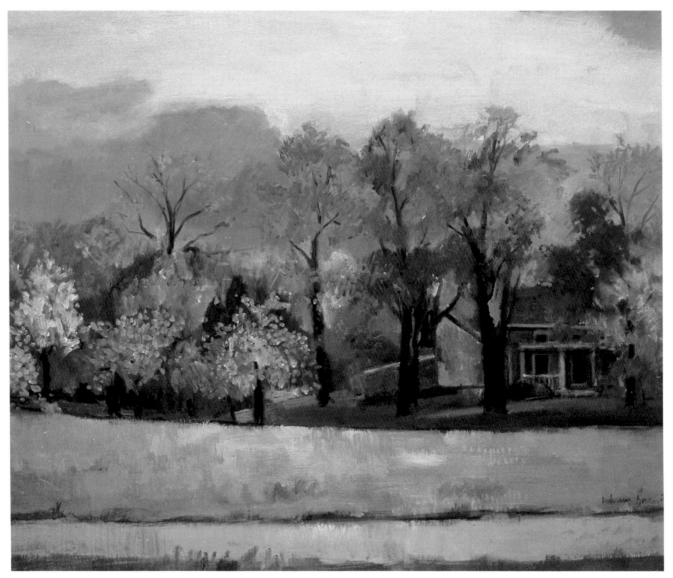

Warren Brandt, SPRING ON MILLSTONE ROAD, 1983
oil on canvas, 24 × 28, Private collection, courtesy of Fischbach Gallery, New York City.

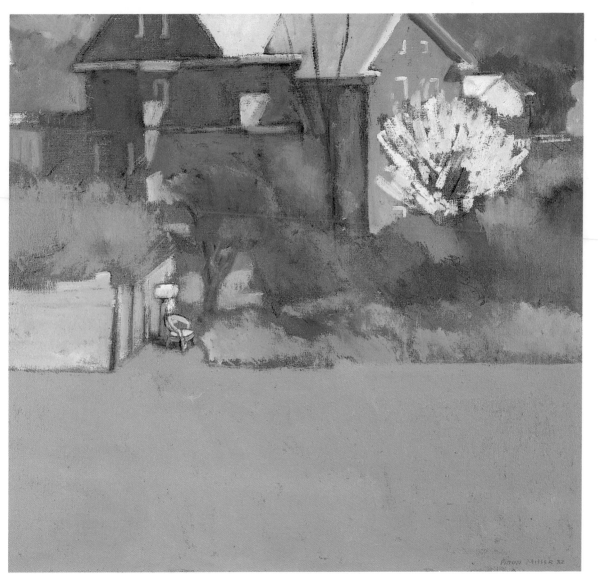

Paton Miller, VIEW FROM THE STUDIO, 1982
oil on canvas, 34 × 37, Collection of William and Penelope Reese.

ALBERT YORK
b. Detroit, Michigan, 1928

Little is known about Albert York, who maintains a very private life on the East End of Long Island. He attended Ontario College of Art and studied at the Society of Arts and Crafts in Detroit. He moved to New York City in about 1961 and studied briefly with Raphael Soyer. It is not known when he came to East Hampton full-time, but he had a house there from 1961 to 1983, and since then has lived in Water Mill. He rarely comes into New York and hardly ever visits museums or galleries; his dealer, LeRoy Davis, has never been to his studio and has had little direct contact with the artist.[1] York paints very slowly, completing, for example, only eleven paintings in a three-year span, and many of his shows are made up of works from years ago. Collectors compete for his work, which is well known and admired by other artists. His small, intense paintings are deceptively simple at first look, but as one reviewer noted in 1963, "He is a specialist in very tiny, important differences: a thread of blue sky above the trees, a small distinct distinction between light and dark, an apt precision in spacing and placement. The paintings are direct experiences but he strikes unerringly for the dominant qualities in what he sees."[2] Fairfield Porter wrote of York, "He does not 'know' anything better than you who look at the painting; rather, he is able to identify with the mystery of the world that our civilization tries to keep us from being aware of."[3]

1. Michael Brenson, "Albert York Abides in His World with Grand Aloofness," New York Times, March 20, 1988, C33, C35.
2. Lawrence Campbell, "New Names This Month: Albert York," Art News, March 1963, 53.
3. Fairfield Porter, foreword to Albert York (Exh. cat.; New York: Davis & Langdale, 1975). See also Klaus Kertess, Painting Horizons: Jane Freilicher, Albert York, April Gornik (Exh. cat.; Southampton, N.Y.: The Parrish Art Museum, 1989).

Albert York, SAILBOAT ON THE SEA, ca. 1970
oil on panel, 8¾ × 10¹¹/₁₆, Collection of Mr. and Mrs. Myron Baum, courtesy of Davis & Langdale Company, New York City.

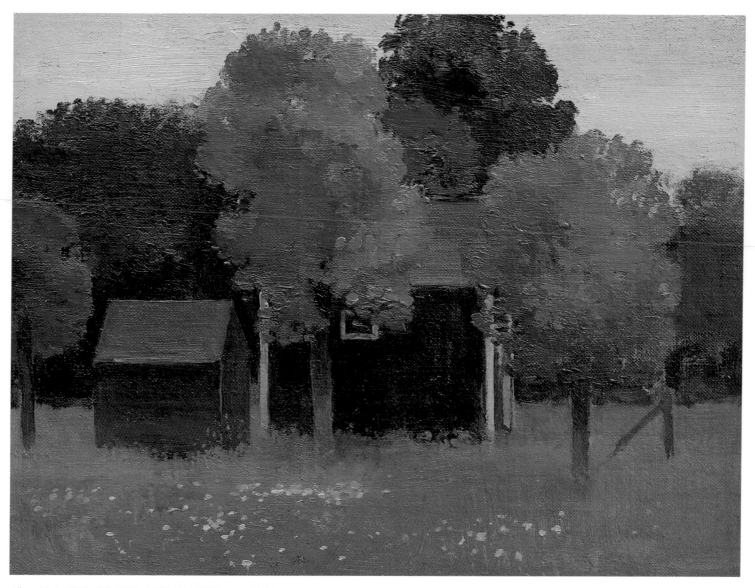

Albert York, TWO HOUSES, EAST HAMPTON, ca. 1964
oil on canvas mounted on masonite, 6⅝ × 12, Private collection, courtesy of Davis & Langdale Company, New York City.

MARGERY RUTKOWSKI
b. Philadelphia, Pennsylvania, 1941

Margery Rutkowski attended Bennington College and then transferred to Columbia University, from which she graduated in 1965. She also studied at the New York School of Interior Design in about 1970. She moved to Southampton in 1972 after spending several summers there, and settled in Water Mill in 1976, at which time she worked with the artist Margery Caggiano at Southampton College. Her paintings, done on a small scale, focus on old buildings on the South Fork, painted in a crisp light, with simplified forms. *Backyard Barn* was painted in the fall of 1988. "I was walking down Jennings Avenue in Southampton when something struck me as beautiful about the almost dark light the sun made hitting the three bushes sitting there in a row, the long shadow cast by the front house, and the starkness of the old barn jutting into the middle of the backyard. The shadows were changed by noontime, so I worked in the late mornings. I painted two other versions, then waited till the leaves had all fallen to get a clearer view when I painted this third version."[1]

1. Letter from the artist, March 6, 1989.

LENNART ANDERSON
b. Detroit, Michigan, 1928

Lennart Anderson earned his B.F.A. from the Art Institute of Chicago in 1950 and two years later received his M.F.A. from the Cranbrook Academy; in 1954 he studied with Edwin Dickinson at the Art Students League. Anderson won Tiffany Foundation grants in 1957 and 1961 and the Prix de Rome from 1958 to 1960, and has been honored with many other awards more recently. Throughout his career he has won critical praise for his landscapes, still lifes, and nudes, despite critics' uneasiness with his traditional realist mode and technical skill during a period when doing something "new" was valued.

Anderson admires the work of Poussin, Ingres, Cézanne, Maillol, and Degas, influences that shaped his concern for structure and form, which is evident in his painting *Prospect Park*. The artist described the distractions he encountered while painting this view of a refreshment stand that has since burned down: "I painted early in the morning, setting up in some woods and wearing dark clothes. Still, there were people about. Joggers, mostly, and people with their dogs. The dogs were the problem. Their owners were constantly throwing sticks in the pond for them to fetch."[1]

Anderson once admitted that he generally did landscapes because his wife insisted that he visit the country each summer, and he explained his methods: "I am tied to what I see. I don't often transpose. I try to paint the way I perceive it. . . . Finding the right place is the hardest part. When I find a great place I'm confident then . . . if you get a really good place, that's most of the job."[2]

1. Letter from the artist, April 14, 1989.
2. Alan Gussow, *A Sense of Place: The Artist and the American Land* (San Francisco: Friends of the Earth, ca. 1973), 113. See also Artist File, New York Public Library.

MARILYN TURTZ
b. Brooklyn, New York, 1955

When she was a young girl, Marilyn Turtz moved with her family to Valley Stream, Long Island. She attended art classes at the Brooklyn Museum Art School and spent three years under the tutelage of Francis Cunningham, who was an enormous influence on her. She continued to study there while she attended Stony Brook University from 1973 to 1975, and also took anatomy classes at the Art Students League with Robert Beverly Hale. In 1975 she transferred to Pratt Institute, where she received a B.F.A. in 1978. She then taught art and art history at Brooklyn Friends School, serving as chairperson of the department from 1985 to 1987. She obtained her M.F.A. from Brooklyn College in 1985.

In 1983 Turtz and her husband moved to Freeport, where she made many paintings of the South Shore. In 1987 they moved again, to Glen Cove, and she now devotes herself full-time to painting, choosing mostly local scenes as her subject matter. The artist tells how her painting of a neighbor's yard, *The Small Shed at Nina's House*, came to be: "Passing Nina's house, I am taken by the lushness of the grounds. They strike me as a bouquet — full with shimmering light, rich texture, and varied pattern. In the midst of this site sits the shed. Unlike the flamboyant forms of organic foliage, the shed is hard-edged and stark white. However, its proportions are so unimposing (neither thrusting skyward with great height nor sprawling with great width), that I experience it as occupying its place with modest dignity. In a self-contained way, the light on the shed is as dazzling as that of the greenery surrounding it. Neither aspect dominates. The harmony created by these complementary natures seems quite poetic to me."[1]

1. Letter and material from the artist, undated.

Margery Rutkowski, BACKYARD BARN, 1988
oil on canvas, 12 × 12, Collection of the Artist.

Lennart Anderson, PROSPECT PARK, 1978
oil on canvas, 14 × 17, Mitsubishi International Corporation.

Marilyn Turtz, THE SMALL SHED AT NINA'S HOUSE, 1988
oil on canvas, 36 × 42, Collection of the Artist.

HOWARD KANOVITZ
b. Fall River, Massachusetts, 1929

Howard Kanovitz attended Providence College from 1945 to 1949, then entered the Rhode Island School of Design, where he worked until 1951. He moved to New York City and studied at the New School for Social Research in 1951–1952 and later, between 1959 and 1962, completed his training at NYU's Institute of Fine Arts. Kanovitz became known in the late 1960s for his airbrushed realist figure paintings, which he placed in unreal, abstract space or made as freestanding or wall-mounted silhouettes. In more recent years he has worked with pastel and painted evocative landscapes seen through freestanding door and window constructions.[1]

Kanovitz began visiting the South Fork in 1952, when he spent time with a group of friends in Springs, including Joan Mitchell and Grace Hartigan. He came more often after his friend Larry Rivers moved out to Southampton in 1953. From 1963 to 1973 Kanovitz and his wife summered in Provincetown, but then decided to build a home in Amagansett on land that had been a wedding present. Kanovitz painted this view of the drive-in in Bridgehampton (now shut down and slated to become a shopping center) the fall his house was being built.[2] Kanovitz was attracted to the idea of the drive-in as an image of popular culture, a symbol of growing up in America, and he chose to depict it as the sun set, just before the movie started. The absence of detail caused by the fading light enabled him to concentrate on the simplicity of forms and planes of the silhouetted screen.[3]

1. See *Howard Kanovitz: Paintings, Pastels, Drawings 1951–1978*, trans. David Rattray (Exh. cat.; Berlin: Akademie der Kunste, 1979).
2. Two drive-ins remain on Long Island, one in Westbury and the other in Bayshore.
3. Conversation with the artist, March 7, 1989. Kanovitz made a film about the creation of this painting.

STEVEN LANG
Brooklyn, New York 1944–1971 Unknown

Little is known about the short life of the artist Steven Lang, who is thought to have died in an accident. He attended the Brooklyn Museum Art School for about two years when he was a teenager, with the idea of being a commercial artist. His teacher David Levine showed his work to John Koch, who critiqued it a few times informally and encouraged Lang by purchasing his painting *Summer Morning*, which was later donated to the Brooklyn Museum. Like Koch, Lang developed an admiration for the work of painters of the past, such as Bellini, Van Eyck, and Rembrandt. Although he experimented briefly with abstraction, he did not have a high opinion of contemporary artists. Lang's shift to working from nature was inspired by the time he spent living in an apartment at the end of Fulton Street in Brooklyn in the mid-1960s, which had a view out the window and a backyard. He developed his realistic technique on his own, by studying things closely and sketching from nature.

For his painting *Summer Morning*, which shows the backyard of this apartment, Lang made about forty sketches. He described the scene as follows: "It is very peaceful. It's early morning, the sun is just coming up and there's no one around. . . . Somehow this scene was very rural even though it's in the heart of the city." Lang took a few liberties by eliminating a few buildings, and he explained, "I designed some of those fences myself." He continued, "I had a very warm feeling about this backyard and what was in it. I made a few other paintings from it. And if I stayed there I would have made more."[1]

1. Steven Lang, interview with Ms. Arlene Jacobowitz, 1966. Courtesy of the Brooklyn Museum Art Reference Library.

ALTOON SULTAN
b. Brooklyn, New York, 1948

Known first for her "portraits" of Victorian houses, Altoon Sultan graduated from Brooklyn College in 1969 and attended Boston University's summer school at Tanglewood. The following year she studied at the Skowhegan School of Painting and Sculpture, and earned her M.F.A. from Brooklyn College in 1971, where she also taught from 1969 to 1973. In the early 1980s Sultan began painting still life, and in her landscapes shifted the focus away from the buildings by placing the structures within the landscape, giving nature equal play. Many of her works have been painted in places within a day's drive of New York City, such as the Catskills or the North Shore of Long Island.[1]

Sultan likes to spend summers in different places, most recently in Vermont and Maine, where she taught at the Skowhegan School. In 1982 she spent several months in Cutchogue, a small town on the North Fork, when she painted this work, of which she says, "Farmland has a particular beauty during the spring. The expanse of freshly turned earth is in rich contrast to new foliage. On Long Island's North Fork, the earth is a reddish color, providing an even more vivid counterpoint to the perspectival lines of young potato plants. For *The Potato Field*, spring was the season I chose to depict. I was still working on this painting three months later, when the plants were ready for harvest. The house, trees and field are facing a road. There is an acid-green road marker, a wooden pole with electric wire stretched across the picture plane. These seemingly discordant elements in an ordinary landscape introduce pictorial tensions. They also raise questions regarding our sometimes uneasy relationship with the land."[2]

1. Susan Koslow, "Altoon Sultan," *Arts Magazine* 58, no. 10 (Summer 1984), 12; see also *Altoon Sultan: New Work* (Exh. cat.; New York: Marlborough Gallery, 1988).
2. Letter from the artist, March 7, 1989.

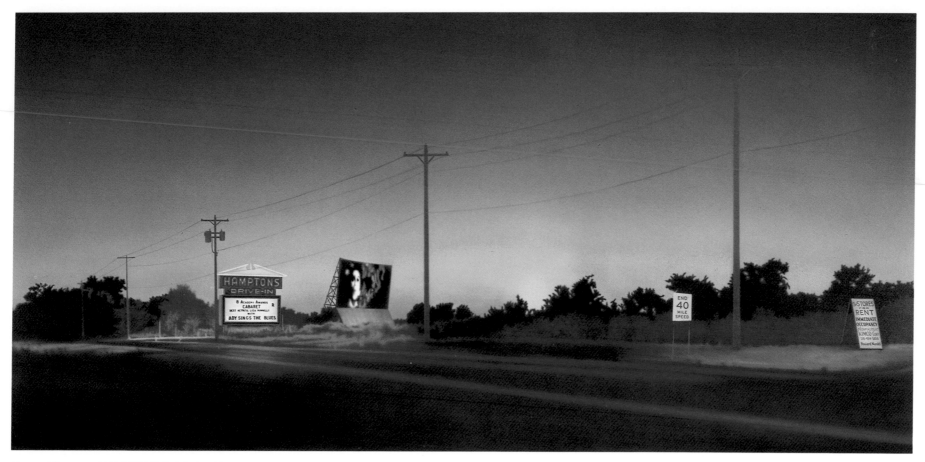

Howard Kanovitz, HAMPTONS DRIVE-IN, 1974
acrylic on canvas, 42 × 90, Courtesy of Marlborough Gallery, New York City.

Steven Lang, SUMMER MORNING, 1964–1965
oil on masonite, 30 × 58¾, The Brooklyn Museum, Brooklyn, gift of the John and Dora Koch Foundation (66.231).

126

Altoon Sultan, THE POTATO FIELD, CUTCHOGUE, LONG ISLAND, 1982
oil on canvas, 15 × 34, Courtesy of Marlborough Gallery, New York City.

SHERIDAN LORD
b. New York City, 1926

Sheridan Lord grew up in Old Westbury and first went to the South Fork when his parents began spending summers in Amagansett and East Hampton in about 1940. Lord graduated in 1950 from Yale University, where he had studied literature and history. He spent nine months in Seattle attempting to write and then attended studio art classes at the University of Iowa from 1951 to 1954. While an art student, Lord made landscape drawings during his visits to the coast of Texas, near Corpus Christi, a practice he had begun during his summers on the East End of Long Island. He returned there in 1954 and settled in Springs, eventually moving to Sagaponack in 1968. From 1963 to 1975 he taught at the Brooklyn Museum Art School.[1]

In the time he could spare from teaching, Lord began to paint landscapes regularly in the summer of 1969. In recent years he has turned more to still-life painting as the South Fork loses its rural character.

Lord explains that *Landscape, June–July* "was actually worked on in the field into September and revised indoors into November. I wanted to convey a sense of high summer, strong blue skies, which is a falsehood, I'm afraid, or a wishful dream, since we rarely have those skies during our Long Island summers. They are only here for a day, maybe two, before they begin changing back to the haze and humidity that comes with the southwest breeze. In fact, this painting might have been finished sooner were it not for the delays imposed, for me, by our constantly changing light."[2]

1. Alan Gussow, *A Sense of Place: The Artist and the American Land* (San Francisco: Friends of the Earth, ca. 1973).
2. Letter from the artist, December 28, 1988.

CHRISTIAN WHITE
b. Rome, Italy, 1953

Christian White's father, a sculptor, was friendly with the artists David Levine and Aaron Shikler, and his mother, a critic for *Art News*, knew Fairfield Porter and Jane Freilicher. Paul Georges and Paul Resika visited the family, and White benefited from all of these informal contacts. From 1966 to 1968 he studied with Paul Russotto, and attended the Rhode Island School of Design from 1971 to 1973 and again from 1975 to 1977.

As a child White spent most of his summers in St. James, in a house that was part of his great-grandfather Stanford White's estate, Box Hill. White's family has a long connection to the area through his great-grandfather's marriage to Bessie Smith, who traced her ancestry back to John Bull Smith, the founder of Smithtown. White has his own house and studio in St. James, where he spends about half his time.

White says, "The series of paintings titled 'For the Least Tern' were all painted on a stretch of sand and dunes which separates the Nissequogue River from Smithtown Bay. . . . This land, which is periodically augmented by dredgings from the mouth of the Nissequogue, has been set aside as a nesting ground for birds, especially a beautiful little swallow-winged gull called the Least Tern which is endangered because it nests in the open ground and abandons its eggs if disturbed by people. When I did this particular painting the sanctuary had been recently covered with new dredgings which left a pool of purple, sun-bleached mussel shells and drowned a number of red pine seedlings in black clay from the river bottom. A service road used by the Parks Department, and marked by telephone-pole stumps, now disappeared into a huge bank of sand and stones. I loved the strange, tranquil isolation of that place, and was inspired by the dazzling colors of shells, clay, dying and living pine trees, and wildflowers."[1]

1. Letter and material from the artist, March 7, 1989.

LEO REVI
b. New York City, 1943

Leo Revi attended the High School of Music and Art in New York and then earned a B.F.A. from Cooper Union. After graduating, he painted still lifes in his apartment and drew landscapes in city parks. During a trip to Guatemala in 1967 he began painting in oil outdoors, a practice he continues today. During the late 1960s Revi made day trips to the North Shore of Long Island and to Lake Ronkonkoma to sketch and paint. He first visited East Hampton in September of 1968 and fell in love with the area. While working as an art director and designer in New York, he went there on weekends and for blocks of time in the summer. In 1972 Revi decided to paint full-time and moved to East Hampton, where he has painted groups of works based on local themes such as the haul seiner fishermen, whose numbers have diminished because restrictions on their catch make it difficult to earn a living.[1] *Strawberry Stand* is part of a series begun in 1974 and painted during the short harvesting season in June. Revi fears that the stands may go the way of the haul seiners, since the fruit grows on prime real estate. He explains how the series developed: "Every June my mother would come out to pick strawberries. I would go to Osborn's farm in Wainscott with her to help pick berries. I was struck by the pictorial possibilities of the fields of berries with people bending over picking. . . . Then I discovered the roadside stands at Schwenk's farm in Sagaponack. They put up colorful umbrellas, red and white, and big eye-catching signs, like a four-foot-high plywood cutout of a strawberry painted in red and green, big signs . . . that are to me real folk art. So then that became one of my favorite motifs."[2]

1. Candace Leigh, "Honoring Artists of the Hamptons: Leo Revi," *Dan's Papers*, September 9, 1988.
2. Letter from the artist, January 30, 1989.

Sheridan Lord, LANDSCAPE, JUNE–JULY, 1977
oil on canvas, 36 × 54, Collection of Pamela S. Lord.

Christian White, FOR THE LEAST TERN #2, 1987
oil on canvas, 36 × 50, Collection of Mr. and Mrs. Alan Spielberg.

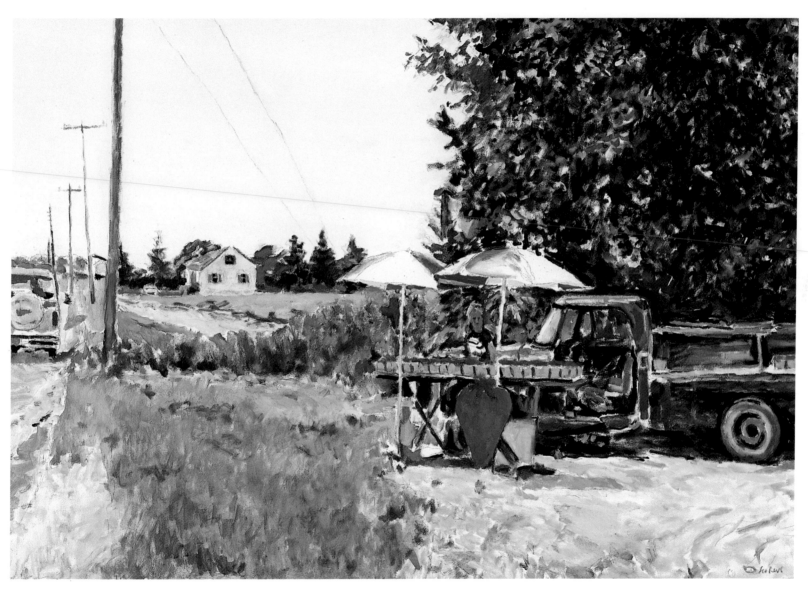

Leo Revi, STRAWBERRY STAND, 1985
oil on canvas, 34 × 50, Courtesy of Gallery East, East Hampton, New York.

JOHN KOCH
Toledo, Ohio, 1909–1978 New York City

John Koch developed a highly finished technique and a wide art-historical knowledge without formal training. He grew up in Ann Arbor, Michigan, and spent two summers in Provincetown, where he was influenced by the painter Charles Hawthorne, though he did not study with him. From 1928 to 1933 he lived in Paris, studying independently in museums and galleries. He returned to New York in 1933, had his first one-man show in 1935, and began his lifelong association with the Kraushaar Gallery in 1939. His paintings of nude models and his wife, family, and friends were most often set in their New York apartment and, from 1946 on, sometimes in their country home in Setauket. They chronicle a private world filled with genteel activity and fine objects, but their subject has been described as light, not the people themselves. Koch liked to use both artificial and natural light, and despite his allegiance to representation, he did not stick strictly to the facts, making things up if it suited him.[1]

Garden at Setauket was painted during one of the Kochs' visits to their home on Caroline Avenue in Setauket, where they spent weekends and occasionally longer periods. Mrs. Koch conducted music lessons there, and they often entertained their wide circle of friends. Koch made a number of paintings at the house, some of them showing the garden, which was maintained by a gardener at the Kochs' direction.[2]

1. See Mario Amaya, *John Koch* (Exh. cat.; New York: New York Cultural Center, 1973).
2. Conversation with Edna Richner, March 27, 1989. Mrs. Richner was a close friend and neighbor of the Kochs' in Setauket. Felicity Dellaquilla kindly put me in touch with her.

NANCY WISSEMANN-WIDRIG
b. Jamestown, New York, 1930

Nancy Wissemann-Widrig began her art studies at the age of thirteen at the Chautauqua Institute, graduated from Syracuse University in 1951, and earned her M.F.A. from Ohio University in 1952. Her landscapes record her immediate surroundings, either in Southold, where she has lived since 1953, when she married a local resident, or in Maine, where she and her husband have spent summers since 1968. Her porch and yard are favorite subjects, and her paintings usually do not include figures. She takes Polaroids to use for reference and tries not to alter what is actually there, choosing instead to change her point of view or wait for different light. She combines her personal feelings about the objects she paints with her formal reactions to the shapes and forms she sees, an approach that allows for elements of abstraction and unlikely color.[1] The artist describes how *Winter Picnic* evolved: "In the part of the year after Christmas before the spring thaw sometimes it is cold but clear and we sit outdoors, so the summer furniture remains ready for a picnic lunch. The random spacing of the chairs and the shapes between them cutting off and defining segments of the landscape were what drew my attention. Then I realized the absence of people signifies perhaps that the 'picnic' is over."[2]

1. See Alexandra Anderson, *Nancy Wissemann-Widrig* (Exh. cat.; New York: Tatistcheff Gallery, 1987).
2. Letter from the artist, January 2, 1989.

MARGO BARNES
b. New York City, 1947

Margo Barnes graduated from Boston University with a B.F.A. in 1969. In 1972 she won a Fulbright grant, which enabled her to travel to Italy. She has been summering on the East End since the late 1970s, attracted by the clear light and the presence of other artists she admired, such as Jane Freilicher and Robert Dash. Her interest is not in the open landscape they and many other artists have depicted, but rather in intimate views of porches and bits of yard, with the main focus usually on some structure. This interest was sparked by an early admiration for the work of Edward Hopper. Many of her summers have been spent in Sag Harbor, where "the small shingled houses so close to each other, the street, and the onlooker, surrounded by gardens and patches of blue skies," became the subjects of many of her earlier works.[1] Her paintings are done during the winter months from drawings, watercolors, and pastels that she makes on the spot in the summer.

From about 1984 to 1987 Barnes painted eighteen views of the porch of the home of good friends of hers.[2] She explains, "I thought about painting *Leopold's Porch* for two or three years. I would sit on that porch in Amagansett from early morning until late afternoon watching the light change the patterns of shadows. I became intrigued with looking through the squares the pillars formed to areas beyond that were like separate smaller paintings. There was a certain mystery in being inside looking out while darkness swept across the porch."[3]

1. Letter from the artist, April 3, 1989.
2. Candace Leigh, "Honoring Artists of the Hamptons: Margo Barnes," *Dan's Papers*, May 29, 1987.
3. See note 1 above.

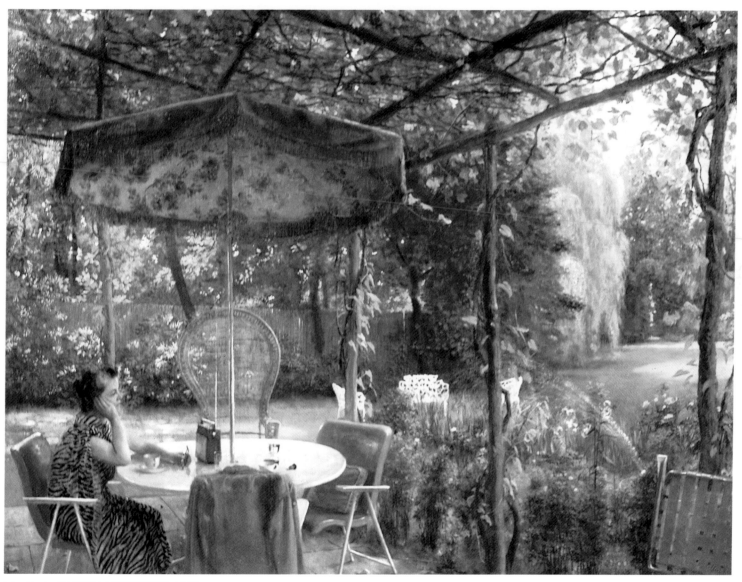

John Koch, GARDEN AT SETAUKET, 1967
oil on canvas, 30 × 40, Collection of Frederick L. Weingeroff.

Nancy Wissemann-Widrig, WINTER PICNIC, 1984
oil on canvas, 36 × 64, Courtesy of Tatistcheff Gallery, New York City.

134

Margo Barnes, LEOPOLD'S PORCH, 1986
oil on canvas, 72 × 72, Collection of the Artist.

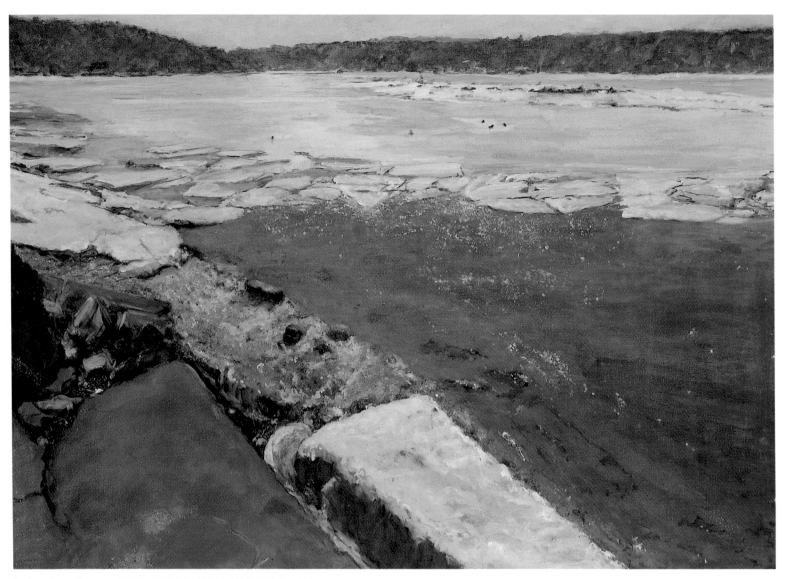

Pauline Gore Emmert, COLD SPRING HARBOR WINTER II, 1978
oil on canvas, 30 × 44, Collection of the Artist.

PAULINE GORE EMMERT
b. Marks, Mississippi, 1923

Pauline Gore Emmert came to painting late in life. She grew up in Jackson, Mississippi, and studied chemistry at a junior college. She was married in 1943 to Richard Emmert, a pilot, and they had two children. Over the years they traveled extensively, and in the 1940s they lived in Miami and Brazil. In 1949 her husband was transferred to New York. Because of their reluctance to live in the city, they discovered Long Island. From 1949 to 1951 they lived in Syosset, and from 1951 to 1956 in Hicksville. In 1954 the Emmerts joined with a group of pilots and bought a tract of land on the easternmost section of the Marshall Field estate at Lloyd Neck, near Huntington, where the Emmerts built a house in 1956. The remainder of the land became Caumsett State Park.

In 1964 Pauline Emmert enrolled in the art department of C. W. Post College, and over the next eight years earned a B.F.A. and an M.F.A., working with Stan Brodsky and Robert Yasuda. She has painted in watercolor, makes figure drawings, and has experimented with photography, but she concentrates on painting the local landscape. She writes, "The route I took to school during those years took me along Lloyd Neck, across the causeway dividing Lloyd Harbor and Cold Spring Harbor, down Snake Hill Road onto Shore Road, and then to Route 25A. The changing seasons along these beautiful shores were the inspiration for many of my paintings. *Cold Spring Harbor Winter II* was painted in February 1978 along Shore Road . . . where the land meets the sea and the sky is reflected. The conflicting forces of the sea against the land, the broken vegetation, the ice, and the winter light reflected in the water were my inspiration."[1]

1. Letter and material from the artist, February 2, 1989.

BERENICE D'VORZON
b. New York City, 1933

Berenice D'Vorzon received a B.A. from the Cranbrook Academy of Art in 1954 and had her first solo show in New York in 1958. She earned an M.A. from Columbia University in 1968. She has won several awards for her paintings, most recently a Pollock-Krasner Foundation grant in 1987. Her early work was created during the heyday of the abstract expressionists and still retains the slashing, active brushwork and paint drips associated with this group. To this D'Vorzon has added a wide variety of other art-historical influences as well as her own strong feeling for nature, which gives her work a romantic quality. For years she has related paintings to photographs she takes herself, sometimes from the air, though she does not paint directly from them. D'Vorzon has painted in Pennsylvania, where she has been teaching at Wilkes College since 1969, and most recently did a series of paintings inspired by the Florida swamps.[1]

D'Vorzon has been visiting the East Hampton area since she was a teenager and has had a house near Louse Point in Springs since 1959. She writes, "I am interested in painting the *experience* of nature rather than a depiction of the landscape. For instance, on Long Island, the light, even at night, has a unique quality. One does not have to actually see the full moon to experience that particular atmosphere, that special color in the sky. There is, therefore, no moon in *Moon over Louse Point.*"[2]

1. William H. Sterling, *Berenice D'Vorzon: Paintings & Drawings, 1980–1982* (Exh. cat.; Wilkes-Barre, Penn.: Sordoni Art Gallery, Wilkes College, 1982); Eva Ingersoll Gatling and Berenice D'Vorzon, *An Artist's Vision of Southern Swamps: Berenice D'Vorzon, Paintings and Photographs* (Exh. cat.; Pensacola, Fla.: Pensacola Museum of Art, 1988).
2. Letter and material from the artist, undated.

JOAN SNYDER
b. Highland Park, New Jersey, 1940

Joan Snyder studied sociology at Douglass College between 1958 and 1962 and then earned an M.F.A. at Rutgers University in 1966. In the late 1960s she won acclaim for her expressionist "stroke" paintings, which incorporated found materials and writings, devices that occur in her more recent work as well. Snyder considers herself largely self-taught and somewhat of a "lone wolf." Her interests are almost completely non-art-historical, but she has responded to the work of the German Expressionists and the Fauvists as well as primitive and children's art. She also admires Cézanne and especially Hans Hofmann. Women's issues have been major themes in her work, and critics have pointed out the intense emotional content of her paintings. Her style is painterly and colorful, and many of her works are divided into sections that are treated differently to create varying moods, which she compares to the variety in music.

In the 1970s Snyder lived with her former husband on a farm in Martin's Creek, Pennsylvania. She came to the North Fork of Long Island in 1982, spending two summers in New Suffolk in a rented house overlooking Great Peconic Bay and painting in the barn there. In 1985 she moved with her daughter to Eastport, a small town that was once the center of the important Long Island duck industry. The artist says, "When I moved to Eastport my house and studio were surrounded by bean fields. It did inspire me. I made many beanfield paintings in all different seasons [such as *Beanfield with Snow*]. The farmer subsequently had a stroke and the fields turned to wildflowers and weeds — more paintings!"[2]

1. J. Baker, *Joan Snyder* (Exh. cat.; New York: Hirschl & Adler Modern, 1985).
2. Letter from the artist, February 1988.

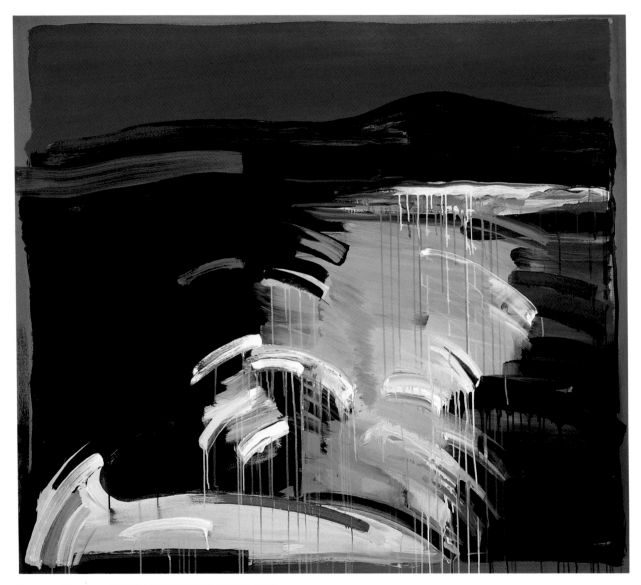

Berenice D'Vorzon, MOON OVER LOUSE POINT, 1983
acrylic on canvas, 60 × 68, Collection of the Artist.

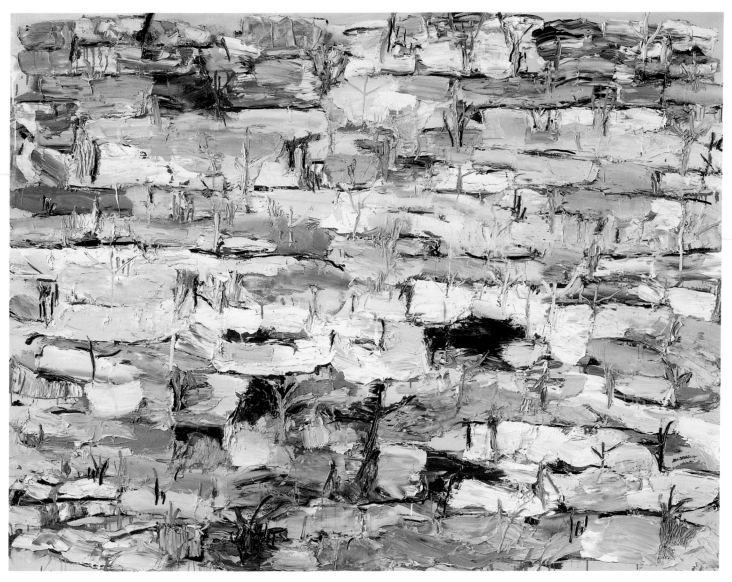

Joan Snyder, BEANFIELD WITH SNOW, 1984
oil and acrylic on canvas, 72 × 96, Private collection.

MARY STUBELEK
b. Southampton, New York, 1951

Mary Stubelek is one of the few artists working on the East End who actually grew up there. She attended Marymount College from 1969 to 1973, and in 1972 studied at the International University of Art in Florence. From 1973 to 1976 she was assistant curator, then curator at the Parrish Art Museum in Southampton, and she has also taught classes there. In 1974 she did graduate work in drawing at Southampton College, where in 1980 and 1981 she served as assistant professor of drawing. Stubelek has won awards at juried exhibitions at the Heckscher Museum, the Guild Hall Museum, and the Parrish Art Museum, where in 1975 she was awarded a one-woman show, held two years later.

Stubelek describes the subject of *Storm over the North Fork* as "an area of open space between two houses with a long view to the North Fork. I kept returning to this view, occasionally stopping to make drawings or watching it, until finally the feeling for it became internalized. I suppose the area became more significant as time passed because I've been working on 'The Last Farm Project,' which encompasses . . . the loss of landscape as well as a way of life on Eastern Long Island."[1] She writes, "The piece is an expressive interpretation of the actual site. As with every piece, as the work progresses the challenge of the medium becomes a priority, along with the interpretation of the subject. In other words, to challenge the medium (in this case a mixed media) as far as possible within its limitations so that the piece takes on a life of its own. This is an ongoing struggle."[2]

1. Statement for "Waterworks," exhibition held at the Heckscher Museum, 1985, in a letter to Ronald G. Pisano, May 27, 1985.
2. Letter from the artist, March 2, 1989.

ROY W. NICHOLSON
b. Cambridge, England, 1943

Roy Nicholson attended the Hornsey College of Art in London from 1960 to 1965. He came to the U.S. and studied at the Brooklyn Museum School of Art in 1965–1966, first visiting the East End in 1966, at the invitation of an artist friend in East Marion, on the North Fork. He returned to England and taught at various institutions before coming back to the U.S. in the mid-1970s. In 1977 his wife, Helen Harrison, accepted a position as curator at the Parrish Art Museum, and the couple moved first to East Quogue and then to Noyac. Nicholson has taught at Stony Brook University and since 1986 has been an assistant professor of art and director of the Fine Arts Gallery at the Southampton Campus of Long Island University.

Nicholson says, "My environment has always had an important influence on my work. . . . General impressions combine with specific aspects of the landscape to create an amalgam of experiences and emotions. As the work progresses, it becomes a compilation of fragments from diverse sources — a reflection, a shape, a color seen, remembered and transformed.

"*Pond (31) Nsiki* is an outgrowth of earlier, less generalized series that dealt with water reflections and the rhythms of ponds. Although still a meditation on natural phenomena, it includes more animated forms associated with a dynamic, volatile environment, like the windswept, rocky bluffs at Montauk but by no means specific to that place.

"There is magic here, too, in the form of an African *nsiki*, a fetish for binding agreements. . . . It sets the seal on the contract I make with the landscape: to wrest from it only those elements that I cannot do without."[1]

1. Letter from the artist, April 5, 1989.

MARY ELLEN DOYLE
b. Hartford, Connecticut, 1938

After two years at Vassar College, Mary Ellen Doyle entered the Ruskin School of Fine Art in Oxford, England, where in 1958 and 1959 she studied figure drawing. She returned to the U.S. and earned a B.F.A. from the School of Fine Arts at Boston University in 1962. During her years in Boston the artist Walter Murch was an inspiring teacher, and he later encouraged her to study with John Heliker at Columbia University in New York. Heliker influenced Doyle to return to drawing subject matter rather than working abstractly. She did graduate work at NYU and from 1974 to 1977 at Pratt Graphics Arts Center. She has taught at Barnard College (from 1962 to 1965), the Museum of Modern Art (from 1963 to 1970), and the New School for Social Research (from 1978 to the present).

Doyle first came to Southampton in about 1963 to stay in her father-in-law's house in Noyac. The scrubby landscape reminded her of Cape Cod, where she had painted as a student, and she began painting directly out of doors. She has had a studio overlooking a large piece of preserved farmland in Bridgehampton since 1984. *Farm Terrain* was painted in August 1987. "I wanted to control one vast space on a contrastingly small, divided paper," Doyle explains. "To emphasize the tension between the perspective and the picture plane, I used similar reds and whites in the foreground, hills, and sky. I worked with strokes, scratchings, and line to paint the planes revealed by the light. As I studied the limits created by the window frames, I defined the edges of the diptych. Finally, inspired by this agricultural, island location, I adjusted the color and drawing of my painting."[1]

1. Letter and material from the artist, January 17, 1989.

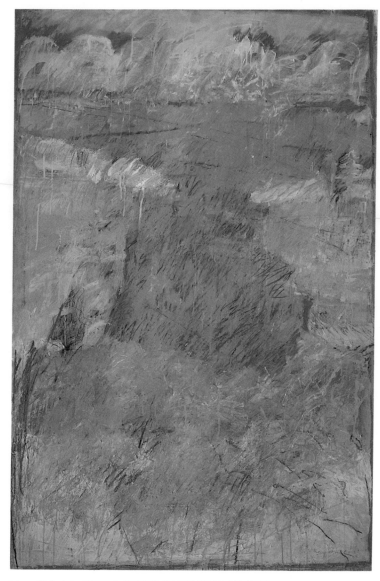

Mary Stubelek, STORM OVER THE NORTH FORK, 1984
mixed media on rag board, 60 × 40, Collection of the Artist.

Roy Nicholson, POND (31) NSIKI, 1988
oil on canvas, 68 × 62, Collection of the Artist.

Mary Ellen Doyle, FARM TERRAIN, 1987
watercolor and lithopencil on paper, 6½ × 11¼, Humphrey Fine Art, New York City.

AUDREY FLACK
b. New York City, 1931

Audrey Flack had an early interest in art and attended the High School of Music and Art and then Cooper Union. After graduate study at Yale and subsequent classes in anatomy and perspective at the Art Students League, she began a series of paintings based on photographs, and in 1969 was one of the first artists to make a painting using a projected slide. Her usual approach involves carefully arranging her compositions and taking hundreds of photographs before painting the work, a very different idea from that behind *End of Fall Sunset on Georgica Pond*.[1]

Flack first came to the East Hampton area in the 1950s, and in the early 1970s bought the painter Jimmy Ernst's house. She says, "I gave myself the challenge of painting the sunset every night. So after working in the studio all day, come late afternoon, I would grab my watercolors, brushes, Arches watercolor block, folding stool, jars of water, etc., jump in my car, and drive around town chasing the sun. *End of Fall Sunset on Georgica Pond* was painted on a chilly fall day. Summer residents clear out and I was free to drive up several private driveways. I was overwhelmed by the beauty of that most incredible sunset which I found at the end of one of those private driveways."[2]

1. See Cindy Nemser, *Art Talk: Conversations with Twelve Women Artists* (New York: Scribner's, 1975), 302–325.
2. Letter from the artist, March 7, 1989.

MALCOLM MORLEY
b. London, England, 1931

Malcolm Morley graduated from the Camberwell School of Arts and Crafts in 1953 and then attended the Royal College of Art, receiving a degree in 1957. He moved to New York the following year, and by about 1964 had received international attention for his superrealistic views of ships and ship's cabins, which he made using photographs as a point of departure. Since about 1969 his work has become increasingly painterly and organic.

Morley incorporates experiences he has had or sketches he has done in different places into sometimes unlikely combinations. In his recent work, bits of East Hampton show up along with Greek themes. In *Kite on Gibson Beach* he combines a huge, colorful kite seen in East Hampton with a view of the beach in Bridgehampton, where he rented a house one year.

Since about 1983 Morley has had a home and studio in a church he has renovated extensively, in the hamlet of Brookhaven. He first came to the area to see his dealer Xavier Fourcade, who had a home in Bellport. Morley had been acquainted with the East End since about 1959, when he and Mel Jaffe had the idea of making a film on Willem de Kooning and traveled to Springs to interview him. He has since spent time on the South Fork regularly. The artist says he has had "some enormous breakthroughs on Long Island," but admits he does not find it "plastically interesting," preferring, for example, the rugged and picturesque area in Maine where he also has a home.[1]

1. Based on a conversation with the artist, April 13, 1989.

Audrey Flack, END OF FALL SUNSET ON GEORGICA POND, 1983
watercolor on paper, 8½ × 14½, Private collection, Boston.

Malcolm Morley, KITE ON GIBSON BEACH, 1984
watercolor on paper, 32½ × 40, Courtesy of the Pace Gallery, New York City.

NELL BLAINE
b. Richmond, Virginia, 1922

Nell Blaine began her art studies at the age of seventeen at the Richmond Professional Institute in Virginia, where she worked for two years. On the advice of her instructor Worden Day, Blaine moved to New York and enrolled at Hans Hofmann's school, where she studied from 1942 to 1944. Blaine developed an abstract style inspired by Hofmann's example and by her admiration for the work of Jean Arp, Piet Mondrian, and Jean Helion. At twenty-two, she was the youngest member of the American Abstract Artists group, and was involved with the Jane Street Gallery, an artists' cooperative.

In the late 1940s Blaine needed a break from her busy New York life, and she traveled through Europe from 1949 to 1953. During the period she was abroad her paintings became more representational, her palette brightened, and her brushwork became active and free. While visiting Greece in 1959 Blaine contracted polio. She recovered from the disease but was forced to retrain herself to paint with her left hand.[1]

Besides her travels through Europe and summers spent in Gloucester, Massachusetts, Blaine has also visited and painted on the South Fork of Long Island. "I visited often in the 1950s a number of painter friends in Springs, East Hampton and Southampton," the artist says, "namely, Jane Freilicher, Larry Rivers, and Fairfield Porter (also Willem de Kooning). In 1966 and 1967 [I] stayed first at Amagansett and then in Springs as a guest of Arthur W. Cohen, my patron-collector. At that time I made a number of watercolors [such as *Tree at the Edge of the Field, Springs*] and a sketchbook with ink drawings."[2]

1. See Edward Bryant, *Nell Blaine* (Exh. cat.; Hamilton, New York: Colgate University, 1974).
2. Letter to Ronald Pisano, April 3, 1989.

BRUCE LIEBERMAN
b. Brooklyn, New York, 1958

Bruce Lieberman considers himself "sort of a pantheist," and says that "therefore a love of nature is part of the whole thing." He attended Stony Brook University, where he studied with Robert White, Mel Pekarsky, Lawrence Alloway, and Donald Kuspit, and then earned an M.F.A. from Brooklyn College, where he studied with Lennart Anderson. He went on to work privately with Paul Georges, and continued his studies at Southampton College (in 1976–1977) and Brandeis University. He currently teaches art at Mineola High School.

Lieberman has painted on the rural East End but now lives in a more suburban area. He says, "I have been forced to adjust and find beauty in the landscape wherever I can . . . in my yard, my hedge or my vegetable garden. This element of the landscape is the majority of what is left. If we do not see it as mystical and beautiful, it too will vanish. . . . Across the street is a stand of trees I've painted many times. They are all that remain of a beautiful piece of woods that I also painted many times. . . . But the good neighbor blindly hacks and cuts back the thickets and rakes the rich dark mulch that years have deposited at the foot of the trees to fulfill some ill-conceived . . . need to make room for yet one more square yard of green neat clean lawn. . . . When the leaves and other good stuff sit on the curb in hundreds of big plastic bags, I'll probably paint them too."

Snow on Branches and Blue Sky "is a view out my window at the moment when the snowstorm has passed, the wind shifted and something new and rich has occurred. That fleeting moment when the snow is going to melt off the branches. The colors vibrate and the day is different. A vanishing moment."[1]

1. Letter and material provided by the artist, February 3, 1989.

STAN BRODSKY
b. Brooklyn, New York, 1925

Stan Brodsky graduated from the University of Missouri in 1949 with a degree in photojournalism and received an M.F.A. from the University of Iowa the following year. He obtained a degree in education from Columbia University in 1959 and has taught painting at the C. W. Post campus of Long Island University since 1960. Among the awards he has won are fellowships to the Virginia Center for Creative Arts, Yaddo, and the MacDowell Colony. In 1985 he collaborated with the poet Arnold Planz on a publication called *Influences of the Landscape*.[1]

Brodsky has been working on groups of abstract paintings inspired by the bays off Huntington, where he lives, and Cold Spring Harbor. "I don't make sketches on the beach," Brodsky says. "The painting develops entirely in the studio, in an unplanned way. . . . The forms just seem to come from my recollections."[2] He has a long familiarity with his subject: "During more than two decades on Long Island, I have driven and walked along Cold Spring Harbor's shoreline countless times, observing its spreading tide, gentle contour and varied, reflected colors. On the particular occasion [when] I painted *Blue Harbor*, the afternoon light shone with exceptional clarity and brilliance. I sought to register its visual and emotional impact by employing caseins in broad, painterly strokes whose contrasting colors would especially define and intensify relationships between the major, natural elements. Overall I tried to establish an intimate, personal sense of nature that revealed its essential rhythms and immediate presence."[3]

1. Published by Backstreet Editions, Port Jefferson, New York.
2. "About Our Cover," *Long Island Philharmonic Program* (April/May, 1984–1985 season), 4–5.
3. Letter from the artist, January 9, 1989.

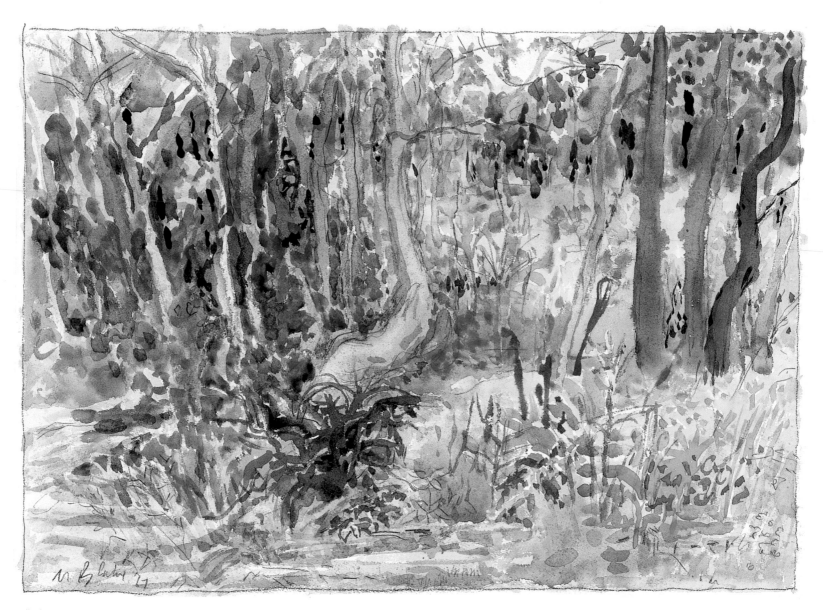

Nell Blaine, TREE AT THE EDGE OF THE FIELD, SPRINGS, 1967
watercolor on paper, 14½ × 20, Collection of Ann and Paul Sperry.

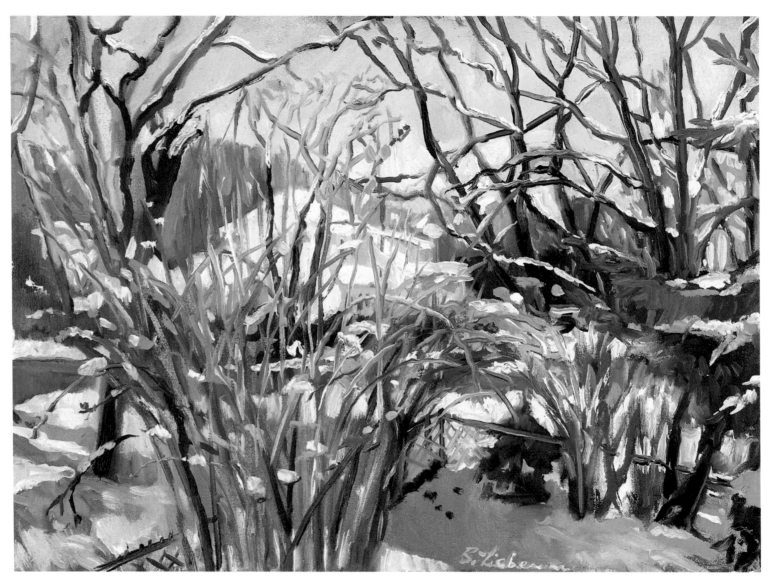

Bruce Lieberman, SNOW ON BRANCHES AND BLUE SKY, 1988
oil on canvas, 16 × 22, Collection of the Artist.

148

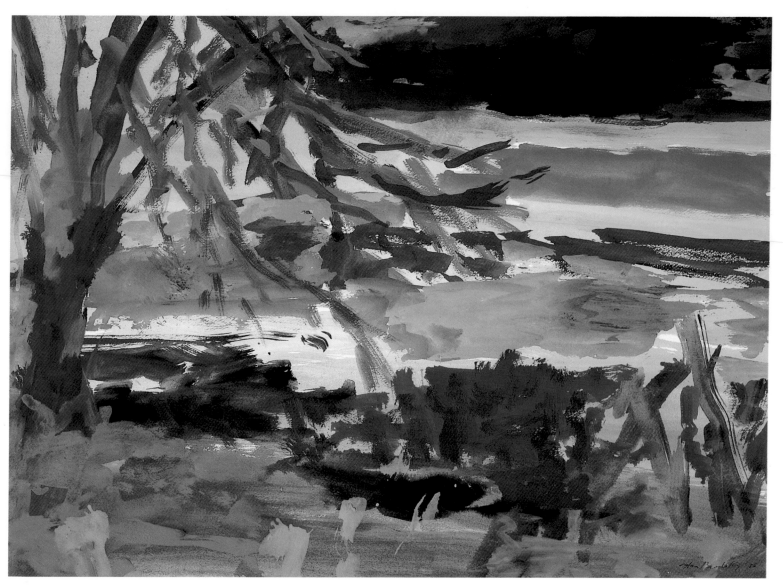

Stan Brodsky, BLUE HARBOR, 1986
casein on paper, 27 × 19, Collection of Joan and Tom Hewitt.

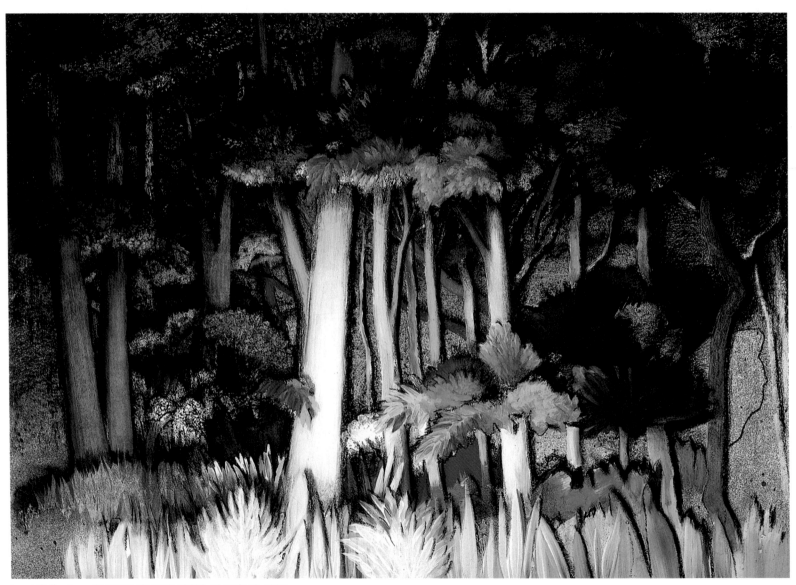

Janet Culbertson, SHELTER ISLAND TREES AT NIGHT, 1987
ink, paint, charcoal on rag board, 30 × 40, Collection of the Artist.

JANET CULBERTSON
b. Greensburg, Pennsylvania, 1932

Janet Culbertson studied at Carnegie Mellon from 1949 to 1953, after which she moved to New York. She earned her M.F.A. from NYU in 1963 and then studied etching at Pratt Graphic Arts Institute. In the early 1970s she began a series of island paintings and silverpoints, using Shelter Island as well as Captiva Island, Maui, and the Galapagos as her inspiration. More recently she has selected an aspect of the landscape or painted indigenous animals and vegetation.

Culbertson had visited the Sag Harbor–Shelter Island area when she was a child and came back in the mid-1960s, renting houses in Sag Harbor before building her own home on Shelter Island in the early 1970s, where she now lives full-time. She explains, "I love it as a place to paint undisturbed, especially in the non-tourist time."[1] She has painted several nocturnal studies based on photographs she made while driving around at night. Culbertson liked the way the flash of the camera singled out objects, as shown in *Shelter Island Trees at Night*. Other landscapes either celebrate nature or suggest the effects of chemical or nuclear pollution. She says of her goals, "I feel anxiety as we crowd out space, pollute the environment, pave over the earth, and find there is no place to go. . . . I am particularly drawn to nature at its apparent stasis point — that moment or even millennium that offers the possibility of a return to life or to a decline and disintegration. . . . I keep searching out those places where the drama is beginning — where vegetation, animals, humans and the elements are cast as protagonists. Nature has become theater and we are audience to its disappearance and transfiguration into a disneyland set."[2]

1. Letter and material from the artist, February 3, 1989.
2. Ibid.

Richard Karwoski, EAST END LILIES, 1983
watercolor on paper, 22 × 30, Private collection.

RICHARD KARWOSKI
b. Brooklyn, New York, 1938

Richard Karwoski studied at Pratt Institute with Richard Lindner, and in 1963 earned his M.F.A. from Columbia University. His early paintings were figurative, with a disturbing quality. In the early 1970s he made many large-scale studies in all media, including assemblage, of boots and shoes. In the mid-1970s flowers and fruits began to appear in his paintings, and he began to work almost exclusively in watercolor, though he does use acrylic and make lithographs as well. Brilliant color, close-up views, and abundant groupings are hallmarks of his style.[1]

Karwoski began visiting East Hampton in about 1960 and continued to spend weekends in the area until he purchased a house and studio in East Hampton in 1977. He now divides his time between his studio in New York and East Hampton. Karwoski feels that his visits to the East End have affected his choice of subject matter, and adds, "I generally work on one image at a time until I exhaust all the possibilities and challenges of that particular subject." His subjects in recent years have been trees, flowers, fruit, and boat basins. He continues, "Although *East End Lilies* is an extension of my flower/garden series, the imagery remains very special to me, for I've only done two in the series. What inspired the watercolor painting are the clusters of orange lilies that I always see growing freely along the roads during the summer months on the East End."[2]

1. *Richard C. Karwoski*, foreword by Marilyn L. Schaefer, 1977, and *Richard C. Karwoski: The Second Catalogue*, foreword by Elaine Benson, 1988.
2. Letter from the artist, March 21, 1989.

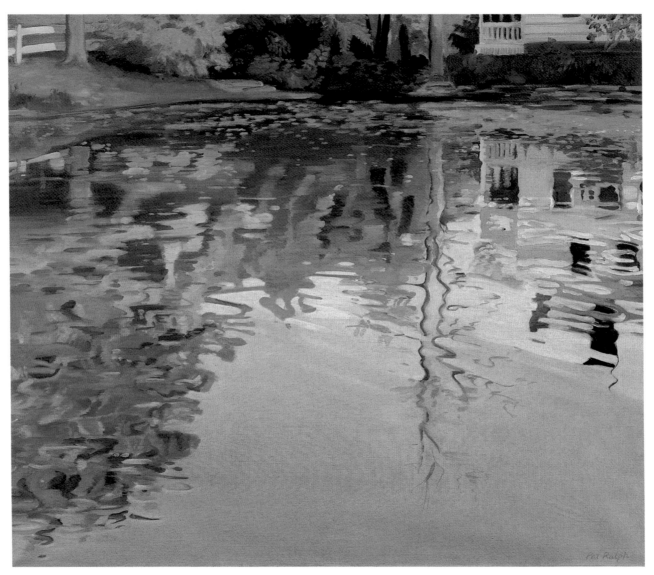

Pat Ralph, MILL POND, AUTUMN AFTERNOON, 1979
oil on canvas, 30 × 36, Collection of Mrs. George Bunnell.

Thomas Dooley, FENCE AT THE MAIDSTONE CLUB, 1983
acrylic on paper, 22 × 29½, Collection of Remak Ramsay.

PAT RALPH
b. West Orange, New Jersey, 1929

Pat Ralph graduated from Douglass College with a B.A. From 1968 to 1973 she studied at the Art Students League, primarily with Julian Levi and, later, briefly with Wolf Kahn. She greatly admires the nineteenth-century American luminist painters such as Sanford Robinson Gifford and Fitz Hugh Lane. Her own landscapes have been praised for their treatment of light, which she uses sometimes to give a sharp clarity and at other times to create a soft and moody effect.

Most of her work has been done around her home in Centerport on the North Shore of Long Island and on the East End. She frequently visits Los Angeles, however, and from 1984 to 1986 concentrated on a series of monotypes of that area to provide herself with a change of pace.

Mill Pond, Autumn Afternoon was painted at the Grist Mill Pond near Harbor Road in the village of Stony Brook. Ralph writes, "In my paintings I seek a stunning image, expressed with clarity and augmented with hints of mystery or wit. My landscapes . . . reflect an interest in light, atmosphere and other natural phenomena. I am particularly intrigued by the singular light of early morning and late afternoon or early evening . . . the hours in which natural effects are most fleeting, which makes the attempt to halt and crystallize the moment fraught with paradox."[1] In this particular work Ralph set herself the task of conveying both the time of day and the time of year through the reflections in the water.

1. Letter from the artist, undated.

THOMAS DOOLEY
b. Chicago, Illinois, 1951

Tom Dooley began his art education on his own by looking at paintings at the Art Institute of Chicago. He particularly admired the work of Monet, Degas, Van Gogh, Sargent, and Kensett. He studied privately with George Rocheleau in 1966 and 1967, but he considers himself self-taught. Upon graduating from the University of Wisconsin in 1974, he visited the southwest coast of Ireland and California, spent a year in Chicago, and then made his way to New York City, which is now his home.

Dooley made the first of many visits to the South Fork in 1976. By the early 1980s he had begun to observe the East End landscape through the eyes of William Merritt Chase and Childe Hassam, who had painted there in the late nineteenth and early twentieth centuries. Dooley says, "The first time I saw red the way William Merritt Chase had used it, I was thrilled. He had passed on a very accurate story about light, and I was happy to receive it." He tells how this work came about: "My wanderings brought me to Amagansett, to Indian Wells, where the first of the puddle pictures was painted. What appeared to be a roadside puddle had formerly been a sacred Indian spring. *Fence at the Maidstone Club* is one of many pictures in this series. Days of continuous rain had made for a very wet spring that year and as I walked the landscape the sunlit East End of William Merritt Chase and Childe Hassam seemed to live only in myth. But the light, water, and landscape of split-rail fences became a source of inspiration. A low spot in the ditch along the fence collected water, holding it long after the rains let up. The convergence of elements: man and nature, earth, water, sky and light at this spot drew me back many times."[1]

1. Letter from the artist, April 7, 1989.

HARVEY DINNERSTEIN
b. Brooklyn, New York, 1928

Harvey Dinnerstein graduated from the High School of Music and Art and studied with Moses Soyer from 1944 to 1946, and then worked at the Art Students League with Yasuo Kuniyoshi and Julian Levy from 1946 to 1947. He then attended the Tyler Art School of Temple University in Philadelphia in 1950. Dinnerstein has exhibited extensively and won many awards, including grants from the Tiffany Foundation in 1948 and 1961. His teaching credits include stints at the School of Visual Arts in New York (from 1963 to 1980), the National Academy of Design (from 1974 to the present), and the Art Students League (from 1980 to the present). Throughout his career he has maintained a home and studio in Brooklyn.

In the early 1970s Dinnerstein felt the need for a change after completing a large studio piece and began a ten-year project called The Seasons, painted in Prospect Park, which is near his home in Brooklyn. The serene *Winter* is unlike most of the others in the series in that it does not incorporate figures. The final paintings do not exactly reproduce the view; the artist has changed elements to suit his artistic purpose. For example, in *Winter* he has eliminated a wooded area behind the tunnel.[1] Dinnerstein explains his method: "The initial studies for The Seasons were small in scale, drawings and sketches in pastel and oil, painted on location. Working from these studies, I constructed the larger canvases in my studio. In developing the concept, I tried to reach beyond my initial studies to another level of perception. The tunnels of the park became passages in time and space, as the painting *Winter* suggests the infinite mystery of the final passage."[2]

1. Harvey Dinnerstein, *Harvey Dinnerstein: The Seasons* (New York: Sindin Galleries, 1983).
2. Letter from the artist, January 29, 1989.

Harvey Dinnerstein, WINTER, 1982
oil on canvas, 60 × 144, Collection of Lois and Harvey Dinnerstein.

DAVID LEVINE
b. Brooklyn, New York, 1926

As a boy, David Levine attended art classes at Pratt Institute and the Brooklyn Museum Art School from 1936 to 1938. He began his formal studies at the Tyler School of Fine Arts in Philadelphia, where he worked off and on from 1943 to 1949 and where he met the painter Aaron Shikler, a lifelong friend, and Roy Davis, who gave him his first one-man show at his gallery in 1953. Levine enjoyed visits to both the Philadelphia Museum of Art and the collection of Dr. Albert Barnes; the works of Vuillard, Eakins, and Corot made a lasting impression on him. Levine was drafted in 1946 and spent two years in the Army in Europe before resuming his art studies in Philadelphia and then in New York at the Hans Hofmann School in 1949. His reputation as a caricaturist began with the depart-

mental headings he drew for *Esquire* in 1958, and evolved with the full portraits that have appeared in the *New York Review of Books* from 1963 to the present. His drawings have appeared on the covers of *Time* and *Newsweek*, and he has illustrated ten books.[1]

Levine's portrayals of political, literary, and artistic figures have nothing to do with the landscapes and figure studies he paints. Levine often works in watercolor, and he feels that the nineteenth-century English watercolorists have influenced his technique and point of view. Coney Island is a favorite subject. Levine writes, "For more than a quarter of a century I have been painting a limited area of Coney Island. This stretch of two bays includes the Thunderbolt, a terrifying ride which I have both taken as a youth and watched others defy. Of course all of this activity takes

place during the summer (for me, each August, when I am free of deadlines for the *New York Review of Books*). As I have grown older so have the rides, boardwalk, shops and games. . . . Coney Island is at present a gothic ruin. Thus the title."[2] The Thunderbolt is one of many terrifying rides that have been popular at Coney Island, beginning with LaMarcus A. Thompson's invention, the Switchback Railway, which opened in 1884. Others were called the Tornado, the Comet, the Rocket, the Giant Coaster, the Mile High Chaser, and the Cyclone, the scariest of them all.[3]

1. Thomas S. Buechner, *The Arts of David Levine* (New York: Alfred A. Knopf, 1978).
2. Letter from the artist, February 10, 1989.
3. Elliot Willensky, *When Brooklyn Was the World, 1920–1957* (New York: Harmony Books, 1986), 182.

P. L. Sperr, Bowery at West Sixteenth Street, Coney Island, July 4, 1936
Courtesy of the New York Public Library Special Collections.

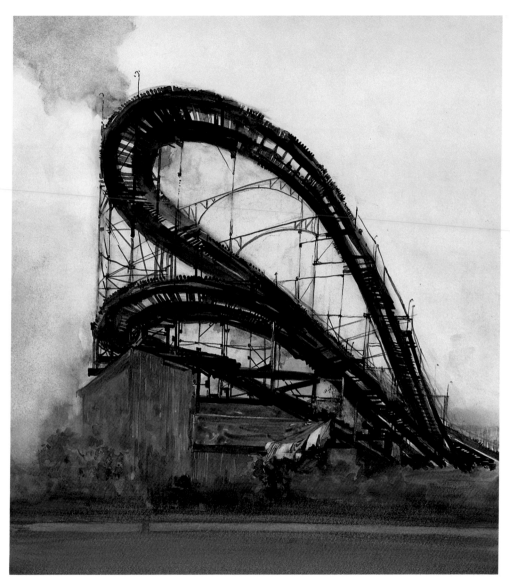

David Levine, END OF JOY, 1986
watercolor on paper, 17¼ × 14, Copyright 1986 David Levine,
Photograph courtesy of Forum Gallery, New York City.

ROBERT GWATHMEY
Richmond, Virginia 1903–1988 Southampton,
New York

Robert Gwathmey studied at North Carolina State College and then at the Maryland Institute before entering the Pennsylvania Academy of the Fine Arts, where he worked from 1926 to 1930 and studied with Franklin Watkins. He won the Cresson fellowship for European study in 1929–1930. Gwathmey began his artistic career at the start of the Depression, which shaped his lifelong concern with social issues and injustices. He mixed social content with a formal style influenced by modernist painters such as Jacques Villon, Lyonel Feininger, Marcel Duchamp, and Stuart Davis. Many of his subjects were drawn from his native South, particularly from the life of the black sharecropper.

Gwathmey moved to New York City in the early 1940s, and from 1942 to 1968 he taught at Cooper Union.[1] During this period he was active in artist's rights groups as well as in broader social issues, having served as vice president of the Artists' Union in the 1930s.

In 1966, Gwathmey asked his son Charles, an architect, to design a house for him on Bluff Road in Amagansett, where he lived until his death. This house was described as "a landmark in American residential architecture . . . a model for hundreds of similar, modernist-influenced homes."[2] *End of the Season* was probably painted at Amagansett Beach and is one of several beach scenes Gwathmey produced. The color and patterns of the umbrellas against the empty beach typify the artist's interest in design. According to his wife, the couple spent a lot of time at the water, and Gwathmey was always amused by the activities of other beachgoers.[3]

1. Abram Lerner, *Gwathmey: Works from 1941 to 1983* (Exh. cat.; East Hampton, N.Y.: Guild Hall Museum, 1984).
2. Douglas C. McGill, "Robert Gwathmey, 85, an Artist of Social Passions and Style, Dies," *New York Times*, September 22, 1988, B11.
3. Conversation with Rosalie Gwathmey, April 4, 1989.

Robert Gwathmey, END OF THE SEASON, 1983
oil on canvas, 29¾ × 38, Courtesy of Mrs. Robert Gwathmey.

GRAHAM NICKSON
b. Knowle Greene, England, 1946

Graham Nickson studied at the Camberwell School of Arts and Crafts in London from 1965 to 1969, after which he attended the Royal College of Art until 1972. He won the Prix de Rome in 1972 and spent the next two years in Rome, where he became interested in the painters of the Quattrocento, especially Masolino. During this time he painted his first bather composition, combining the classical structure he admired with a contemporary look.[1] Nickson moved to New York in 1976 and the following year was invited to Wainscott by friends, a "magical trip." From 1979 on, Nickson has rented houses in Wainscott, most recently spending summers and weekends in a large barn formerly used for potatoes, which he rents year-round. Although he makes excursions around the South Fork, he favors the particular stretch of land between Georgica Pond and Wainscott. He likes the diversity of light in the area and its ability to create acid color, and the way the terrain is divided into "strips."

On the South Fork, Nickson developed his bather series further, having been struck by a strange sight in the distance on a deserted beach in Wainscott, which turned out to be a bather standing on his head, a motif he had already explored. He has made a few watercolors and paintings on the theme of *Bather with Reflector*. The artist likens the figure to a "fallen caryatid," but the inspiration for this work came from the present-day sight of one of the many sun-worshipers who crowd the beaches on the East End.[2]

Nickson's work has been praised for its "sense of architecture," as well as for having "a sense of drama" created by cropped compositions and the anonymous quality of his figures.[3]

1. See Sasha Newman, *Graham Nickson* (Exh. cat.; New York: Hirschl & Adler Modern, 1983).
2. Information about Nickson's connection to the East End is based on a conversation with the artist, May 2, 1989.
3. John Russell, "Art: Nickson's Beaches," *New York Times*, December 10, 1982, C29.

Janet Culbertson, Jessup Neck
Photograph courtesy of the Artist.

Graham Nickson, BATHER WITH REFLECTOR, 1982–1983
acrylic on canvas, 96 × 96, Hirschl & Adler Modern, New York City.

JENNIFER BARTLETT
b. Long Beach, California, 1941

After graduating from Mills College in California, Jennifer Bartlett was accepted at Yale on the strength of her loosely painted abstractions. By the fall of 1964 she had earned her B.F.A., and the following year her M.F.A. She took a job teaching at the University of Connecticut at Storrs, which she held until 1972. In 1968 she rented a loft on New York's Greene Street, while continuing to commute to Storrs and New Haven, where her husband, Ed Bartlett, lived. She began to make constructions using cheap objects she found at stores on Canal Street, and also started to write essays and an autobiography with the tongue-in-cheek title *The History of the Universe*.

In the late 1960s Bartlett began to create large-scale multiple images on steel plates, using systematic combinations of dots painted with Testor enamel colors over a sink-screened grid. She gradually began using broader brushwork, varying color sequences and painting styles, and incorporating recognizable elements such as houses and trees to transform the repetitious forms. Her major work *Rhapsody* was begun while Bartlett looked after the house of friends in Southampton during the summer of 1975. The complete work, 988 plates in all, was exhibited at the Paula Cooper Gallery in New York and became Bartlett's first important sale. She went on to explore series of paintings on single themes, with freer brushwork, eventually using canvases in conjunction with the steel plates — one of houses, and then the Swimmer series. In 1979 she completed a group of nearly 200 drawings entitled *In the Garden*, inspired by the setting of a villa she lived in for a few months in the south of France.

Around 1982, Bartlett began working entirely in oil on canvas, painting more straightforward landscapes from different vantage points to depict the same subject on large canvases divided into two or three panels. She sometimes combines paintings with three-dimensional objects, or sculptures, as in her commission for the Volvo Corporation in Sweden.[1] In 1983 she remarried and began spending part of the year in Paris with her European husband. While awaiting the birth of their daughter in August 1985, Bartlett rented a house in Sands Point, in order to be near the water, yet close to her doctor and hospital in New York.[2] During the time she spent there she used pastel and oil on a large scale to explore recurrent themes of a small house, a boat, and water, as in her painting *At Sands Point #21*.

1. See Marge Goldwater, Roberta Smith, and Calvin Tomkins, *Jennifer Bartlett* (New York: Abbeville Press, 1985).
2. Conversation with Vicky Cardaro, Ms. Bartlett's assistant, March 21, 1989. Bartlett spent the summer of 1987 at Saltaire on Fire Island.

Jennifer Bartlett, AT SANDS POINT #21, 1986
oil on canvas, 36 × 84, Private collection, New York City.

BIBLIOGRAPHY

"Amagansett Art School to Start Season June 15." *East Hampton Star*, June 9, 1938, 1.

American Art Today. Exh. cat. National Art Society, 1939.

Bailey, Paul, ed. *Long Island: A History of Two Great Counties, Nassau and Suffolk.* 2 volumes. New York: Lewis Historical Publishing Co., 1949.

Bell, Jane. "Malcom Morley." *Arts Magazine* 48, no. 3 (December 1973), 74–75.

Blakelock, Chester R. "Know Your State Parks." *Long Island Forum* 4, no. 1 (January 1941), 13–14.

Bookbinder, Bernie. *Long Island: People and Places, Past and Present.* New York: Harry N. Abrams, 1983.

Braff, Phyllis. *Artists and East Hampton: A Hundred-Year Perspective.* Exh. cat. East Hampton, N.Y.: Guild Hall Museum, 1976.

Carlin, John. *Coney Island of the Mind: Images of Coney Island in Art and Popular Culture, 1890–1960.* Exh. cat. New York: Whitney Museum of American Art Downtown at Federal Reserve Plaza, 1989.

"A Conversation: Malcom Morley and Arnold Glimcher." In *Malcom Morley.* Exh. cat. New York: The Pace Gallery, 1988.

Dwyer, Norval. "Camp Upton — World War II." *Long Island Forum* 27, no. 9 (September 1964), 193, 194, 210, 212.

Ellis, David M., et al. *A Short History of New York State.* Ithaca, N.Y.: Cornell University Press, 1957.

Gatner, Elliott, S. M. "The Beginnings of Long Island University." *The Journal of Long Island History* 14, no. 1 (Fall 1977), 443.

Harrison, Helen A., and Prescott D. Schutz. *Art and Friendship: A Tribute to Fairfield Porter.* Exh. cat. East Hampton, N.Y.: Guild Hall Museum, 1984.

Harrison, Helen A., et al. *Dawn of a New Day: The New York World's Fair, 1939/40.* Exh. cat. Queens, N.Y.: Queens Museum, 1980.

Hazelton, Henry Isham. *The Boroughs of Brooklyn and Queens, Counties of Nassau and Suffolk.* 2 volumes. New York: Lewis Historical Publishing Co., 1925.

Kertess, Klaus. *Drawing on the East End, 1940–1988.* Exh. cat. Southampton, N.Y.: Parrish Art Museum, 1989.

Levin, Kim. "Malcolm Morley." *Arts Magazine* 50, no. 10 (June 1976), 11.

Loring, John. "The Plastic Logic of Realism." *Arts Magazine* 49, no. 2 (October 1974), 48–49.

McDermott, Charles J. *Suffolk County, New York.* New York: James H. Heinman, 1965.

Newton, David. *The Peconic River: Gateway to the Long Island Pine Barrens.* Riverhead, N.Y.: Suffolk County Cooperative Extension, Cornell University, n.d.

O'Hara, Frank. *The Collected Poems of Frank O'Hara.* Edited by Donald Allen. New York: Alfred A. Knopf, 1971.

Perloff, Marjorie. *Frank O'Hara: Poet Among Painters.* New York: George Braziller, 1977.

Perreault, John. *Audrey Flack: Light and Energy.* New York: Louis K. Meisel Gallery, 1983.

Pisano, Ronald G. *Long Island Landscape Painting, 1820–1920.* Boston: New York Graphic Society, 1985.

———. *The Long Island Landscape, 1914–1946: The Transitional Years.* Exh. cat. Southampton, N.Y.: Parrish Art Museum, 1982.

———. *The Long Island Landscape, 1865–1914: The Halcyon Years.* Exh. cat. Southampton, N.Y.: Parrish Art Museum, 1981.

Randall, Monica. *The Mansions of Long Island's Gold Coast.* New York: Hastings House, 1976.

Rubenstein, Charlotte. *American Women Artists: From Early Indian Times to the Present.* Boston: G. K. Hall, 1982.

Sandler, Irving. *The New York School: The Painters and Sculptors of the Fifties.* New York: Harper & Row, 1978.

Smits, Edward J. *Nassau, Suburbia U.S.A.* Garden City, N.Y.: Doubleday & Co., 1974.

Solomon, Ruth. *Artists of Suffolk County: Part IV, The New Landscape.* Exh. cat. Huntington, N.Y.: Heckscher Museum, 1970.

Stott, Peter H. *Long Island: An Inventory of Historic Engineering and Industrial Sites.* Setauket, N.Y.: Society for the Preservation of Long Island Antiquities and the Historical American Engineering Record, National Park Service, 1974.

Viemeister, August. *An Architectural Journey Through Long Island.* Port Washington, N.Y.: Kennikat Press, 1974.

Westwater, Angela. "The Louis Comfort Tiffany Foundation: A Summary, 1918–1980." Great Neck, N.Y.: Louis Comfort Tiffany Foundation, n.d.

Wolfe, Judith and Rae Ferren. *Winterscapes: Forty-eight Artists of the Region Interpret the Theme.* Exh. cat. East Hampton, N.Y.: Guild Hall Museum, 1982.

INDEX: ARTISTS AND TITLES

Photo credits:
Unless otherwise indicated, photographs are credited to the individuals, institutions, or firms owning the works that are reproduced, with the following exceptions: Carl Andrews, 91; Sheldon C. Collins: 47, 79; Stephen Donelian: 61, 89, 106, 122, 123; Greg Heins: 144; Henry Nelson: 17, 19, 45; Jon Reed: 117, 131; Ñoel Rowe: 95; Lee Stalsworth: 21; Ellen Page Wilson, © 1988: 73; Dorothy Zeidman: 115.

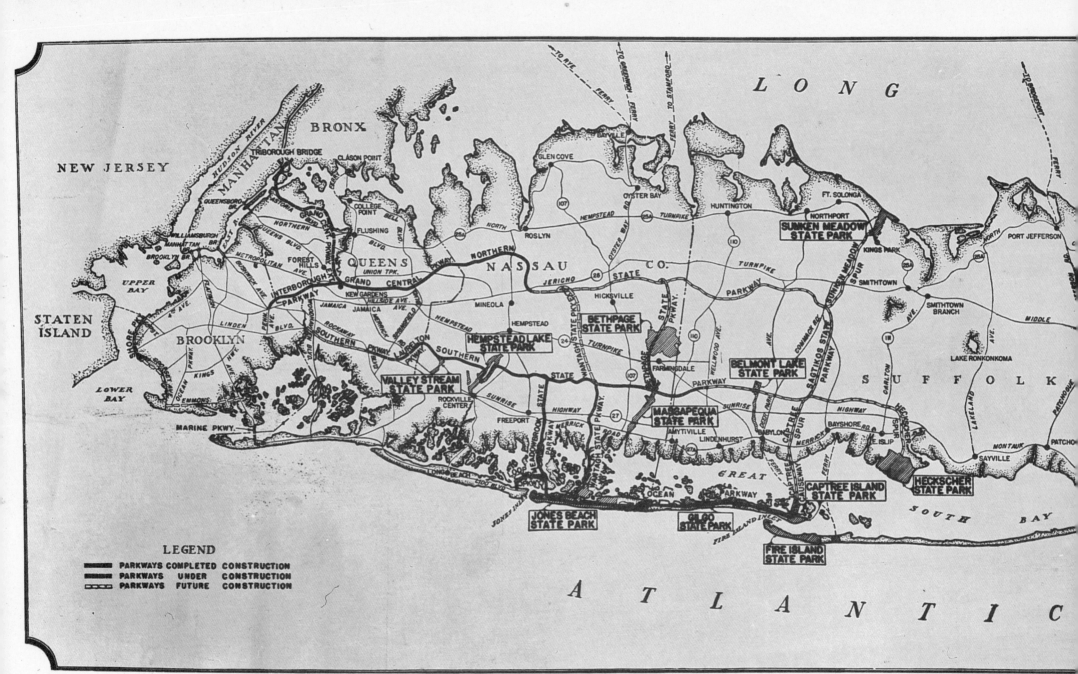